Jim Shaw

The Rinse Cycle

Edited by Laurence Sillars

BALTIC in association with Koenig Books, London

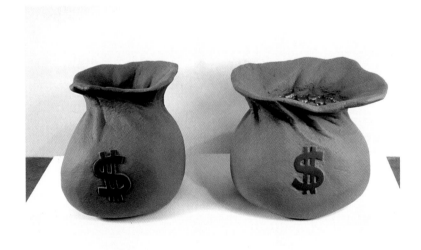

Money Bags, 2001, foam, acrylic, paint and resin
58.4 × 67.9 × 50.8 cm and 59.7 × 60.3 × 66.7 cm

Foreword

Jim Shaw has, to me, always been the embodiment of an artist where greater consideration exponentially rewards the viewer with a far richer experience of the artist's sense of the world. This is, of course, the case with all artists, but more so where the protagonist manages an almost unfathomable lexicon of material and memories, images and imaginings.

Shaw's work enmeshes its audience in a complex web of socio-political and psychological cogitations that deftly locates us in an enthralling, but often less than comfortable, place from which we have to find our way back to the familiar. For this reason, amongst many others, the opportunity for BALTIC Centre for Contemporary Art to present a major retrospective exhibition of Jim Shaw's work accompanied by this, the most comprehensive publication on his practice to date, represents a wonderful moment for the institution and its audiences.

It is of course an undertaking that has only been made possible by the hard work and generosity of very many people. The realisation of this exhibition has been a long-held passion of BALTIC's Chief Curator, Laurence Sillars, and he joins me in recognising the many people that have been involved in supporting and enabling him, and BALTIC to fulfill this undertaking.

Jessica Mastro, from the artist's studio has been a tower of information, patience and enthusiasm throughout the organisation of the exhibition and much gratitude goes to her as well as Sachiyo Yoshimoto, formerly of the Shaw studio, for her contribution to the initial stages of the project.

New and informed perspectives on Jim Shaw's practice were always central to BALTIC's aspirations for this project and so much credit must go to the writers who responded to the invitation to contribute with such enthusiasm and have brought a tremendous richness to the publication. Artists Anne Carson and Robert Currie, novelist Darcey Steinke, and John C. Welchman, Professor of Modern and Contemporary Art at University of California, San Diego have ensured this publication becomes not only a lasting testament to the exhibition but an invaluable and authoritative volume on Jim Shaw. We were delighted to have the opportunity to work again with designer Peter B. Willberg and are most grateful for his sensitive and enriching interpretation of this book.

Special thanks are also due to Michael Briggs for his role in launching this project, and to Scott Benzel, Glenn Bray and Lena Zwalve, Amy Gerstler, Mike Kelley, Dani Tull and Benjamin Weissman, each of whom was especially generous with their time, hospitality and reflections during Laurence Sillars' research trips to Los Angeles, and each of whom has been so important in enabling the exhibition to be as rich as we had all hoped.

Those galleries representing Jim Shaw internationally have also supported this exhibition in so many different ways and have been especially helpful in ensuring that so many pivotal works were able to be included in the show. We are grateful to Simon Lee Gallery, London, especially Nick Baker; Blum & Poe, Los Angeles, especially Tim Blum and Sam Khan; Metro Pictures, especially Allison Card and Karine Haimo and Galerie Praz-Delavallade, Paris, especially Flavie Loizon. We also thank Marc Jancou Contemporary, New York, Bernier/Eliades Gallery, Athens; Patrick Painter Inc, Santa Monica and their staff.

The terrifically generous lenders, too numerous to mention here but all detailed in the list of Exhibited Works, have been critical to the success of the exhibition and have so graciously given their full support by making works available from their collections. Each of them has played a vital part.

I also offer my sincere thanks to Crown Fine Art, not only for bringing the works together from around the world but for its generous sponsorship of the exhibition.

A project of this ambition and significance inevitably requires the commitment of the entire team at BALTIC and I am grateful to all that have helped to deliver this show and its related publication. Laurence Sillars has been very ably supported by the unstinting efforts of Katharine Welsh, Laura Harrington and Adrianne Neil and Katie Gibson, as well as the consummate work of the technical team, lead by Chris Osborne and Ian Watson. I also thank Vicki Hope, whose work was invaluable in the project's early phase.

Last of all and of most importance, I offer a great vote of thanks to Jim Shaw, the artist. Jim's legendary energy and creativity have been made continuously available to this collaboration and we are deeply indebted to him for his unstinting commitment, time and generosity of spirit.

Godfrey Worsdale
Director, BALTIC Centre for Contemporary Art

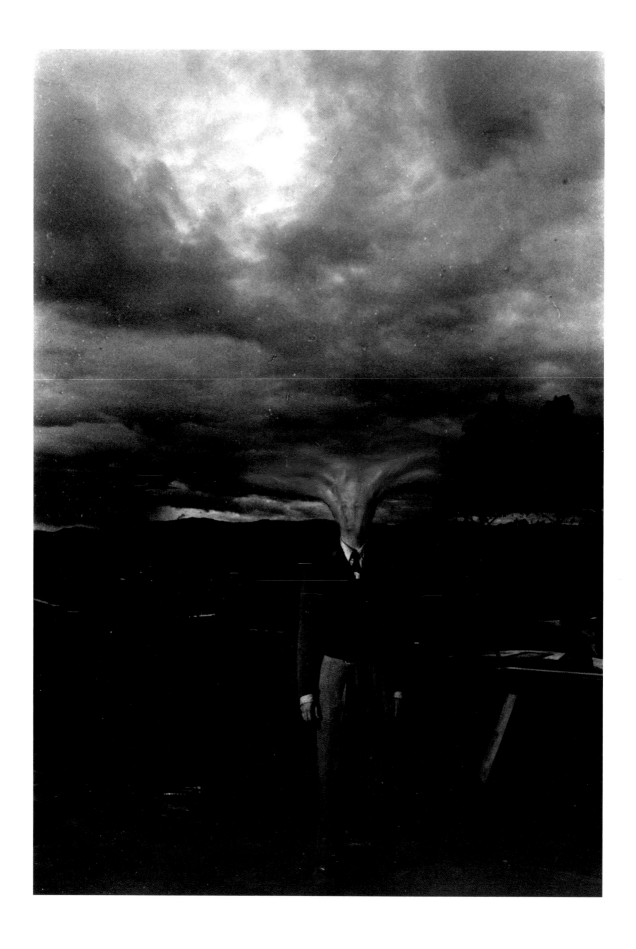

8 Untitled, 1978, retouched photograph, 25.3 × 20.2 cm

Jim Shaw: From the Shakers to The Avengers
Laurence Sillars

Soon after Jim Shaw bought his first house in Los Angeles his new neighbour ruefully remarked 'you think you own your stuff, but your stuff owns you.'[1] Stuff, especially that propagated by every strain of America's vast popular culture, is something Shaw has an unfathomable knowledge of. He has accumulated it for decades, from the monster magazines and comic books that provided a rare masculine outlet as a child in a female-dominated house to the scatterings of new American religions, crackpot science, movies, music, ad agencies and the wider vernacular that melt together in the sprawling, sun-addled pot of his now home city. This stuff drives the majority of Shaw's waking – and sleeping – thoughts.

Mirroring the abundance of this cultural debris, there has seldom been an artist so prodigious in output as Shaw, nor one so vehemently diverse in production. A conceptual artist who uses structure and form in equal measure, he typically works in series that are heavily researched, exist as hundreds of elements spanning many media and can occupy him for years. To ask Shaw about a work or series, or indeed any subject, is to be taken on an informed, seemingly intergalactic, journey navigating dizzyingly through often oblique references, pausing briefly by each one before landing firmly at the start again. He has a unique way of making sense of it all, bringing together America's history, madness and collective cultural subconscious, and that is what has made him one of the most uniquely influential artists of his generation in that country.

Born in 1952 in Midland, Michigan, Shaw studied at his state university in Ann Arbor from 1971 to 1974, building upon a taste for Pop art and Salvador Dalí's 'starter drug' Surrealism. His tutors were mainly evangelists of the Abstract Expressionists, who, emerging from New York in the 1940s, pushed Hans Hofmann and Clement Greenberg. Shaw 'tried to ignore them'. However, Gerome Kamrowski, an American Surrealist and automatist, was a significant influence there, as were Fluxus filmmaker George Manupelli and the Pop ceramicist Jackie Rice. Shaw's eclecticism and the levelling of high and low sources for which he is now known were solidified in Michigan. He looked up to Captain Beefheart, the Velvet Underground and Sun Ra and discovered the freeform experimental guitar playing of Hans Reichel and Fred Frith. Music, especially that which operated beyond the rules through improvisation, became an important part of his creative equations – he would soon be a founding member of the concept band Destroy All Monsters. It was also in Michigan that he met Mike Kelley, who remained an important conspirator in both ideas and friendship, and it was with him that he found permission to bring his love of comic books into his art. During a trip to New York, Kelley convinced Öyvind Fahlström to give a guest lecture at the university. Drinking at the bar afterwards, Fahlström revealed that some of his favourite artists were those of EC Comics. 'To hear that from the lips of a fairly respectable, adult, Communist, Marxist was exciting.'

Shaw ended up following Kelley to the California Institute of the Arts (CalArts) for his postgraduate studies. A school with a twenty-four-hour-a-day work ethic, hyper-analytic ethos and party-hard atmosphere, it suited him well. Yet Shaw lacked direction in

terms of his work's coherence. Hearing that one of his tutors, Richard Artschwager, was about to fail him he swiftly concocted a UFO-based religion (a precursor to a later series) and presented an extensive body of corresponding work united by narrative, rather than form or medium, at a parody opening 'with orange, green and purple "Martian" food set to the music from *Psycho*'. If CalArts taught him anything, it was how to present his art. His career since can be understood as the creation of a number of similarly diverse, although often dauntingly ambitious, receptacles into which to put ideas and working methods over a sustained period. Narrative brings order to his work; the lack of consistent signature style has been firmly retained.

Shaw describes the conception of *My Mirage*, his first extensive body of work after CalArts, as 'a post-grad exercise'. Begun in 1986, it comprises 170 wildly different component parts with scale as its only formally unifying device – each piece measures 17 × 14 in. While his own work had taken a back seat as he worked in a Hollywood special effects lab and storyboarded TV commercials, Shaw had been contemplating a study of 1960s aesthetics. The title of the series was borrowed from a track on Iron Butterfly's *In-a-Gadda-Da-Vida* (1968), an album that evoked many of the themes Shaw wanted *My Mirage* to address. 'Iron Butterfly made this great, absurd point to hook it on. Between being the soundtrack for more virginities lost in the '60s than anything else, *In-a-Gadda-Da-Vida* was combined with a sort of church-style organ that runs throughout their music and occasionally moralising tone.'[2] For Shaw, their music provided the perfect symbol for the Christian and puritan underbelly that regularly emerges in American culture and did so especially at the end of the '60s.

My Mirage tells the fragmented tale of Billy, a boy born through the birth canal of middle America into the 1950s. Blond-haired, blue-eyed, suburban, he is kid average. Billy's story unravels through a foreword and five chapters, each a segment of his life detailing some kind of rite of passage. Each chapter incorporates a number of elements that repeat throughout in a modified state according to Billy's changing psyche: a frontispiece, a *My Mirage* logo, a grid of girl classmates, a spiral and a collage. Beginning as a naive, sexually anxious adolescent, Billy's prototypical teen-guilt harnesses a journey into the excesses and escapisms of psychedelia during his college years. Hedonism turns to nightmare and, during a hallucinogenic episode, he follows a woman he adores into a pagan sect. Ultimately, Billy returns to the religion of his youth and experiences rebirth as a Christian fundamentalist. While he traverses these experiences he is presented either directly or by implication through all manner of media – painting, screen-prints, sculpture, drawing, video and collage.

Billy offers something of an intermittent alter ego for Shaw: Midville is substituted for Midland, and many of the images are loosely based upon the youthful experiences of the artist and his friends. *Sin of Pride* (1988) is underpinned by Shaw's recollection of entering a Halloween poster competition (his over-confidence cost him the vote amongst school peers), while 'Miss Foot', the designated owner of the school desk on which the apple of temptation rests in *Pandora's Box* (1986), was his second-grade art teacher. But while there is autobiography, *My Mirage* is really a study of a nation's visual history. Each of its images is appropriated from one in circulation in America and is contemporaneous with

Billy's position at each narrative step. *My Mirage* is thus one of the most complete archaeological digs through the archives of 1960s American tastes and motifs. Furthermore, its strategies, motivations, sources and references allow it to become a kind of code book to much of Shaw's subsequent art.

Among popular publications and advertisements, *My Mirage* includes often overt references to Frank Stella, Salvador Dalí, Archie Christian comics, Ed Ruscha, De Chirico, Steve Ditko, R. Crumb, Basil Wolverton, Jess, Jack Chick, Hieronymus Bosch, Victor Moscoso, Richard Hamilton, Gerry Anderson, John Baldessari and many others. Each work in the series rests upon its own aesthetic base but every image has been heavily adapted or embellished with a dense layer of further references to suit its new narrative purpose: Billy's coming of age as a cipher for the puritanical American Pilgrim. *The Golden Book of Knowledge* (1989) is a case in point. It reveals the morally bound Pinocchio sitting, knife in hand, on a tin of Sucrets throat sweets, in some faux-domestic chamber set into a dank basement utility room. The composition is based on a cover from a children's encyclopaedia magazine sold in instalments in supermarkets. Each issue had a distinctive *trompe l'oeil* cover crammed with groupings of disparate objects signalling its contents, including the week's letters. Pinocchio, whose puppet strings have been nailed to a cross, is sectioned off from the rest of the scene by a sewing machine and an umbrella – a reference to a quotation from Comte de Lautréamont much loved by the Surrealists, where he described the beauty of a chance encounter between a sewing machine, an umbrella and an operating table.[3] Beyond this interaction are, amongst other things, two clocks (one of them another apple) giving different times, a *trompe l'oeil* painting of a dead rabbit (*My Mirage*'s first chapter is titled 'The Rabbit Died'), a bloodied pair of binoculars taken from a murder scene in the film *Horrors of the Black Museum* (1959) and a nod to Oedipus, a James Bond bubblegum card and a pinned-up clipping from Harvey Kurtzman's *MAD* magazine with Popeye 'tromping' on Olive Oyl – Shaw is ever the bad pun enthusiast.

Innocence, domesticity, temptation, deviancy, comfort, sex, death, isolation, fear, religion and humour are all here. While a holistic introduction is thus made to the narrative

The Golden Book of Knowledge, 1989
gouache on board, 43.2 × 35.6 cm

that will follow, the image also exists as a self-sufficient critique of the wider social and political musings that *My Mirage* conveys. Many of these sources link to narratives beyond the specifics of this one image, yet they also begin a web of self-reference that pervades the series. Indeed motifs frequently reappear, requiring those wishing to probe more thoroughly into the story to vary their order of reading and to cross-refer to decipher its infinite subtleties. Repetition also allows the evolution of multiple narrative threads – Pinocchio's Sucrets being such a device, and in this case one that also perpetuates a shift between Billy and Shaw's experiences. In *Frontispiece 1* (1988), Sucrets appear alongside Billy's favourite toys, fictional characters and his anatomical diagram, suggestive of good health. In *Frontispiece II* (1988) they have been replaced with a tube of glue, and in the next chapter with a drug cocktail including an acid-impregnated sugar cube. With fracturing innocence, in *Billy Goes to a Party I* (1986) he is offered an open tin of the sweets by a devil-costumed classmate who proceeds to jab his pitchfork into the tin, which now contains Billy's brains (the image is based on a dream Shaw had when he was five). His temptation and suffering begin. Sucrets were forced on Shaw when he was sick: 'they take away the ability to taste, the only joy I had left, and now symbolize the masochism of everyday life to me'.

The intricacies and significance of *My Mirage* are enhanced by regular nods to its modes of production, as Shaw exploits the qualities of different materials by making direct reference to them. *Watercolour* (1989) is painted in watercolour and is about water, *Charcoal Drawings* (1990) – inspired by the Manson Family's cutting of swastikas into their foreheads, crossed with Ash Wednesday references – follows suit. Statements are also made about the techniques utilised to make the series. *The Soft Margarine* (1989) is a William Burroughs-style 'cut-up' of randomly reconfigured text and highlights the enduring influence of the writer's technique on Shaw's own creative methods. It is also relevant to its various modes of display. Conceived as a novel, *My Mirage* has only recently been published in book form in its entirety and was ordered according to one of numerous possible narrative structures rather than, say, chronologically.[4] The physical works have

Billy Goes to Party 1, 1988
watercolour and Xerox on rag
43.2 × 35.6 cm

The Soft Margarine, 1989
Photostat on paper, 43.2 × 35.6 cm

been exhibited twice in near totality but are otherwise reconfigured on a smaller scale in a revised order each time. Much like Burroughs' intention for readers of his novel *Naked Lunch* (1959), the viewer of *My Mirage* is at liberty to study the images in any order, whatever the context in which they are encountered.[5]

While *My Mirage* offers a taste of the youthful unrest of Billy (and his creator), its aesthetic accumulations reflect a social disquiet nationally. In *Sometimes He Found Disturbing Things on the Street* (1986), for example, Shaw recasts the masochistic collisions of American society as a Tom of Finland pornographic drawing: Jesus' suffering is highlighted as the touchstone of Christianity and the hero Superman needs someone like Lex Luthor, the embodiment of capitalist America, to cause him pain in order to feel human. Collectively, the iconographic clustering of *My Mirage* is one glorious metaphor for the production, consumption, absorption and waste that rose to new heights during the Reagan era. The processes and effects of popular culture, imbuing society with a push and pull of persuasion, archetype, promise and moralistic debris, are littered throughout.

Shaw is fervently conscious of his role as an artist and makes the pitfalls and potentials of creativity apparent in his work. Another aspect of Iron Butterfly that Shaw found inspirational for *My Mirage* was the band's brief flowering for two highly successful records followed by their rapid descent into obscurity, something Shaw considers symptomatic of the era. 'I was always curious about that aspect of creativity, how it seemed to come into focus and then go away.' The same of course applies to many visual artists whose formal, conceptual or technical evolution comes to a halt once a certain level of commercial success has been achieved, or simply because they find themselves in a creative cul-de-sac. Shaw's self-consciousness and anxiety around what and how an artist should contribute are manifested through his propensity towards autobiographical content and his frequent shifts among different media and styles – for Shaw, consistency is a trap. After *My Mirage*, he created a work called *Black Narcissus* (1992) to fill a gallery in a New York exhibition. A large shed constructed of cardboard was filled with row upon row of photographs, almost 300 in total, of Shaw pulling faces – he and his art-making had become inseparable.

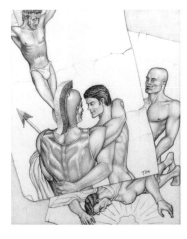

Sometimes He Found Disturbing Things on the Street, 1986
pencil on board, 43.2 × 35.6 cm

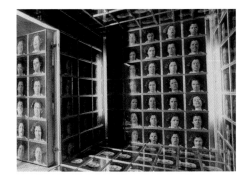

Black Narcissus, 1992
C-print, 268 parts, each 43.2 × 35.6 cm

His inner creative workings were laid bare for the next major series of works, the *Dream Drawings*. Shaw frequently used to dream about art objects (although he states that the demands of fatherhood, school runs and pet-care have now put an end to these dreams). Sometimes the objects would appear to be made by known artists – in one instance by John Baldessari, his former CalArts tutor – and sometimes they were made anonymously. Curious to record the creative whirrings of his subconscious mind, he began to write down his dreams, anticipating the creation of a potentially endless depository of ideas that could be brought to life as sculptures. Losing too many dreams mid-sentence, he streamlined the process with the aid of a bedside tape-recorder and in 1992 he began to turn these recordings into drawings.

Completed in pencil, the *Dream Drawings* have a fluidity in keeping with their origins, yet a detailing and a texture that give them a reality of their own beyond mere record. Stylistically, they were as different as possible from the preceding work to pre-empt any critical accusations of typecasting. Each drawing was made at a scale small enough to allow Shaw to work on it anywhere. His previous experience as a story-boarder is evident in the drawings' compositional structure, with each page typically divided into boxes that contain an image encapsulating either an entire dream or a section of dream narrative. The more drawings Shaw made the more he condensed them, leading to increasingly unusual juxtapositions: 'later drawings might have six different dreams on them and the earliest ones might have three pages, one image per section and that would make up a dream'. But his enthusiasm for comic book covers, especially those published by DC – home of Spiderman and Batman – is also pertinent to the renderings of these oneiric outings. 'DC comic books brought together the absolutely absurd but would always, later in the story, ground them in an explicable reality… they had this strange convention that they needed to make everything rational but had to have this surreal aspect to the covers and would bend over backwards to have the weirdest image.'

As a locus and source of iconography, dreams and art had of course met before. Shaw, however, used the opportunity to re-colonise the subject, moving away from the trappings it had inherited from European Surrealism. While Dalí and Magritte, for example, had created worlds that existed firmly in a dream-space, Shaw's drawings were set within a world of offices, shopping malls, suits and missed deadlines, and there were frequent references to the art world. This reality pushed into an imaginative beyond was rendered in black and white rather than technicolour to further distance the drawings from the handling of similar subject matter by his predecessors. Crucially, it had also always been Shaw's objective to bring the objects of his dreams into reality and to render them in three dimensions; the drawings should thus be understood as 'the text that made you understand the objects that were yet to come'. After two years, Shaw had amassed a vast number of drawings and began the *Dream Objects*, as ever in awe-inspiring numbers. Unlike the drawings, Shaw's sculptures display no formal unity and are as inconsistent as the dreams that created them.

Shaw's most elaborate fiction to date arrived in the form of the pseudo-religion Oism, initiated while he was still bringing his dreams to life. The idea of Oism evolved from the new and self-created religions of America, a country with more faiths today than any

other. It was supposedly founded by Annie O'Wooton, a virgin who gave birth to herself through the earth. Oism has its own mythology and pre-history, paralleling Mormonism, and is traceable through objects of worship, narrative comics and commemorative rituals recorded and presented on video. A number of paintings also exist, some presenting designs for posters for Oist movies. Such fragmented and sporadic 'evidence' of Oism paradoxically lends it credibility, suggesting an ongoing phenomenon rather than an already completed full narrative. Shaw is currently working on *The Rinse Cycle*, an Oist prog rock opera in four parts. Like any religion of initiates, Oism can bewilder those beyond its circle.

Shaw appears to operate in a parallel space, be it his subconscious, Billy's Midville or another product of his self-confessed attention deficit disorder. Yet we should be wary of labelling his work 'fiction', for the realms he brings to life are always by-products of that which already exists and which has already been mediated through the forms that he appropriates. While Shaw's use of the real could be aligned with the tendencies of artists at the end of the last century who reacted against the reductive art of the 1970s or the postmodern simulacrum of the 1980s, his is distinctive in its operation between the narratives of mythology and the facts of reality and its consequent eliding together of popular culture and the everyday – which are in so many areas of contemporary American social life already indistinguishable.

Much as the aesthetics of the 1960s reciprocally shaped and were shaped by America's societal structures, as suggested by the tangled webs of *My Mirage*, so too are its new religions and the desires that give rise to their continual multiplication. Since the mid-1970s the messages of these faiths have been spread and received via the same means used to disseminate popular entertainment – dedicated cable TV stations, books and magazines, and a manufacturing industry that churns out religious gifts alongside X-Men figurines. In 1975 religious broadcaster Gene Scott began preaching to the nation for several hours every night on television from Faith Center in Glendale, Los Angeles County, a church that owned four broadcast stations. In 1980 he was the subject of Werner Herzog's documentary *God's Angry Man*. The intersection of faith and popular culture has also

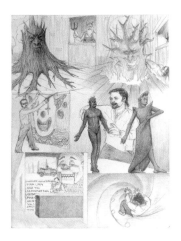

Dream Drawing ("I was in a Vegas show about a Viking farmer..."), 1995, pencil on paper
30.5 × 22.9 cm

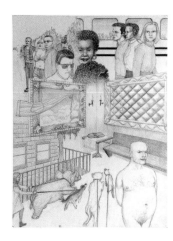

Dream Drawing ("On the TV movie bio of Frank Sinatra...")
1996, pencil on paper
30.5 × 22.9 cm

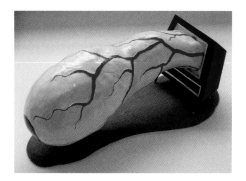

Dream Object (Eyeball TV Model), 2006
epoxy, wood, steel, polyester, enamel paint
and gold leaf, 13.7 × 33.3 × 13.3 cm

taken off in Hollywood, with Mel Gibson's *The Passion of the Christ* (2004), the film adaptation of Dan Brown's *The Da Vinci Code* (2006) and Ridley Scott's alternative creation myth *Prometheus* (2012). Faith has become big business, produced and consumed on a mass-market level. Shaw's Oism reflects this: just as, in his earlier series, dreams and the preoccupations of adolescence merged with popular cultural artefacts, here the same occurs with the products and processes of the new religions.

Among Shaw's favourite haunts in Los Angeles are the numerous flea markets and thrift stores. There, values are renegotiated in a hotbed of reverse fetishistic consumption that gives America's cast-offs the chance of salvation. For Shaw, these first-Sunday-of-the-month conglomerations 'are like the whole history of America' and reveal the 'floods of waste, fraud and abuse of its culture'. Much like his work, they bring a perverse, idiosyncratic order to the vernacular, melding the weirdness and wonder of its estranged detritus. 'We're very good at producing crap,' he says. 'We started with the Shakers who produced exquisite furniture of a simple form and we've gotten to the point where we can produce things like *The Avengers* that are full of non-meaning and meaning at the same time.' Shaw has made a series of works out of the paintings he finds here, presenting them as found objects with the intervention of new, purely descriptive, titles: *Pink Poodle with Hydrant* and *Text or Off-road Helmet Merges with Landscape*. But most of all these emporia feed his collage mentality, providing, just as the dreams once did, an inexhaustible source of objects and topics of research, flooding his works with both personal and societal streams of consciousness.

During one such investigation Shaw discovered a number of theatrical remnants for sale in the form of vast, partially painted backdrops. At the time, he was consumed by a different kind of theatre – the build-up to the 2004 presidential elections. Dismayed by 'the perversities of the [George] W. Bush campaign, I was having hallucinations as I walked and was listening to three and a half hours of news everyday'. With pentimenti of Americana as their base, Shaw's overpainted banners signal his ever greater unease, already present in *My Mirage*, at the societal change begun under Reagan that was

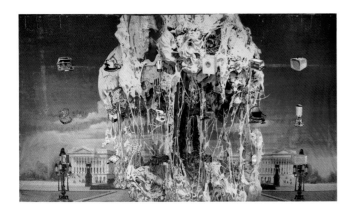

Capitol Viscera Appliances mural, 2011
acrylic on muslin, 500 × 1016 cm

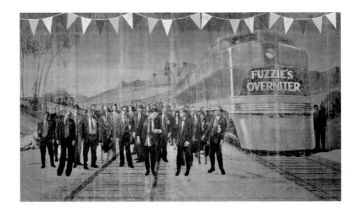

Untitled, 2006
acrylic on muslin, 485 × 1188.7 cm

about to reach its apotheosis under Bush. He called the series *Left Behind* in acknowledgement of ordinary American workers, suffering from the collapse of a manufacturing economy in the wake of globalisation – and with reference to the bestselling series of Christian fantasy novels.

As ever, the paintings include multiple layers of reference, some identifiable, others lost. *Capitol Viscera Appliances mural* (2011) sees a pre-existing view of a state Capitol building under a serene blue sky overlaid by Shaw's cataclysmic mushroom cloud, exploding both upwards and downwards with equal force. Made out of a glutinous, impasto resin gunk that hangs off the picture surface like spray-on cheese, the structure is littered with cut-out images of household appliances with reference to the household appliance business established by the church fathers after Annie O'Wooton and the feminist aspects of her religion were ostracised. The cloud also resembles a disproportionately large banyan tree, alluding to that which the *Book of O*, the founding text of Oism, uses as its 'tree of life'. In another banner, *Untitled* (2006), a pack of businessmen zombies stumble in the desert beside 'Fuzzie's Overniter' – a freight train with a fez-wearing driver from the original backdrop that led Shaw to speculate on its Masonic allusions. The scene is adorned with the addition of a line of used car lot bunting. Closer inspection reveals text in cuneiform reading 'Work will set you free', a translation of the inscription 'Arbeit macht frei' over the gates at Auschwitz.

Shaw's banners are, in essence, political cartoons, and recall those from the 1800s created in the style of historical paintings and the spirit of the early American cartoonist Thomas Nast. The sequential, narrative work of William Hogarth and the mysticism of William Blake are also important stopping points. As with much of Shaw's work, despite the more specific political reflections of the banners, their conflation of known and obscure sources affirms that misinterpretation should also be considered a valid response, forming its own layer of reference. As Mike Kelley noted in a published conversation with Shaw, few viewers will be able to identify all of Shaw's sources and so in one sense the full narrative complexity of his work is put at risk.[6] Shaw, however, builds in misinterpretation as a

Cake (Jim Bent), 2011, oil on digital ink jet
print and acrylic and ink on panel
Painting: 100.3 × 95.3 cm
Panel: 31.8 × 62 cm

map, allowing misconnections to be just as relevant as 'correct' connections, if not more so – he has stated that as a child he often found more meaning in a misheard lyric than he did in those printed on the record sleeve. The stream of images that one receives from Shaw's art is no less democratic than that which is fed to us through multiple channels every day: most of his source material has already been chewed up, digested and spat out before he begins to tamper with it.

Shaw's uniqueness lies in his bringing together all of this stuff, finding meaning in the apparently meaningless as he digs incessantly at America's never-ending popular culture landscape. Drawing on history, labour movements, religion, comic books, monsters, art, science fiction, literature and so many other sources, he finds connections that are fundamental to a present-day understanding of the social structures of the USA. *Cake (Jim Bent)* 2011 features a realist rendering of the artist's exaggeratedly fleshy form, bent double, in front of a Jackson Pollock-esque paint-smothered background. Once again alluding to his own creative role, blatantly exploiting the great art-historical divide between the figurative and the abstract, Shaw prods at the proclaimed purity of the latter – his work is actually an overpainted image of an advert showing a sickly, icing-drizzled cake from a 1950s women's magazine. Shaw's hunched, pain-driven pose is derived from the anatomical illustrations of Dr Frank Netter, a German-American medic who illustrated the inner and outer symptoms of illness. A white, painted-out hollow above Shaw's image is matched in scale by a second component to the work that hangs to the side of its main panel. On it, further Pollock-esque swirls reveal themselves to contain contorted ghouls twisting and grimacing – the microcosms causing the figure's ills. 'The devil is in the details', says Shaw. It is the details, the stuff of America, that Shaw connects up, revealing the elision of trivial experience and the trivia that both direct and mediate it. Yet there is a powerful irony here. The multiple allusions and visual-literary iconographies that Shaw uses hark back to a much older, perhaps more ordered and secure society, making his work even more forceful.

Throughout Shaw's art there is a complicity between what he appropriates and what he produces. His archaeological dig into the landscape of American popular culture fetches to light some of its darkest, most deeply buried connections. Consumption, waste, the need for faith, the drive to escape, the desire for constant entertainment and comfort at perhaps any cost are shown to be the products of an incestuous, mutually reinforcing relationship between the 'real' world and that of popular fantasy and myth-making – a relationship in which Shaw, as a creator, knows himself all along to be complicit.

Notes

1 All quotations, unless otherwise stated, are from conversations with the artist in his studio in Los Angeles in November 2011 and May and August 2012, and from email correspondence with the artist between November 2010 and August 2012.
2 *In-a-Gadda-Da-Vida* was supposedly so named because the band members were too stoned during recording to say 'in the Garden of Eden' – a link to the biblical text and to ideas of innocence and deviancy that Shaw also enjoyed.
3 Shaw regards this work as a collage and repeats the sewing machine and umbrella motif in further collages in *My Mirage*. However, he uses it as a dead metaphor – the encounter of the two objects is now staged, rather than accidental.
4 Lionel Bovier and Fabrice Stroun, *My Mirage* (Zurich: JRP Ringier, 2011).

5 Readers of Burroughs' *Naked Lunch* were encouraged to progress through its chapters in an order of their choosing. Its text also unfolds as though told by William Lee, the alter ego of its author.
6 'Here Comes Everybody: A Conversation between Jim Shaw and Mike Kelley', in Noëllie Roussel and Fabrice Stroun, *Everything Must Go* (Geneva: MAMCO, 1999), p. 40.

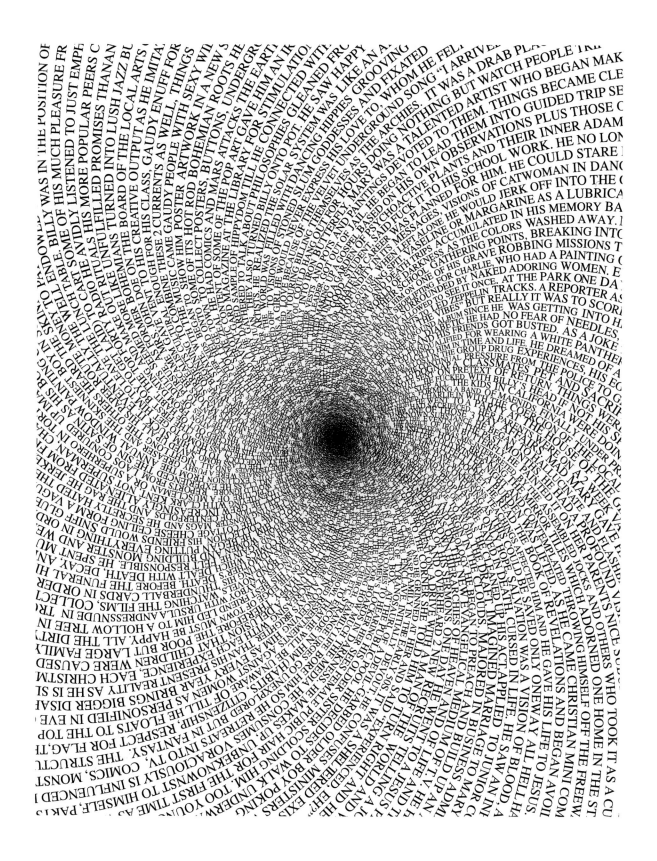

Foreword, 1990, Photostat on paper, 43.2 × 35.6 cm

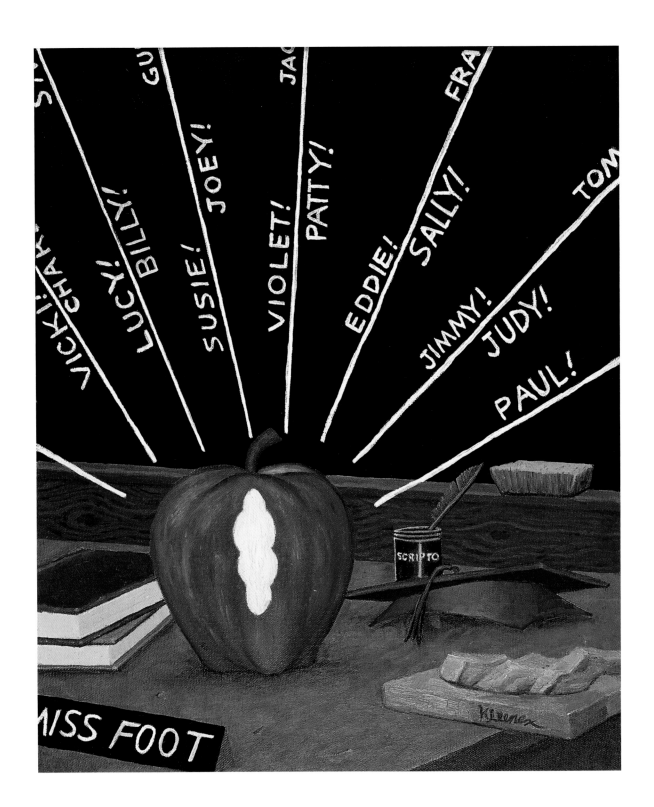

Pandora's Box, 1986, oil on canvas, 43.2 × 35.6 cm

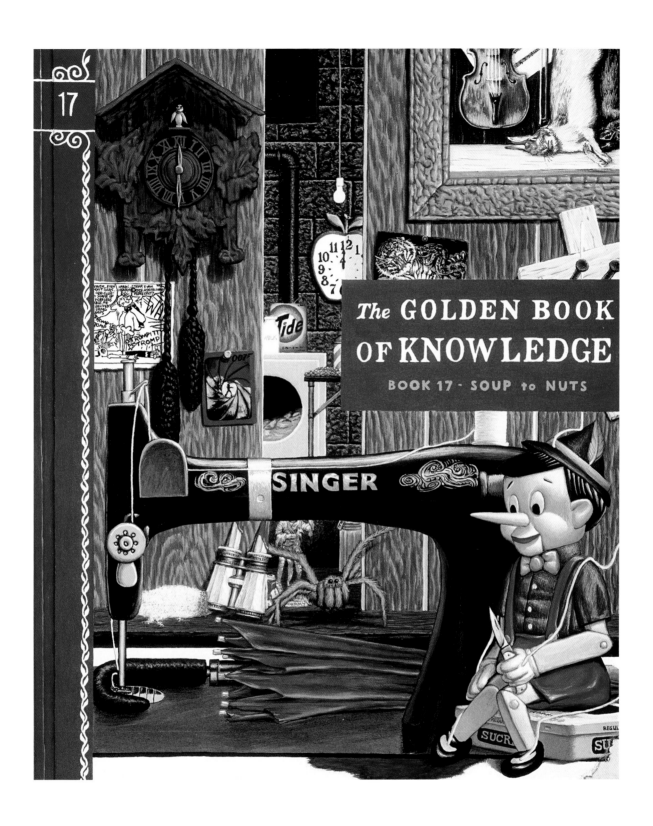

The Golden Book of Knowledge, 1989, gouache on board, 43.2 × 35.6 cm

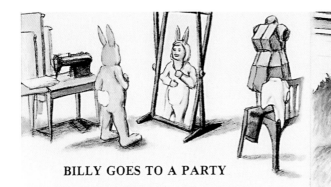

BILLY GOES TO A PARTY

Billy and Susie were getting ready.
Billy was in his room.
He put on a rabbit costume.
The rabbit costume looked good to
to Billy.
Billy went to Susie's house.
Susie's mother said, "Susie is almost
ready. She will be right down."
Susie came down the stairs.

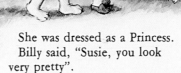

She was dressed as a Princess.
Billy said, "Susie, you look
very pretty".
Susie said, "Let's go to the party."
They walked to the house where the
party was being held.
As they approached the house, they
heard gay sounds coming from the
the backyard.
Many children were singing and
playing games.

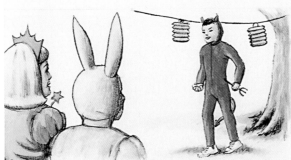

As they turned the corner of the
house, a boy dressed as the Devil came
up to them.
Billy recognised him as an older boy
from his church.
His name was Paul.
Paul had on red pajamas with a tail
attached, some Halloween Devil horns
and a small pitchfork.
Billy and Susie said, "Hello Paul."
Paul said, "Hi."
He held out his hand.

In his hand was a box of cough drops.
Paul asked Billy, "Do you know what's
in here?"
Billy said, "No."
Paul smiled and opened the box.
Paul said, "It's your brains."
Then Paul stuck the pitchfork into the
box as he grinned intently at Billy.
Billy felt a small pain in his groin.

Billy Goes to a Party I, 1986, watercolour and Xerox on rag, 43.2 × 35.6 cm

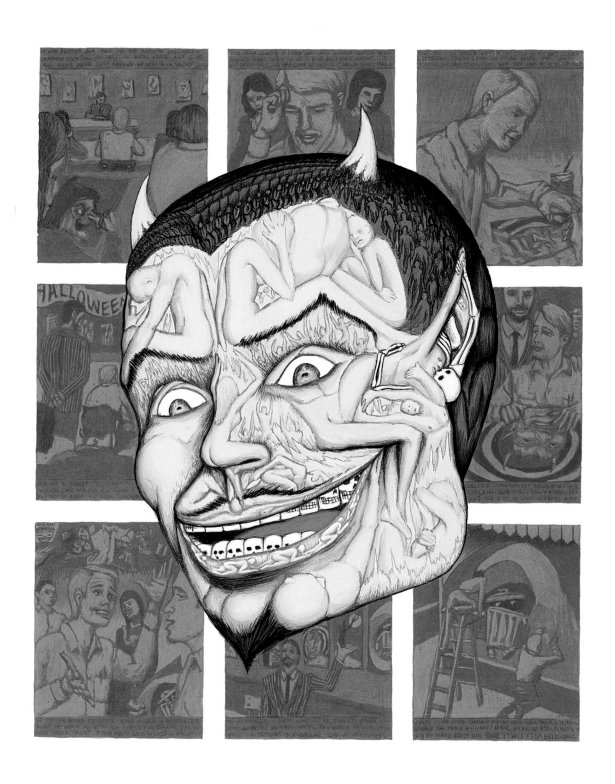

Sin of Pride, 1988, watercolor on paper, 43.2 × 35.6 cm

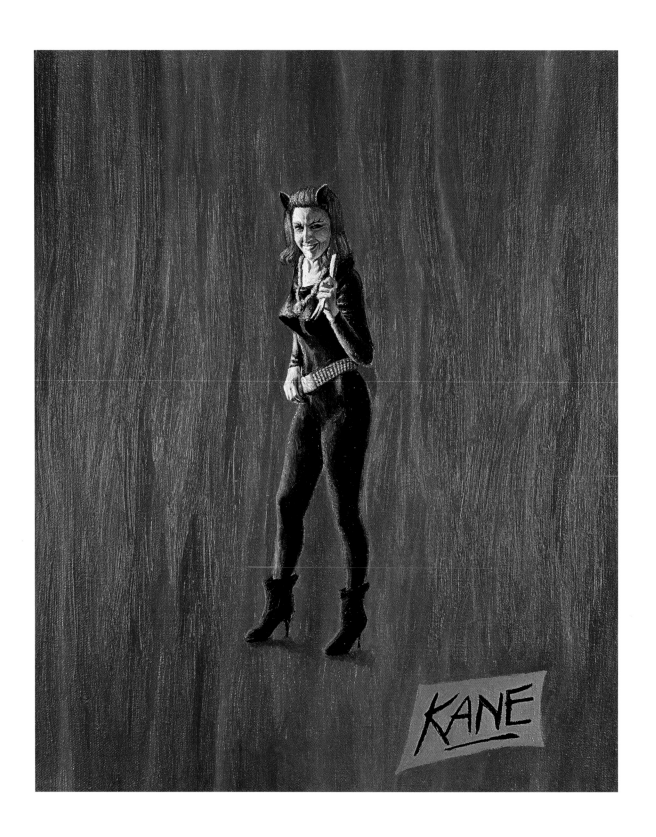

Anima I (Earth), 1986, oil on canvas, 43.2 × 35.6 cm

CHAP. XXIII

Mary and Joseph tell Jesus to conceal his miracles. Furniture begins to move and dishes are broken. Miracles begin to happen in the middle of the night. Strangers mysteriously die. A conspiracy against Jesus.

W HEN the Lord Jesus turned thirteen, Joseph and Mary, being fearful of their neighbor's wrath, entreated their son to refrain from performing any more miracles in public.

2 That night the Lord Jesus refused to eat his supper and went to his room, clapping his hands.

3 Joseph and Mary became fearful for their own safety.

4 The chairs they sat in began to shake and the arms did stretch.

5 Mary's best china then began to fly off the shelf and break against the wall.

6 Many jars and implements were overturned and broken.

7 The next day they were miraculously repaired and put back with not a single grain out of place.

8 The Lord Jesus apologized to his mother and father and promised to control his temper from then on.

9 However, from time to time, the Lord Jesus' ill temper was again manifested in this manner.

10 Once, in anger towards Joseph he said, "You are not my real father."

11 On one occasion a cobbler who had befriended the Lord Jesus was given a large order for sandles for the King's guards which he could not fulfill.

12 He was much grieved for the head of the guards had threatened his life should he fail to deliver the order.

13 The cobbler wept as he struggled to complete the demand the day before the guard's return, for he had not one quarter of the time nor materials required nor any means to acquire them.

14 Passing his shop, the Lord Jesus heard the old man wailing, and paused to inquire of him, "Wherefore dost thou weep, old cobbler?"

15 And the cobbler paused long enough to explain the cause of his anguish.

16 The next morning when the cobbler awoke to the guards rapping, he trembled, then wept for joy as his shop was filled with sandals.

17 The Lord Jesus beamed with a sly smile as he passed the cobbler's shop that day.

18 On another occasion, a stranger passing through Nazereth withered and died after a theft of some cloth from the milliner's shop.

19 The cloth mysteriously reappeared and those who wore it were blessed with good luck.

20 Some of the Lord Jesus' neighbors, becoming fearful of his rumored powers began to plot against him.

21 The Lord Jesus' only weakness was from his old nail and hair clippings, which the conspiring neighbors gathered up and worked a cabalistic spell upon him, whereupon he became ill for the first time in his life.

23 That night a dark cloud hung over Nazereth and the people shuddered with dread.

24 The next day the Lord Jesus was laughing and playing in the yard, but lo, the houses of the conspirators were filled with weeping and lamentation, for they had vanished from the face of the earth.

CHAPTER XXIV

Jesus renews his homework from a dog. Jesus gets all A's without studying. A teacher who reprimands him loses the use of his arm. Jesus doesn't suffer the growing pains of puberty. Classmates ask his help, who turn out to be Paul and Luke.

O N another day, the Lord Jesus was walking to school when a vicious dog attacked him and tore away with his homework.

2 The dog had just finished tearing the paper to shreds when he gave out a yelp and fell over dead.

3 Whereupon the Lord Jesus summoned his homework and reassembled it miraculously before the eyes of his classmates.

4 When the semester came towards its end the Lord Jesus suddenly realised that finals were the next day and yet he hadn't been attending his astronomy class or studying the heavens at all.

5 The Lord Jesus slept fitfully that night and awoke in a cold sweat.

6 When the final examinations were given, however, the Lord Jesus received A's in all subjects and his teachers did give praise unto him.

7 Unlike other teenagers the Lord Jesus was immune to facial blemishes, and his smooth complexion and confident air made him the most popular boy in school.

8 One teacher was jealous of his perfection and wanted his own son to win the student body presidency, so he did everything he could think of to humiliate the Lord Jesus in front of his classmates.

9 On a certain day this teacher began to swat the Lord Jesus wrists with a ruler for false reasons

10 His arm then became withered and useless.

11 This teacher's son, who was Judas, lost the election to the Lord Jesus.

12 One day after school two of the Lord Jesus' fellows came up to him and pleaded for him to help them with their papers or else they would flunk out of school and become a shame to their parents

13 The Lord Jesus agreed and helped them, that the next day they recieved A's on their papers

14 These two grew up and became the apostles Luke and Paul

CHAPTER XXV

On a camping trip the scoutmaster attempts to sodomize Jesus and dies. One boy is cured of chronic masterbation. The boy is the apostle Thomas. Jesus leads them back without a compass.

O ne weekend the Lord Jesus went on a camping trip out to the woods with a group of his fellows.

2 Several of the boys were plagued with snake bites and scorpion stings which the Lord Jesus promptly cured.

3 When they had set up their camp and it grew dark, the scout master crept around and saw that they were fast asleep.

4 The Lord Jesus' youthful beauty was such that the scoutmaster felt compelled to attempt to sodomize him as he slept.

5 When the Lord Jesus felt these stirrings in his bed clothes, he awoke and said, Thou that doth attack me shall fall and never rise.

6 And at that moment the scout master fell down and died.

7 The next day the boys bathed in a lake in the woods.

8 Another boy bathed in the water the Lord Jesus had cleaned himself with and was instantly cured of chronic mastur-bation.

9 And that boy who was miraculously cured was to become the disciple Thomas.

10 The boys were much afraid of their situation as their scoutmaster was dead and they did not know how to get back to Nazareth

11 However the Lord Jesus broke a twig off a tree, spun it, and determined the direction home

12 On the way back into town they encountered the usual snake and insect bites.

13 Again the Lord Jesus cured them in his familiar manner of blowing on the wounds, or causing the animals to retract their venom.

14 Everyone praised the Lord Jesus and prayed to Jehovah.

15 When they returned to town everyone marveled at the youthful Jesus and his ability to direct the boys back home.

CHAPTER XXVI

Jesus' dog has powers of flight and super strength, and threatens to give away his secret. His dog saves him from a plot. Jesus uses his powers to get a date with Lana. His dog helps solve and awkward situation.

T he Lord Jesus found a dog one day and named him Zoraster

2 Because it often bathed in the same water as its master and was often comfited by him, Zoraster had aquired some of the Lord Jesus' miraculous powers

3 Zoraster could uproot trees with a tug of his mighty jaw and could leap high in the air, as though he was in flight

4 Because he was shielding his true identity from his fellow townspeople and the king, the Lord Jesus often had to miraculously replant whole gardens that the playful Zoraster had dug up, lest the gardener become enraged and suspect what was really going on in Joseph's household.

5 When Zoraster would fly by the window, The Lord Jesus would have to distract the other students with a small fire, a false cloud of locusts or a plague of frogs.

6 On one particular day, some students who suspected that the Lord Jesus was the son of God prepared a trap using some of his toenail clippings and hair.

7 If he were the savior, the conspirators knew, their cabalistic chants would render him weak and unable to pass the spot where they had buried their charms.

8 However, Zoraster, recognizing his master's scent, found the magical implements.

9 He urinated upon them and rendered their powers harmless

10 The students were unaware of Zoraster's visit, and when the Lord Jesus passed their charms unharmed, decided he was a simple carpenter's son, and not the son of god

11 Judas and the Lord Jesus were rivals for their classmate Lana's affection.

12 As Lana was known to be particularly fond of daffodils, the Lord Jesus sent Zoraster down to the daffodil field

13 When Lana petted him she became enchanted by a spell his owner had formed

14 The big harvest dance was coming up and the Lord Jesus asked Lana if she would accompany him to it.

15 She gladly accepted the Lord Jesus' invitation for she was now in love with him.

16 Judas cursed as he heard her talking of her love of Jesus to her girlfriends.

17 On that day he swore to get even with the Lord Jesus who had once again bested him

18 When the night of the dance came, the Lord Jesus and Lana were inseparable

19 As they danced, Lana begged him to come with her down to where the daffodils bloomed

20 There Lana bade him lie down so that she could tell him a tale of the ancient past.

21 It soon appeared to the Lord Jesus that she wanted to do much more than to simply tell him a tale

22 Lana began to undo his garments and kiss his flesh

23 Since he knew his carnal knowledge might destroy any mortal girl he had to think quickly to avoid revealing his secret or hurting Lana's feelings.

24 The Lord Jesus used his super sonic whistle to call Zoraster to the spot

25 Zoraster leapt barking into the glade, scaring her and releasing her from his spell.

26 Lana quickly finished her story and apologised for her forwardness, then begged his pardon as she ran embarrassed back to the dance.

27 All of Lana's friends rumored and gossiped about what might have happened to the two of them

28 That night Jesus spilled his seed in that grove of flowers

29 Because of the Lord Jesus' sacrifice that night, daffodils' flowers remain the yellow and white color we know today instead of the red color Lana knew them to be.

CHAPTER XXVII

Jesus sleeps overnight at a friend's house and has a nocturnal emission in the boy's sister's bed. She gives birth to a baby girl named Jane. Everyone marvels at Jane's superior powers and abilities.

O n another day the Lord Jesus was invited to sleep over at his friend Simon's house.

2 Simon's mother and father were out of town for the weekend.

3 On that same night, Simon's older sister Beth was invited to a slumber party in the wealthy part of town

4 Her bed being empty, the Lord Jesus lay down in it after many hours of story telling and ribald jokes

5 During the night the Lord Jesus had an uncontrolled emission into the bed clothes.

6 The Lord Jesus suffered a little trouble urinating the next day but thought little of it

7 The next night Beth again slept in her bed.

8 Miraculously she became heavy with child and five months later she gave birth to a baby girl.

9 The girl was named Jane and within six months she could talk

10 On her first birthday she wrote out a verse explaining the meanings of the letters of the alphabet.

11 By the time of her second birthday, Jane was conversant in mathematics, and by her third year she was adept at astronomy.

12 Jane was a marvel to all who came in contact with her.

Beach Boys Weekend, 1988, pencil on paper, 43.2 × 35.6 cm

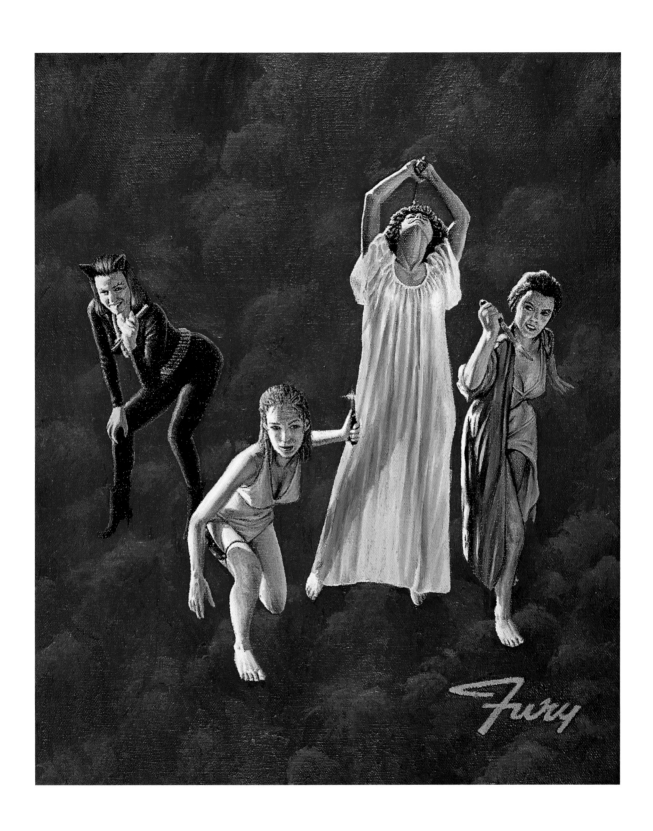

Anima IV (Combustion), 1987, oil on canvas, 43.2 × 35.6 cm

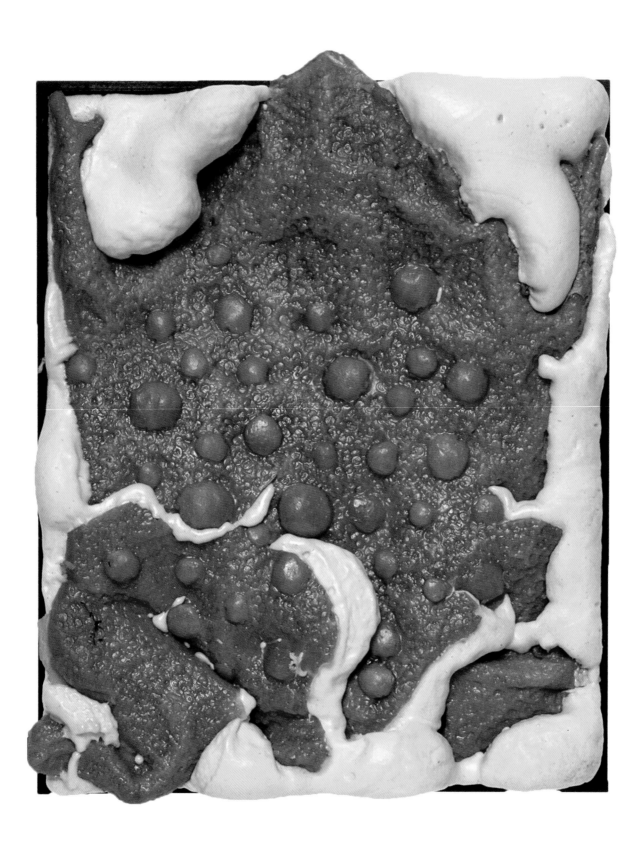

Toad Candelabra, 1990, wax and vacuform, 43.2 × 35.6 cm

The Temptation of Doubting Olsen, 1990, gouache on board, 43.2 × 35.6 cm

*B*illy removed the lampshade and turned to face the large living-room mirror, his body shiny with grease

*P*layboy centerfolds were strategically set within eye's reach and propped up as well as possible and he began to stroke....

*T*he lighting exaggerated his adolescent physique as he tensed his muscles for effect.

*A*s his hand played up and down his cock, he tried to imagine what it might be like to actually fuck when he remembered the time he discovered ants trapped in his dried jissom, like zebras at a watering hole.

*R*edoubling his efforts, Billy concentrated on the play of light and water on Ursula's erect nipples, the image he returned to again and again.

*T*he rush of warm, white liquid swelled from his groin and spewed out on the golden carpet, glistening for a moment.

*A*s feelings of stress returned to his groin, Billy started thinking about cleaning up the mess when he saw lights from his parents' sedan play upon the hedge alongside the driveway.

Classics Illustrated, 1989, gouache and ink on board, 43.2 × 35.6 cm

Sometimes He Found Disturbing Things on the Street, 1986, pencil on board, 43.2 × 35.6 cm

Manlicker, 1991, ink and gouache on board, 43.2 × 35.6 cm

Space, 1989, Photostat on paper, 43.2 × 35.6 cm

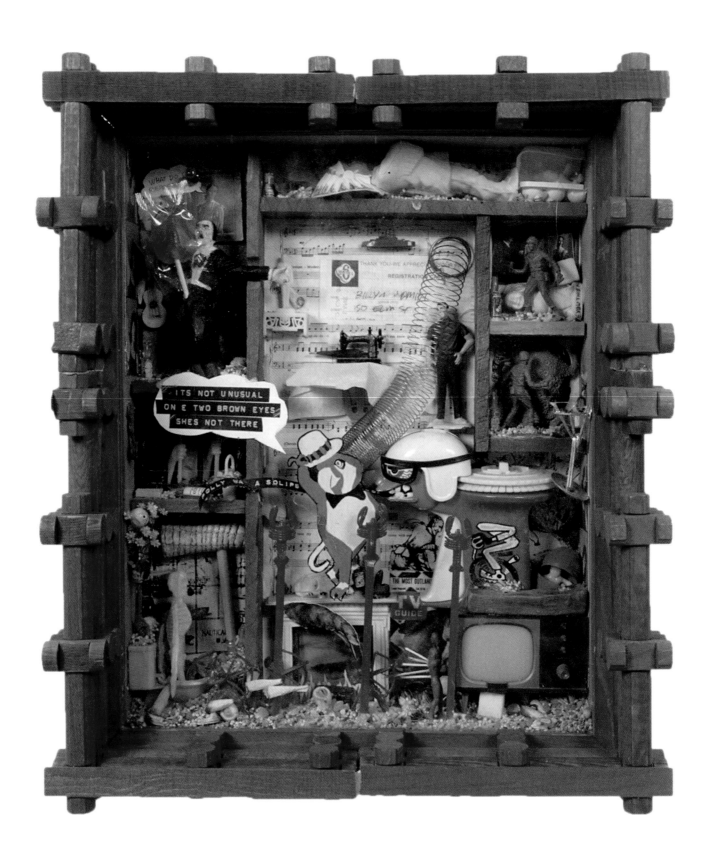

*Ecology Box, c.*1990, mixed media, 43.2 × 35.6 cm

Un Mois de Dimanches, 1989, Photostat on paper, 43.2 × 35.6 cm

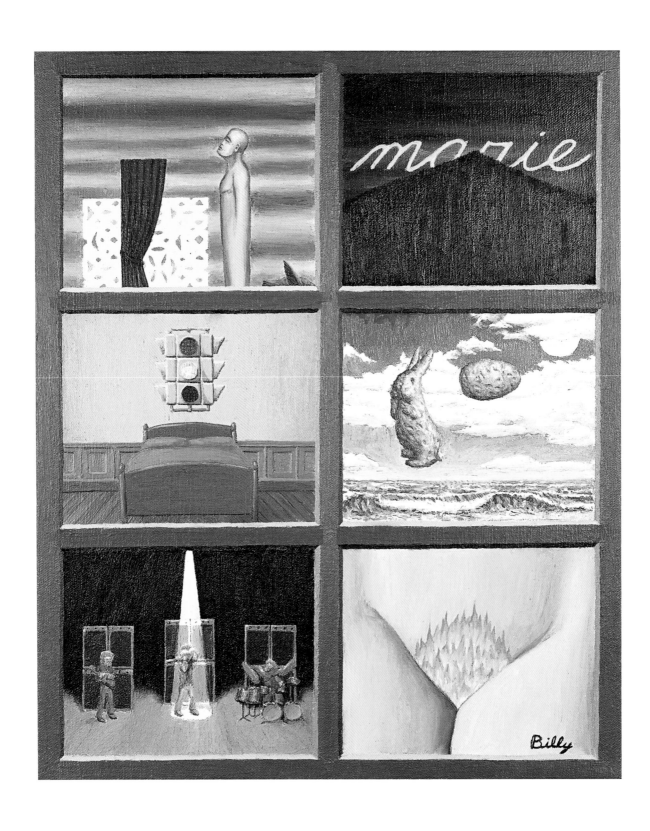

36 *Bon Idee*, 1989, oil on canvas, 43.2 × 35.6 cm

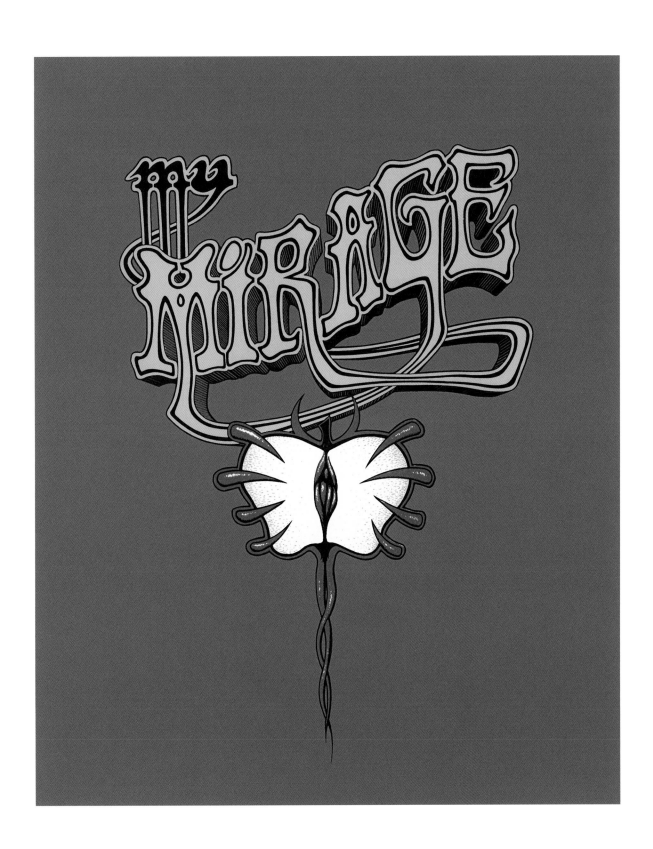

My Mirage Logo III, 1997, silkscreen print on paper, 43.2 × 35.6 cm

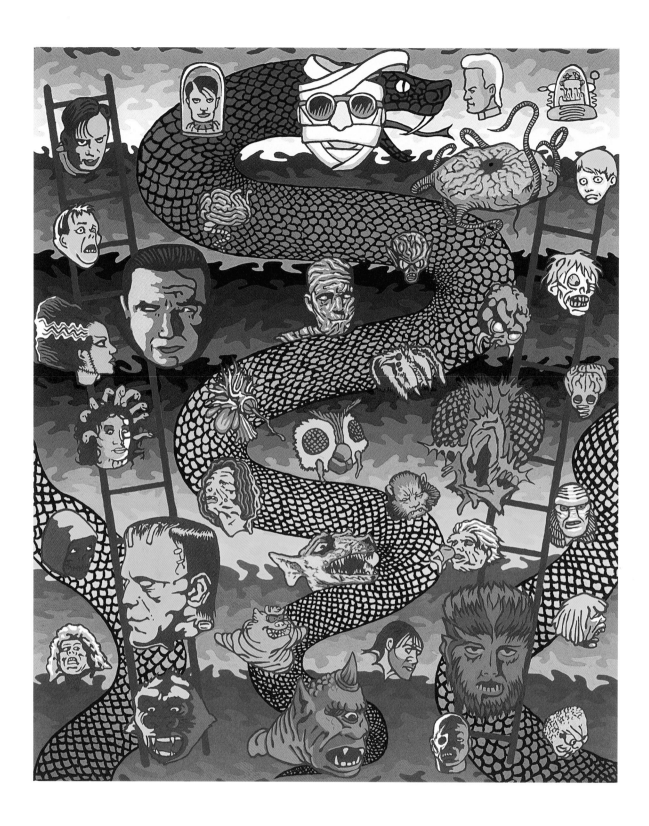

Monster Chakra Chart, 1990, gouache and Mylar on board, 43.2 × 35.6 cm

ALL CONSUMING GUILT

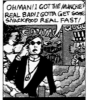

 SOME BEER AND SOME YOGURT AND SOME SCREAMING YELLOW ZONKERS AND SOME FRITOS AND....

EXCUSE ME. HUH?!?

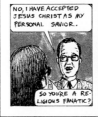 YOUNG MAN, DID YOU KNOW THAT EVERY TIME YOU TAKE A BITE OUT OF SIN, GUILT TAKES A BITE OUT OF YOU? WHAT ARE YOU, A NARC OR SOME THIN'?

NO, I HAVE ACCEPTED JESUS CHRIST AS MY PERSONAL SAVIOR. SO YOU'RE A RELIGIOUS FANATIC?

YES, AND IM GOING TO TRY AND SAVE YOUR SOUL. BUT MAN, I DON'T HAVE A SOUL. I'M ONLY FLESH & BLOOD

 WHY DO YOU THINK YOU WERE PUT HERE ON EARTH, TO EAT JUNK FOOD TILL YOU DIE OF A HEART ATTACK? THEN YOUR SOUL & FAT WILL BURN ON THE BRAZIERS OF HELL FOR ALL ETERNITY!

 OH WOW! WHY DIDN'T ANYONE TELL ME THIS BEFORE? BECAUSE THE MAJOR FOOD CORPORATIONS ARE CONJOINED IN A CONSPIRACY TO SEND AS MANY SOULS TO HELL AS POSSIBLE!!

 HOW WILL THEY DO THAT?!

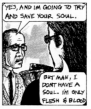 BY FEEDING YOU FOOD THAT IS IMPRINTED WITH THE MARK OF SATAN, LIKE THOSE RITZ CRACKERS OVER THERE AND THAT CRESCENT MOON SYMBOL ON SOAP PACKAGES.

 GEE, I NEVER SAW THAT BEFORE!! OF COURSE NOT!

 EVEN ROMAN CATHOLIC COMMUNION WAFERS HAVE SATANIC SYMBOLS PRINTED ON THEM!! EAT OF MY FLESH

 ITS REALLY ONLY A CONTINUATION OF THE PAGAN CUSTOM OF CANNABALISING THE DEAD TO ASSUME THEIR POWERS. NEVER EAT SACRAMENTS!!! NEW! TRY IT!

 BUT WHAT ABOUT THIS YOGURT? SURELY THERES NOTHING PRINTED ON IT!

 FOOD DOES NOT NEED SYMBOLS EMBEDDED TO BE SINFUL! GUILT!

 WHEN ADAM AND EVE ATE OF THE FOOD OF THE TREE OF KNOWLEDGE THEY COMMITED ORIGINAL SIN AND THEIR FLESH MADE BRUTISH. WHEN THEY ACQUIRED DIGESTIVE TRACTS THEY KNEW THEY WERE BANISHED FOREVER FROM THE GARDEN OF EDEN!!

 ALL THAT WE EAT TODAY CONTINUES TO MAKE US BRUTISH AND WE EMIT FOUL SMELLS AS BAD AS THE STINK OF HELL-FIRE!!

 YOU MUST ONLY PARTAKE OF THE FOOD YOU NEED FOR SUSTENANCE, JUST AS YOU MAY ONLY HAVE CARNAL KNOWLEDGE SO THAT YOU MAY REPRODUCE!! SNAP!

 YES, REMEMBER "IT IS EASIER FOR A FAT MAN TO GO THROUGH THE EYE OF A NEEDLE THAN TO PASS THROUGH THE GATES OF HEAVEN" YOUR NAME DOES NOT APPEAR IN THE BOOK OF LIFE

 HOW CAN I SAVE MY OWN SOUL? WHAT DO I DO? GET OUT YOUR BIBLE AND START FASTING AND PRAYING AS ADAM DID TO ATONE FOR HIS SIN, REGAIN HIS BETTER NATURE AND REENTER EDEN

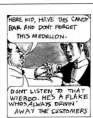 NOW WAIT JUST A MINUTE PAL! DON'T START COSTING ME SALES! I'M A BUSINESSMAN

 HERE KID, HAVE THIS CANDY BAR AND DON'T FORGET THIS MEDALLION. DON'T LISTEN TO THAT WIERDO. HE'S A FLAKE WHOS ALWAYS DRIVIN' AWAY THE CUSTOMERS

 UH, GOSH.... THANKS.

 CHOKE!

 CRASH!

 OKAY KID, YOU'VE GOT TO KEEP EATING THOSE THREE MUSKETEERS BARS FOREVER!!! OH WOW, MAN WHAT A BUMMER!!

 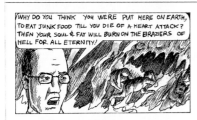

CHICK LETTS PUBLICATION

All Consuming Guilt, 1986, Photostat on paper, 43.2 × 35.6 cm

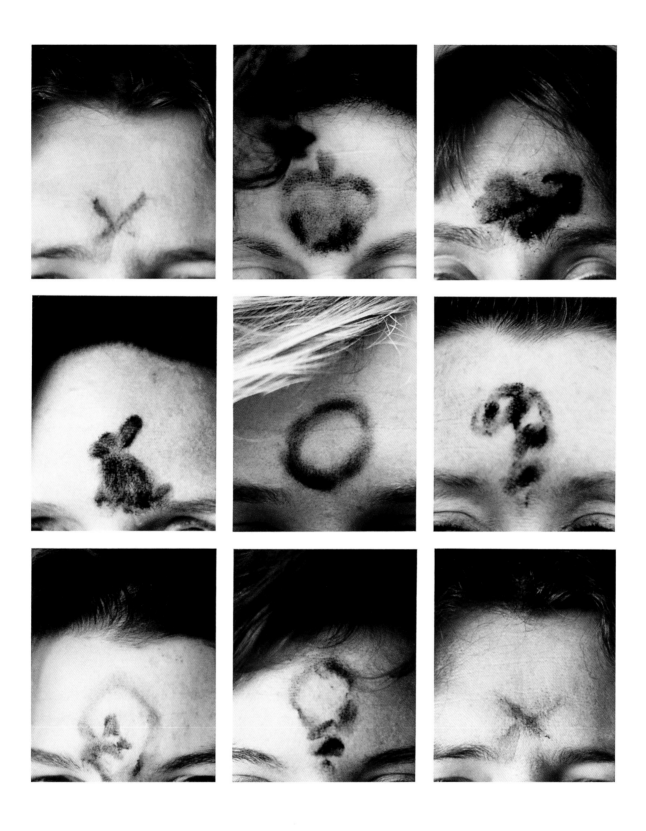

Charcoal Drawings, 1990, cibachrome print, 43.2 × 35.6 cm

Sizzling Quiz For Teens

Dear Anne Landers: All the kids at school were hoping you would reprint a quiz we heard about from our older brothers and sisters. Some teens had sent it in and you could use it to rate yourself. Signed—Just a Good Kid.

Dear J.G.K.: You kids are just too darn curious, but here goes—I have updated it a bit from the original I received several years ago. I always get lots of response when I run this one.

(Rate yourself from 1 to 12 for each yes answer)

1. Have you ever dated a member of the opposite sex? 4

2. Have you ever lied to your parents? 2
3. Have you ever stolen worthless items from a dimestore just for fun? 2
4. Have you ever been kissed? 4
5. Do you smoke? 2
6. Have you ever lied to your pastor? 2
7. Have you ever played with yourself? 3
8. Have you ever peeled out in front of a fast food joint? 1
9. Have you ever told on your friends to authorities 3
10. Have you ever been French-kissed? 4
11. Do you drink? 2
12. Have you ever cheated on schoolwork? 2

13. Have you ever been kissed while in a reclining position? 5
14. Have you ever put water in your parents' liquor bottles to replace what you drank? 4
15. Have you ever gotten someone else to do your homework? 5
16. Have you ever been kissed in the nude? 7
17. Have you ever broken your vow at Lent? 2
18. Have you ever sniffed airplane glue? 5
19. Have you ever gone all the way? 10
20. Have you ever performed an animal sacrifice? 5
21. Have you ever sniffed spray-paint of Bactine in a bag? 6

22. Have you ever had sex with a member of the same sex? 12
23. Have you ever smoked pot? 7
24. Have you ever struck your parents? 5
25. Have you ever participated in an orgy? 12
26. Have you ever dropped acid or STP? 10

Ask Anne Landers

27. Have you ever worshipped the devil? 8
28. Have you ever given anyone a social disease? 12
29. Have you ever had to go to the hospital for an overdose? 10
30. Have you ever attempted suicide? 12
31. Have you ever gotten anyone pregnant? 13

Scorecard

15 or less-Uncool
16 to 30-Triangle—a square with something missing
31 to 45-Alive and kicking
46 to 60-Average Joe or Jane
61 to 75-Too groovy for words
76 to 90-Unreal and in trouble

91 to 105-Don't let you see if you marked the p 106 and Over-Going to hell for all eternity

Dear Anne Landers: My is driving me crazy with urges. He wants "it" all Sometimes he surprises middle of the day whe he's at the office and wa drop my housework satisfy himself. The m animal! What should Signed-Had it in Pittsbu

Dear Had It: First tha stars he isn't chasing seci the office. Then ask him a guidance counselor.

Showing off her students' handiwork under an experiment to tune in to a new kind of muse is art teacher Miss Foot (right). Seated next to her superior work is Central High's prize art student Mary Williams.

EXPERIMENT IN LOCAL ART CLASS

By JOSEPH R. SCHWINKENDORF
Daily News Staff Writer

The music of **NOW** echoed into the normally silent halls of Central High school today. It was all part of an attempt to involve our youngsters in their school work, in this case, Miss Foot's art class. "We are trying to get down to their level, to communicate in their language" she said.

While a long cut with a driving beat by the popular rhythm group "Iron Butterfly" played, the students were encouraged to make art that described what the music meant to them. "We were given a demonstration at the state teachers convention last month" said Miss Foot. "It really gives them encouragement to open up

and free associate." The long, abstract instrumental section provides much room for exersizes on a mental jungle-gym, while the sparse lyrics are vague and idealistic.

One rather excited student was working out an abstract-expressionist form from modeling clay mixed with natural materials when I querried him. "I'm just grooving to the vibes, man" was his explanation. Another worked intently on a vision of Adam and Eve in paradise. Other takes ranged from racing cars to geometric abstractions to pretty fashion models to, simply, the words

"Iron Butterfly" in a appropriately convoluted swirl.

The prize was awarded to star art student Mary Williams. Miss Williams, who had also won this year's Halloween window painting and Christmas card contests, came up with a brightly colored and incredibly detailed painting in the (relatively) short span of seventeen minutes the song takes to wind its way to an end. "We just worship the Butterfly" she said by way of explanation. Miss Foot says she has quite a career as an artist or art teacher ahead of her.

Others outside of the school system are not so approving. Dr.

Daniel Rodgers said "It has been proved that frenzied beats have a deleterious effect on the youth of our country. I object strenuously to the forced exposure of innocents to this communist-inspired "underground" music in our public schools." Dr. Rodgers is a spokesman for the local John Birch Society.

Regardless of the controversy over rock 'n' roll music in our schools, Miss Foot said today's experiment was so sucessful she's having her students bring in records of their own choice to listen to and create to starting tomorrow.

LOCAL NEW

Bizarre Dog Abduction

Local police were baffled by the disappearance today of Osiris, pet dog of Dr. and Mrs. Joseph McCay. The dog, a German shepherd, was apparently given tranquilizers in his dog food. His dog dish showed traces of P.C.P. (an animal tranquilizer), and his rope had been severed with a knife or other sharp object. "He must have been drugged or he would have barked his head off" said Mrs. McCay. No ransom has been demanded and the police have no motive in this unusual case. "We miss him and just want him back alive and unharmed" said daughter Julie McCay.

Tomorrow Is Law Day

National Law Day occurs on Wednesday and Mayor Christensen will address the subject at a fathers and sons prayer breakfast at city hall tomorrow morning in a speech entitled "The Law and Our Country—Partners in Progress." Other festivities include a poster contest in the schools' art classes and an afternoon social given by the Moose women.

Police Put On Pressure

Local police have set up a special anti-drug task force to combat growing abuse by the town's youth. In an announcement from city hall, police chief Jablonski said "We are alarmed at the information we are getting as to the amount and type of drugs flowing into this community. It is largely due to outsiders who have moved into town. We intend to clean up the streets and make them safe again." Surveilance of individuals as well as Central High School is planned.

Mosquito Spr

Experimental spray new insecticide which d mosquitos but will ster begins in our area this Scientists from Bell Ch the new compound wi impossible for them duce, thus eliminating insects from spoiling ou fun. Bell will begin spra airplanes next month.

Break-In At L Church

Authorities are inves burglary at Saint Reform Church Thursd The pastor said he he giggling and saw the lig the church's basement s ed the doors and c police. When they arr ficers surrounded the and gave orders for the ers to come out with th up. However, the intru already escaped through basement window, taki church items which were monetary value", acc pastor Moench. Police the sickly-sweet odor juana smoke inside and couple of scurrilous dr hymnals.

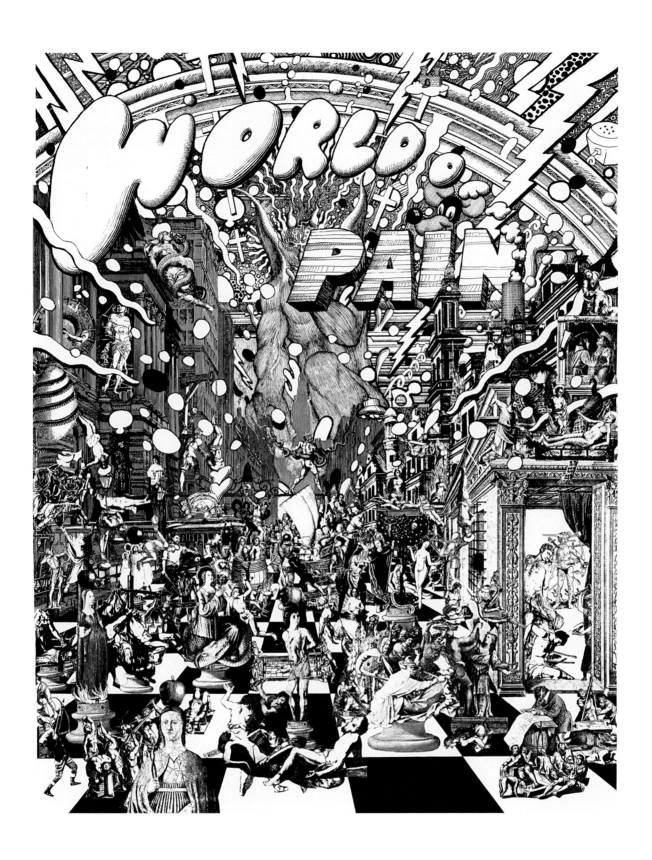

World of Pain (Silver Version), 1991, Photostat on Mylar with cardboard back, 43.2 × 35.6 cm

44 *Fabric Design*, 1991, silkscreen on fabric, 43.2 × 35.6 cm

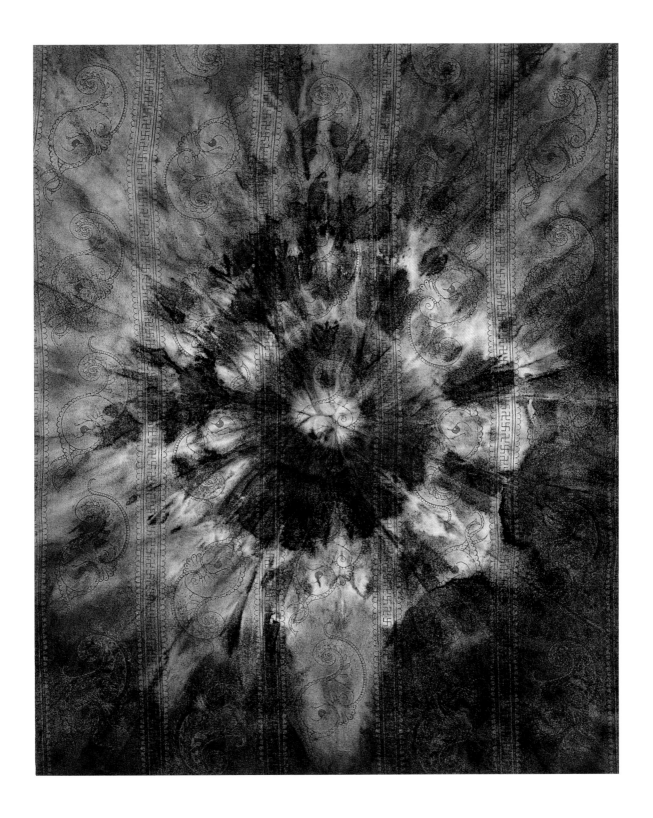

Tie-Dye, 1991, ink and silkscreen on fabric, 43.2 × 35.6 cm

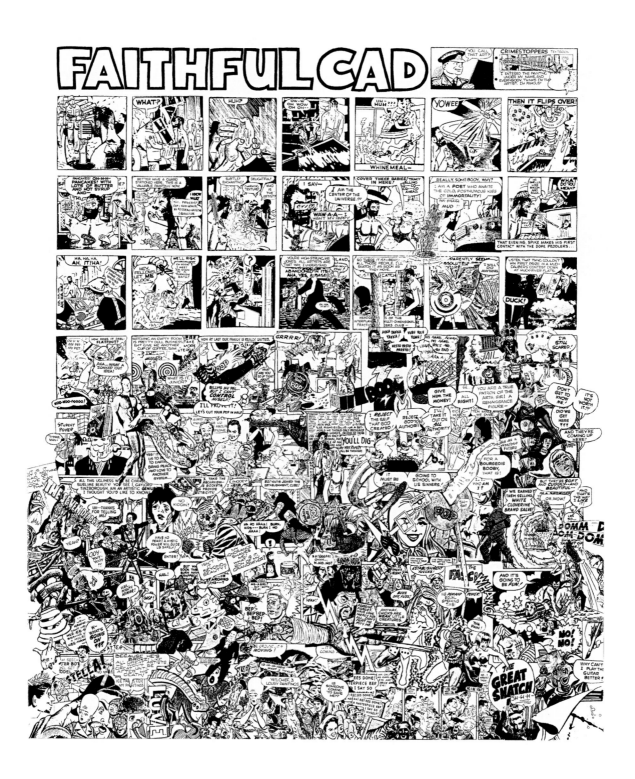

Faithful Cad, 1988, Photostat on paper, 43.2 × 35.6 cm

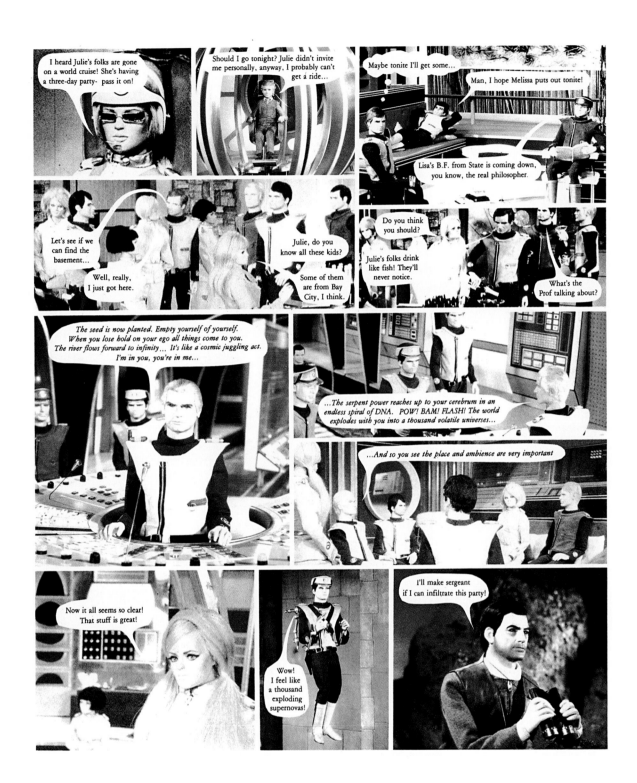

Fumetti, 1989, Photostat on paper, 43.2 × 35.6 cm

WE LIVE IN A 4 DIMENSIONAL WORLD, TIME IS OF THE ESSENCE.

HELL IS THE 5TH DIMENSION, SINS ITS MOST VISIBLE EMISSARIES.

IN DEATH, THE WORLD BECOMES 3 DIMENSIONAL, THE MATERIAL WORLD WITHOUT TIME

IN JUDGEMENT EVERYTHING IS A FINE LINE, OUR DEEDS REDUCED TO 2 DIMENSIONS

HEAVEN IS A POINT. THE PUREST OF ALL WORLDS IS FOUND IN 1 DIMENSION.

3-D, 1990, ink on rag paper, 43.2 × 35.6 cm

The others are cutting classes, partying at the Dog House-fake maple paneling beer and coffee spilled armrest tatters cling to new dress code bell-bottom hip-huggers-"Aren't you ashamed to be seen like that, honey? I know it's legal-so's picking your nose in public." "Toxic air boxes are blowing by, fifty feet up. "La Marseilles" plays on our headphones. Mrs. Babcock-scrambled egg smell-fiddles between her tits-we think its early senility-bad cock we call her. Jacques is reading his sentences from cuecards we hold up she never looks back-when he gets to "bon idee" we crack up, bad cock turns to see what's so funny, we I drop cards real fast. It's almost good Friday and "Up with People" are playing in the civic auditorium-time off for good behavior. Out picture window streams of chemical fumes, stuffed rabbits, chocolate stained wrappers blowin' in the wind. "Sa nom Bra." We close up books, I hang May '68 poster of De Gaulle "Le Merde in Bed, C'est lui." The others are cutting classes but I just can't bring myself to do that. Crashing sound muffled through brick walls, in Mr. Kiefer's English class next door the picture window has been smashed by a flying ankh, dazing most of the class, slicing those who gazed idly out to look at the world blowing by. Kiefer catches glass in neck narrowly missing jugular. After some milling about we walk to our lockers, "Jacques" joking about the nares in the ceiling getting sliced to ribbons prize of blood dripping down through air ducts, Casey does queer imitation, wrist bent "They fellaths" jars break in science room destroying woman's brain in formaldehyde with trichinosis worms like slice of swiss cheese, "bad pork you see", Argus, twelve legged, five eyed stuffed calf is smashed-old Mr. Dershnaugh running around trying to save these precious artifacts, the tarantula pie, the beehive hairdo that housed nest of black widows, the jissom, just like amber, so many ants trapped in it like zebras at a watering hole-plate glass cuts Mr. Bare's head clean off blood flows into air ducts drowning nares in ceiling-Mrs. Sutton droning from history book "America's greatness etc owing to our unique heritage etc" attacked by devilled ham figure doing idiot Hendrix guitar solo math teacher knifed "Hey old man" swim teacher with inverted left nipple knocks up cheer leader in stale beer, kid grows up to kill old man. I walk to locker and find lock missing. None of my posters or pinups are gone so I put my books in and turn to leave. The hallway is empty now, a long extruded square of bricks and interminable rows of lockers lined up like mexican mummies. They reflect the grey daylight, poplars blowing almost horizontal, kids leaving supposedly to see "Up With People" in exchange for rest of day off. Directly in front of me a future farmer of America is opening the modern plate glass door when just like in the joke you pretend your nose is broken it snaps back into his body cracking around him as he falls back. A candy striper runs up as I walk past to my dad's car. Pulling away I notice police cars tooling up to school-"so there's been a spot of bother here"-approaching the Dog house I see still more pigs and remember the phone call from Sgt. Pnacek in toxic air Rodney smashed its nuts with a history book as Eric held the cat yowling "Now just sit here" as he threw the switch her hair on end mamulatus clouds hung in moment of stillness sky thick and grey like a watercolor-running across golf course the pigs on either side "What's this? You drop something kid?" Erick is sitting in room fluorescent light flickers like it needs new bulb. A fly buzzed the thick air. Billy the kid is plopped in sulking "you know we have all the proof we need." The fly continued picking at their ears "Listen kid you wanna go to law school or what? Your poor suffering folks."The pigs looked at each other. "You can talk freely in here-we gotta go watch the local news" closing door behind them. Billy and Eric look in the mirror. "Where'd you hide the stuff, Billy?" -"Charlie's stash-the Matt Mattel brief case that turns in to a machine gun" the fly's guts popped out like toothpaste. Narcissus his blood" is transfixed till John Carradine bites him and they both fight Italian musclemen in papier-mache cave/drip in pool ripples across reflected spiral clouds. The tooth becomes you" just sat there dissolving in a glass of coke like a nite-lite. After systematically leering villain turns up closing all the drapes and pulling out his collection of center clouds. Billy stripped. 1950's bedroom He pressed his palm in, then lifted his hand and spread the soft margarine across Grief" a drop of lubricant glinted in the his chest and stomach. Staring transfixed into the big living room mirror, he"Reverend! Your eyes are bigger than your stomach!" stroked his cock to the rythms of "In-a-gadda-da-vida." A dental hygiene peace signs like custom steering wheels commercial played on T.V. A happy tooth jerked in limited movements, talking toshop could apparently not get good distributors-a few a toothbrush that stroked its head foaming, cavities like Beagle Boys approached. nakcd girl at seashore with "if we get together its groovy" poem, flocked The dwarves danced around the spot, fire lighting them like a spastic strobe-smell zodiac fucks, incense, not much else. Obese pimpled of burning toads as dental drill cuts air-slowly the tooth rises from its burial spot- hiding Jaybird magazines, keep on truckin' sign the man in the double breasted pinstriped suit and mustache tried desperately to "I have grass-you dig the unbelievable is going to happen." avoid it as he drove through the dense, dark, city forest at break-neck speed. It "Are you happy?" Uncle replied "Ya gotta learn how to seemed to grin at him as he drove wildly popping out from behind this tree or that the scene", a tadpole emerging from behind his ear. rock. The dwarves joined in his car skidded uncontrollably. "Terrible consequence bursting out from behind tapestries a top comes a of touching self "Billy's chest as shiny as Ursula's breasts smell of rancid olio (red- sitting on a windswept battlement resembling a giant haired boy freckled ass takes shit from tree house drops stolen watermelon his record cleaner-kids today listen to the Moody crushed like brains in black angel's death song) erections in study hall, half asleep Institute. The old rugged cross is just a coat rack holding books in front of crotch down hallway custodie wheels thunder of hundreds of baby tuning out the gospel when they should be turning alligators on sticks at regular intervals bending away from source of ancient names of rock stars instead of picking up on the explosion police had file this thick on you-dental drill picking tooth-gang of received a letter from a fellow who had phony twelve year old boys in barracuda jackets, cards in spokes make noise of Johnny and Hadji run through the dense descending aircraft the jokes in your hand-thinker is sitting on toilet reflected still" He knocks scorpion off Johnny breathing as a fist in a sea of glass, a bottle with a message floats up Gilligan pops cork drop shorts dive in water laughing splash loosing terrible genie on island toilet flushes as dope spirals down-ants rush in sun on ass hairs, Bandit licked Hadji's cock to eat up jissom but are frozen like circle of covered wagons-mushroom cloud swimming forwards towards camera. Johnny explodes revealing cartoon map inscribed "No Bikini Atoll" Billy rolls eyes as Hadji grabs a tin of Vaseline and begins stroking perseus chops the medusa's head off while carefully notating her location in Johnnie's checks and with circular motion his highly polished shield-scorpions and centipedes rise up from the blood rectum finger moving inside in corkscrew that drops from her severed writhing snake head (this is the church, this is the Hadji inside Johnny feels emptiness in stomach steeple-while fly inards pop out as Tingler is released from his spine) all men putty reflecting ten short movements Johnny must stand naked before God vets with polaroids of finger necklaces in glove in pants gay cartoon surfer son dies in blaze compartments of towns peel out of Jr. college parking lots let he who is washcloth and began circular motion smell without sin throw stones in a glass house. The scorpion first twists into an musty jock straps-incredible Mr. Limpett infinitely swimming paisley then translucent into an angry foetus snarling in jizz rows of pretty boys in mod vests, flares, flames upon the flocked gold wallpaper. Vacuum cleaner of knives explodes idiot Hendrix imitation incredible Mr. Pennypacker poking Magilla Gorilla, Lippie the Lion, Wally Gator, Quick Draw McGraw unending stream of white from his palms, his in the butt-"Ooh! That smarts!" Strolling groups of folk singing Christians thru Mr. Kiefer's window-Rodney and I had walk through carrying large translucent plastic crucifixes with iridescent live out the term-Bandit ran in circles flecks that catch the light. Youths with beer bottles break mirror tiles. The and Dr. Quest faced each other and removed girls are dancing playing tambourines under the jailhouse windows calling Race's shorts sticking straight out books in out for Charlie as they sway sensuously in their granny dresses-idiot big- turned him and rubbed KY inside his rectum nosed Indian dances into frame singing "I've got a secret and I won't tell they came together shuddering short spurts "eyes open on Billy's back, picking at them tadpoles emerge from zits and smell of mosquito repellent Johnny and Hadji swim away smell of sulphur pool bottle rockets fly out back of car on and gagged in to the waiting holes of freeway/clean cut guys in jockstraps and towels spinners (Note: very statue by somnambulant dark-skinned priests short girlfriends) at their sides raised with the hall with their noses, pants them, grease their balls with BenGay, shove of the boys by layers of clammy papier-mache watermelons up their asses, put peanut butter on the toilet seat he just Priests are conferring oblivious to Race as he stood there grinning, fist still held up firm, Billy got up weary. As the stuffed rabbits, Mexican mummies, Question black eye developed the older boy would look at him and sneer, Billy's Christ in peanut butter, smell of menstrual dad was mighty proud. Greasers with hooker headers phone him to smoke "all men come up short before God" the unbuilt development deadends corp.leer at him and call him "miss" rows centipede men sticky sweet poison consume of gym teachers with inverted nipples take turns inflicting pain humiliation eating plants mate as earthworms trapped on grueling punishment Clark prostrate from the green kryptonite is buried rain Easter lily blasts into Does face as in lead container, Lex gloating at the sweet irony thick black hair gasping "released from mortal patterns, my sprouting in most unlikely places "I hear Charlie's got this painting of beyond "smell of dying earthworms after himself as the devil surrounded by naked woman "the centerfold flopped green translucent grass, smell of hard boiled out playing tambourines-splash of white water in cigarette ad oracle fish- cow" cried Mary a snake crawled across eye lens photo of naked woman spread eagled in park-split fountain ink diamonds one fell from its forehead a a thousand eyes blink mirror cracks strobelight blinking cartoon explosion lights in driveway "Christ on a fuckin stick" snake cracks out of Billy's

spine in orgasm spurts like python eruption from San Andreas fault snake stiffens then contracts into an "s" shape and crawls away-Mr. Magoo, drunk, riding on an ass, preceded by women throwing rose petals, Josie and the Pussycats, knives flashing slice through George Jetson, Wally Gator, Underdog, Tennessee Tuxedo hang in ribbons. Thurston Howell the third laughs to himself but can't find the captain, the professor, or Gilligan. Mrs. Howell, Mary Ann and the movie star are piled up on the beach, unconscious, clutching knives their clothing spattered with blood/Perseus hold up the detached head to the father/son pancake breakfast-smell of rancid sausage links/Mr. Magoo rides into the sunset saying "the doors of perception, by golly" rows of centerfolds. Zap comics, Oracles, "How do you like my dynamic duo, Batman?" "Floating on smooth as glass mediterranean surrounded by flamingos and ibis's newspaper taxis appear on the shore rows of perfectly same breasts nipples erect at once rows of Baby Ruths cartoon boy with eyeballs cut them into bologna slices with rapid fire movements "like Armando's stiletto" they fall on floor running in circles making dog whimpers "yi-yi-yi" crabmen toddle out of spine to piano tinkles James Bond jigsaw pinch them on ass "yi-yi-yi" torture scene Lorelci shores me into my doom. "Our unabashed dictionary defines jerk-off as what kind of man reads Playboy". Miss December smiled blandly off the page... The strobe candle flickered violently. Charlie lit a fart and held a stick of incense up to the brief flame "from the stink of farts you can smell the truth...from the lowly cowshit grows the divine mushroom...from the dogshit comes the flock of flies always lookin' for the truth...the pigs worship eight-eyed potato liquor and corn mash and get drunk on fermented grapes at mass...they're parasites sucking'our Blood like fleas...fleas are damn hard to kill...we dogs are the flies of the world, alert, ziggin' an' zaggin', breakin' down their garbage for 'em-those meat eatin' pigs aren't fit to wipe my ass...when is a door not a door? when is a plane not a plane? when it's a plain of jars!! they fell silent for a while. The flickering candle and incense were nauseating Billy. A split-apple vagina in blowing sand for a thousand years. Charlie spoke up. "Life without balance can you call this love? I'd say without knowing, it's high enough...for me this is the end." When is adore not a mouth? when it's agape sickly sweet odor reverend chasing boys pants down couple fucking in pew, teenagers wend out empty coffin-it's a folk mass!-Mad Mary Williams says "lets score some pot down at Abc's place (dutch reform church "youth reach out" center) "keeps 'em off the streets you know"-Billy felt his balls tense up-I met a pretty girl on a date last night and let me tell you now she was groovy-his lower intestine filling up with shit as he entered the facility "pickle factory" God is love-Che laid out on slab "you clean John with toothbrush, we catch you like that" ninety-six tears, I like bread and butter. Billy gazed at the departing counselors muscular hairy ass grunted "you guys are a bunch of gluteous maximi-look it up" grinning the freckled boy stood over Billy, fist erect, Billy dazed "you pussy" sneered the older boy. Billy's dad smiled in bathroom, trains running on time smell of rank shit and room deodorizer. Gomer sang out in piercing tuxedo voice "gollee sarge" Question Mark picked up t-shirt youths drop bowling balls off freeway over passes onto plymouth furies driven by ladies in flowered mumms "death was instantaneous" long-haired peach demonstrators march chanting "kill the pig, spill his blood" in her daily torture column Lowella reports "Y'know the peace sign stands for piece of ass was really created by satanists trotskyite glasses going all the way "it licks Hadji's cock growing stiff like water snake swimming incessantly towards each other laughing girl in white water bent over felt sun drying ass hairs Bandit raised the washcloth and began circular motion smell of deodorant soap and musty jock straps rows of pretty doing idiot Hendrix imitation Incredible Mr. Limpett, clowning lies a bitter Rod Skelton "The Bible states and his name shall be wormwood" Billy felt an unending stream of white flow from his palms "Feelin Groovy" spider sense tingling as he emptied out, shriveled up and let clowning lies a bitter Rod Skelton "The Bible man with tree growing from groin-apple vagina and crashed thru Mr. Kiefer's window-we had bet on whether he would live out term-Bandit ran in circles going "yi-yi-yi." Meanwhile, Race and Dr. Quest faced each other and removed shirts, belts, slacks, Race's shorts sticking straight out books in front Doc turned him over and rubbed KY inside his rectum ten quick strokes and they cam together shuddering short spurts of iridescent white smell of mosquito repellent. Johnny and Hadji were lowered bound and gagged into giant stone toad mother by somnambulent dark skinned priests in loin clothes. Slowly the inscrutable priests began to seal them in with the rest of the boys by layers of clammy papier-mache trips. Priests confer, chatting, oblivious to Race as he pours contents of jar-stuffed Mexican mummies, question mark, BenGay, Christ in amber, acrid smell of menstrual fluid and cigarette smoke stale beer "all men come up short-burst out as centipede men sticky sweet poison dew drop priests whole, kiss in man eating plants, mate as earthworms trapped on sidewalk after spring rain-Easter lily blasts Doc's face as Race collapses in corner gasping "released from mortal patterns, my mind now goes beyond" a brilliant student named William came up and related a story of a little girl who had been watching T.V. and listening to top forty radio. She asked her mother "is God like T.V.?" God is beaming to us every second! You just have to adjust you tuner to his frequency! Smell of dying earthworms after spring rain red and green translucent grass, smell of hard boiled eggs "almost had a cow" cried Mary fading away and the guy said experienced, eh?" Jimi Hendrix asks "have you ever been experienced?" Iron Butterfly speak of a "soul experience." God wants your soul to have a Jesus Experience! In Life magazine Johnny Cash states "I've tried drugs and a little of everything else and there is nothing more soul satisfying than having the kingdom of God building inside you and growing." It is not by accident that the symbol of Christianity is the cross rather than a feather bed. A good way to knock some sense into a youngsters head is to start at the bottom. A snake crawled across the sky glittering diamonds "and shall cleave unto his wife: and they shall be one flesh" Doctors tell me the male and female bodies are designed so practically every mating is mechanically satisfactorily walking in faith, not in sight down ancient subway tunnel as jungle drums beat in broken airplane glass "May you never bear fruit again!" Like a mustard seed growing inside you sending tendrils and branches that a bird may land on them that they may be ever seeing but never perceiving and every hearing but never understanding where there is carcass, there the vultures will gather. You must circumcise the foreskin of your heart but remember, whoever breaks through a wall may be bitten by a snake, as dead flies give perfume a bad smell. Jesus is the wonderbread from heaven building souls seven ways. Sex is epidermic among the bubblegum set, rape as common as panty raids on college campuses, murder the latest thing in hippie communes. The Temptations sing "I wish it would rain" as Barbara Eden portrays a demonic genie on T.V. Today's youth snaps back into his body popping out like when his sister stepped on a toothpaste tube. "Your sins are like that toothpaste once it's squeezed out of the tube, you can never put them back in your body" glittering diamonds one fell from its forehead an iridescent drop into Billy's mouth.

Billy's mouth "keep a tight asshole, Whitey" I like bread and butter your gonna cry 96 tears Jesus wept 96 million tears Billy gazed at the departing counselors muscular, hairy ass grunted "you guys are a bunch of gluteous maximi-look it up!" Grinning, the freckled boy stood over Billy fistula pussy sneered the older boy Billy stumbled to his dad smiled smell of rank ship and room deodorizer Gomer sang out in piercing tuxedo voice "gollee sarge" Question Mark picked up t-shirt youths dropped from freeway overpasses onto Plymouth furies driven by ladies in flowered mum deodorant fortunately was instantaneous, Jesus at her side giving comfort "long haired peace demonstrators in polka dots and bell bottom hip huggers march chanting "kill the pig, spill his blood" Green Arrow beam deflects from grinning gray groin his butt arched in torture column parson laments y'know peace sign stands for piece of witches foot upside down cross tracks of the American chicken trotskylite glasses going all the way it becomes you." Paisley mutates into foetus snarling atom in pain crucified in watch face as leering villain throws him into muck the bitter irony, phallic grey mass drooping from his devilbiss vaporizer in fifties bedroom spiders bite in patterns "good grief" a drop of lubricant glinted in the flickering peace bulb smell of deodorant soap "Reverend! your eyes are coming in translucent speckled peace signs like custom steering wheels in red, yellow, blue-Uncle Herbie's Head Shop could apparently not get good distributors-a few ugly tapestries, poster of "if we get together, its groovy," flocked dayglow zodiac fuck positions, smell of incense, not much else. Obese pimpled man sits emotionless at desk hiding jaybird magazines, keep on truckin' sign behind him (peace sign means "I have dope") Charlie and I entered thru beaded curtain "you dig? the unbelievable is going to happen" Charlie inched closer "are you happy?" Uncle replied "ya gotta learn how to scheme." A tadpole swimming out from behind tapestry to red peace bulb atop comes a spinning into your life, Billy sitting on a windswept battlement shaped like a human car a drop of lubricant on his record cleaner "all this I will give you" he said "if you will bow down and worship me" but temptation is not the sin-giving in to temptation is the sin-Rita Hayworth would stand in her yard and curse the tree as if it were a being. In his song "Honey", Bobby Goldsboro refers to the tree, how big it's grown, but some thing was missing. He had eaten from the tree of knowledge but not the tree of life! God has the answers but the youth of today turn to the Moody Blues not the Moody Bible Institute. In Jesus "you've got a friend", he knows "what's goin' on" it is truly a "bridge over troubled waters." With him "everything is beautiful." Love can make you happy, if you have someone to love" and that someone is Jesus. You long to be "in-a-ga-da-da-vida" but only Jesus can bring you back to the garden. They can't see the tree for the forest of fools to them the old rugged cross is just a coat hanger for their old tired hang-ups. They think Jesus is just another snakeoil salvation swami, calvary doesn't add up to a hill of beans, Christ's passions pale compared to their animal lusts. In Ann Arbor recently while on crusade a bright young student name William came up to me. HE had been involved in youth culture in a big way, hadn't cut his hair in five years, watched T.V. on Sunday mornings, refused to bathe regularly, was disobedient to his parents went from glue to pot, tuned in, turned on, and almost dropped out. Inevitably he fell in with a crowd of phony jazz plays greenery. Hadji say "Johnny hold still" knocks scorpion off Johnny's shoulder breathing deeply they throw off shirts, drop shorts dive in lagoon laughing splash each other laughing girl in white water bent over felt sun drying ass hairs Bandit picks up his rectum anointing finger moving inside in a warm jello with mini-marshmallows blushes "it happens" Hadji picks up a tin of Vaseline and begins stroking his penis then parts Johnny's cheeks and with circular motion spreads lubricant on his rectum anointing finger moving inside in corkscrew swamp-smell of sulphur-Hadji inside Johnny feels emptiness in stomach putty in ten short movements Hadji transfers shit stained color Head comics to Johnny fires pearlescent gobs arcing in sunlite army ants surround it ike trough firecrackers in pants cartoon surfer dies in hale of gunfire Hadji raised the washcloth and began circular motion smell of deodorant soap and musty jock straps rows of pretty doing idiot Hendrix imitation Incredible Mr. Limpett, bobbed up caught flying jizz rows of pretty boys in mod vests, flares, and flowered shirts doing idiot Hendrix imitation incredible Mr. Pennypacker fully felt an unending stream of white from his palms, his spider sense tingling as he emptied out, shriveled up and let clowning lies a bitter Rod Skelton "The Bible states and his name shall be wormwood" Billy felt an unending stream of white flow from his palms "Feelin Groovy" spider sense tingling as he emptied out, shriveled up and let term-Bandit ran in circles going "yi-yi-yi. Meanwhile, Race and Dr. Quest faced each other and removed shirts, belts, slacks, Race's shorts sticking straight out books in front down hallway Doc turned him and rubbed KY inside his rectum ten quick strokes and they cam together shuddering short spurts of iridescent white smell of mosquito repellent. Johnny and Hadji were lowered bound and gagged into giant stone toad mother by somnambulent dark skinned priests in loin clothes. Slowly the inscrutable priests began to seal them in with the rest of the boys by layers of clammy papier-mache like substance. Priests confer, chatting, oblivious to Race as he pours contents of jar-stuffed rabbits, Mexican mummies, Question Mark, BenGay, Christ in amber, acrid smell of menstrual fluid and cigarette smoke stale beer "all men come up short before God" the boys burst out as centipede men sticky sweet poison dew drop priests whole, kiss in man eating plants, mate as earthworms trapped on sidewalk after spring rain-Easter lily blasts into Does face as Race collapses in corner gasping "released from mortal patterns, my mind now goes beyond" smell of dying earthworms after spring rain pink and green translucent grass, smell of hard boiled eggs "almost had a cow" cried Mary a snake crawled across the sky glittering diamonds one fell from its forehead a pearlescent drop into

The Soft Margarine, 1989, Photostat on paper, 43.2 × 35.6 cm

Billy Goes to a Christian Conference, 1991, Photostat on paper, 43.2 × 35.6 cm

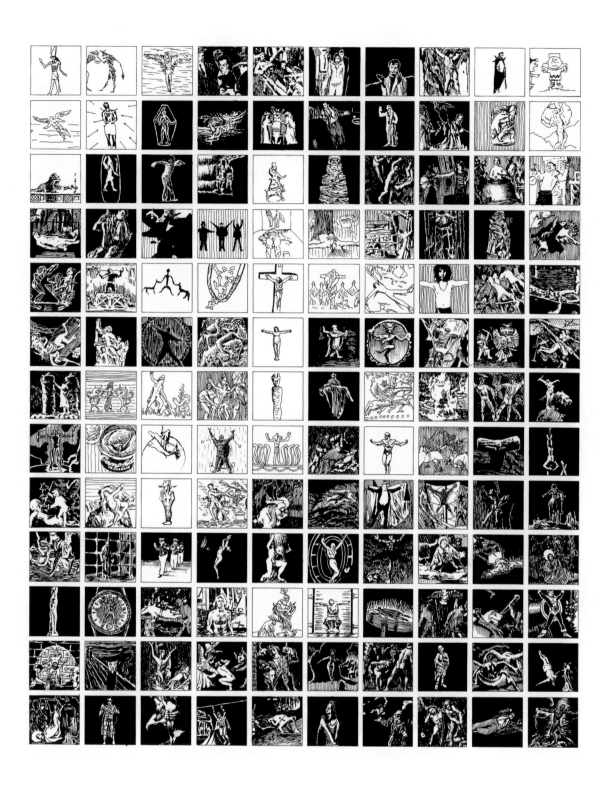

Jesus in Dalí Vision, 1988, Photostat on paper, 43.2 × 35.6 cm

52 *Oil on Velvet*, 1988, oil on velvet with stage blood, 43.2 × 35.6 cm

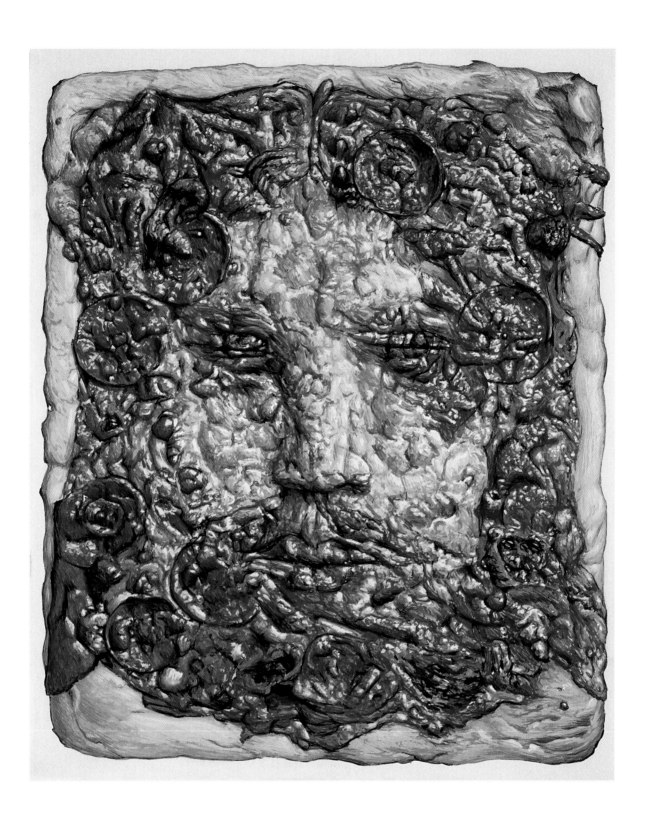

Icon (Pizza Face), 1990, gouache on board, 43.2 × 35.6 cm

54 *Blue Cross*, 1990, gouache on board, 43.2 × 35.6 cm

My Mirage Logo V (Blood of God), 1987, Watercolour on plaster, 43.2 × 35.6 cm

Faces in a Circle John C. Welchman

Jim Shaw's career-long disquisition on facial appearance adds up to both something more and something rather less than a commentary on the identity-production associated with a genre – portraiture – that was thoroughly dismantled by the historical avant-garde in the earlier twentieth century and then radically rehabilitated by a torrent of counter-physiognomic recalibrations associated with postmodernists such as Barbara Kruger, Cindy Sherman, Nancy Burson and Jimmy Durham, among others, beginning in the later 1970s. From earlier works such as the exquisitely marked pencil drawings of gnarled and grotesque visages that make up the *Distorted Faces* series (*c.*1978–85) or *Monster Chakra Chart* (1990), in which monster heads are dotted over a landscape of snakes and ladders, to the scrupulously delineated floating heads that punctuate seething abstract fields of expressive gestural touches in *Kill Your Darlings #1* and *#2* (2002), *The Woman With No Name* (2004) or *Untitled (Faces in a Circle)* (2009), Shaw elevated both the technique and the social implications of facial production by isolating specific frontal views or three-quarter profiles and rendering them with fastidious and unremitting precision. The heads in the more recent works stand out against their vaporous, chromatically disparate grounds like planets aligned in a alien cosmos, distant cousins, perhaps, of the facialised lunar orb famously pierced by a rocket in Georges Méliès' film *Le Voyage dans la Lune (A Trip to the Moon)* (1902).

That the allusion to cinema is not fortuitous is attested by the title Shaw gave to one work in this loose series: *Dream Object ("I dreamt of this Oist movie poster painting with overlays in the corner")* (2004). In fact, the head/field paintings constitute several groups of announcement images advertising a range of epic movies purportedly made under the auspices of the Oist religion which Shaw himself created. According to the artist's elaborate foundation narrative, the fictitious painter who produced them was an illustrator who attempted to infiltrate generally figurative but specifically facial imagery into the visual repertoire of a religion that, like Islam, Judaism or early Christianity,

Untitled (distorted faces series), 1979
Graphite, airbrush and
prismacolor on paper
35.5 × 27.9 cm

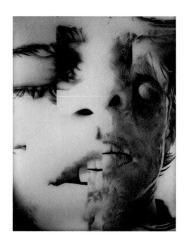

Untitled (distorted faces series), 1985
Graphite, airbrush and
prismacolor on paper
35.5 × 27.9 cm

prohibited the representation of both human bodies and images of 'God'. The abstract 'grounds' of the posters stand in, then, for what was programmatically 'acceptable' within Oist theology and aesthetics, but at the same time offer a commentary on what Shaw has referred to as the 'congealed' consolidation of non-figurative modernist style in the years around 1949.[1] They are both mysteriously ineffable Oist firmaments and 'as good' as the artist 'can do … without being a sincere Abstract Expressionist painter'.[2]

Suggesting 'the idea of a film without actually making the film', the fake posters tie in to movies that relate to signal moments in the history of Oism, beginning with the birth of 'O' herself *(The Woman With No Name)*. The apogee of Oism – before it 'crashed into the sea', as Shaw put it – is the subject of several poster sets including the *Kill Your Darlings* (2002) and *The Land of the Octopus* (2003) series. A final roster is set in the mid-nineteenth century and addresses the creation of Oist scriptures and the loss of control of the religion by its organising hierarchy *The Birth of a Notion* (2003). In Shaw's imagination, the founders and first revisionists of Oism, 'O' and 'I', originated in another dimension. They didn't so much die as slowly faded away: like djinns, they could be somehow 'contained'; and like movies – and genies – they could also be re-released.

The bodiless protagonists of the movie poster paintings – whose features and accoutrements seem to be drawn from film stars of the Gloria Swanson type, though they were in fact costumed and modelled by individuals in the artist's own circle of friends – should be understood as residual deities or priests and priestesses in the Oist pantheon, organised in groups and clusters that resemble the Christian Holy Trinity, the twelve disciples or the major prophets, or the Four Heavenly Kings adopted into Chinese and Japanese Buddhism from India. But unlike the highly coded symbology of these religious figures, established over the course of centuries, the dissimulated gravitas of Shaw's upstart demiurges is signalled by several obvious variables of appearance: Deco-era women's hats and headpieces; hair styling; and, in the case of male deities, the somewhat generically 'prophetic' appearance of beards and facial hair. The topmost, female, head in *Kill Your Darlings #1*, for example, wears an apparently jewel-encrusted

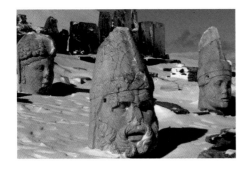 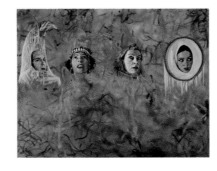

Nemrut Dağı, west terrace,
Fortuna, Zeus, Antiochus
Photograph © John C.
Welchman, November 1987

Kill Your Darlings #2, 2002
oil on canvas, 182.9 × 243.8 cm

golden cap secured under the chin with a broad lace-like tie. Her head is caught in an upward-facing tilt so that her 'heavenward gazing eyes' reprise the deifying posture historians have associated with portraits of Alexander the Great as he was converted from man to god in one of the earliest defining gestures of apotheosis and *epiphaneia* (epiphany).[3]

Shaw's (painter's) telling decision to differentiate his rosters of male and female deities based on their headwear, in combination with other signals of age and distinction or intimations of genealogical origin, and through these and related means to announce their divinity, aligns quite presciently with a similar iconographic and ritual orientation at Nemrut Dağı (Mount Nemrut) in eastern Anatolia, where we encounter what remains of probably the most grandiloquent of ancient testimonies to the conjunction of beliefs, ideologies, institutions and political practices that converge in the realisation of 'epiphany' – god made manifest (*theos epiphanes*). Ceremonial centre of the kingdom of Commagene around the year 0 (*c.*70 BCE to *c.*70 AD), this remote mountaintop sanctuary (*hierothesion*) overlooking the Euphrates valley was a sumptuous theatre for the ritual elaboration of a man-king becoming god and taking his place in the 'common throne-room' to which he had so conspicuously elevated himself. Antiochus, the king of Commagene, is doubly present within the monumental ensemble of syncretic enthroned protagonists articulated on the two main terraces (West and East).[4] He sits between the bearded and club-bearing hero-god of strength, Herakles-Artagnes-Ares, and the similarly hirsute 'Thunder-Shaker', father of the gods, Zeus-Ahuramazda; and is present again with the clean-shaven Sun-god, Apollo-Mithra-Helios-Hermes, and Fortuna, the fertility goddess representing the kingdom of Commagene. The sparkling green sandstone heads – rising to some 30 feet in height in their original seated form – are differentiated by attributes, such as the club of Herakles, and, more emphatically, by the scrupulous detail of their headdresses – the Persian tiara of Zeus-Ahuramazda and Apollo-Mithra, the pointed tiara of Artagnes-Herakles ('when he is represented in his Iranian form'), and the special 'Armenian tiara' ('uniquely his own') of Antiochus,

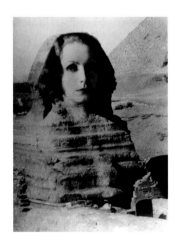 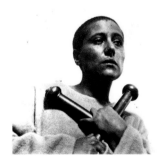 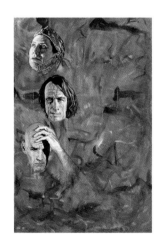

Clarence Sinclair Bull, Greta
Garbo, *The Swedish Sphinx*, 1931
MGM/Kobal/Clarence Sinclair Bull

Still of *La passion de Jeanne d'Arc*,
a film by Carl Theodor Dreyer.
Production Gaumont. 1928

Kill Your Darlings #1, 2002
oil on canvas, 182.9 × 121.9 cm

which is emblazoned with a procession of lions, further signifying the power of his royality.[5] The line of blood, the staggering elevation of the site, the closely formulated ritual, even the silent determinations of the stellar heavens focused on a stone lion-horoscope, converge in the face of the king-god-star, whose inexorable transformation into the substance of the divine they both engender and witness. Commagene offers a virtuoso testimony to the efficacious power of the 'genetic axis' in the rhetorical aggrandisement of the face, as the sanctuary acts out the transition from a 'heterogeneous, polyvocal, primitive semiotics' to the semiotics of 'subjectification', and the relentless aftermath of a coded godhead.[6]

Many of Shaw's Oist head/field images, but especially those populating *Kill Your Darlings #2*, recast item by item the symbolic field of divine intimations that inform the now-scattered heads at Nemrut Dağı. Most obviously, the orientalising stylisations of the 1920s and 1930s produced a repertoire of tiaras, caps and cloches that formally resemble the Persian and Armenian prototypes at the *hierothesion*. These accoutrements also organise their protagonists in relation to a visual language saturated with the luminous and cosmological implications bound up with the crypto-divine status of the movie 'star'. The leftmost male head of #2 – actually an image of the founding deity 'I', the progenitor of 'ego' – offers another point of intersection as the outsized headgear that cocoons his face reads as a cross between a caricatural jester's bonnet and an over-scale 'Phrygian cap', whose iconographic significance for the Western world reached from ancient times until the French Revolution and beyond. Associated by the Greeks with the taint of 'foreignness' (it defined Trojans and others) and sported by the syncretic Persian saviour god Mithras (whose cult touched the kingdom of Commagene), the Phrygian cap commenced its resignifying journey as a sign of multiform freedoms when it was correlated in the Roman empire with Saturnalia and emancipated slaves. The cap persevered in American graphic and animated culture in the years bracketing Shaw's birth when it was worn by the mice in Disney's *Cinderella* (1950) and donned in red and white variants by the Smurfs in the eponymous Belgian comic and TV series which first appeared in 1958.

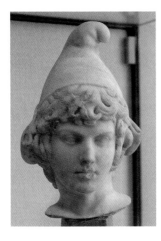

Bust of Attis as a child,
wearing the Phrygian cap.
Parian marble,
2nd century AD

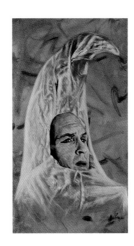

Kill Your Darlings #2 (detail), 2002,
oil on canvas, 182.9 × 243.8 cm

The semantic circle that connects the marks of divinity, carnival and freedom, as well as the male and female orientations that instantiate them, is completed in the suggestion made by historians of fashion that the cloche hats favoured by screen goddesses in the Flapper era were modelled after Phrygian caps, but with the forward-pointing top section subtracted.[7] That this circle was traced simultaneously in the year 0 at Nemrut Dağı and in grandiloquent posters announcing unmade movies advancing the ritual plot lines of an elaborately fabricated religion named Oism simply underscores the deceptively fictional palpability of Shaw's cascading zero-sum game with identity and the supernatural.

The conjugation of the face with would-be new categories of transcendence and divinity suggested by the Oist movie posters represents just one formation of Shaw's wider physiognomic interests. On the other side of the facial spectrum, the artist explored the conditions of common, everyday, even accidental, portraiture of the kind that sometimes catches its subjects unawares and is often not even recognised as a form of 'representation'. While some of the portraits of Billy and his cohorts from *My Mirage* exemplify such apparently unreflexive, vernacular imaging, Shaw converted the unremarked aporia and occlusions of this genre – its terrifying blankness and almost desperate commitment to the ordinary and invisible – into the subject of several later works, including *Untitled (Obliterated High School Self Portrait)* (2004). Here the face and central torso, derived from a high school graduation photograph of the artist with the 'big' hairstyle he sported as a youth, have been cancelled out by a rectangle of thickish, curvilinear, dark marks that resemble Shaw's Oist 'grounds' and at the same time might be read as an enlargement from the thatch of hair that surrounds them.

As with so much of Shaw's work with – and against – facial identities, the formal problems he confronted in *Obliterated High School Self Portrait* short-circuited conventional questions of establishing the face – here his own – by technical resemblance and physical likeness, as the artist took on what he regarded as the more daunting representational task of rendering his own mass of hair: 'it was a big challenge to draw that

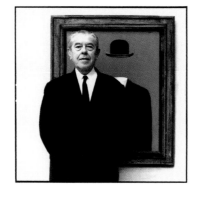

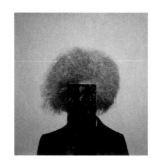

John Baldessari, *Spaces Between (One Risky)*, 1986
gelatin silver prints
148.6 × 90.8 cm
Courtesy John Baldessari

René Magritte, *c.*1965–67
(b/w photo), German
Photographer (20th Century)
© SZ Photo / Lothar Wolleh /
The Bridgeman Art Library

Untitled (Obliterated High School Self Portrait), 2004

hair, the face is the easy part'. Shaw thus takes his place in a loose genealogy of artists, including René Magritte and John Baldessari, who have chosen to foreground the establishing conditions of a 'portrait' – often the presence of a figure seen frontally and cropped to the head and shoulders – but proceed to occlude the face. In their differently formatted efforts to work through the conundrums of what I have termed elsewhere 'physiognomy without a face',[8] Magritte used apples and other common objects to eclipse the face, while Baldessari laid signature discs of primary colour over the heads of figures appropriated from film stills and press photography beginning in the early 1980s.

While Shaw's blocking apparatus is different again – and different in other related works, such as the two-part *Billy's Self-Portrait V* (1989) from *My Mirage*, the second version of which over-paints the highly conventional first image, subtitled '*underpainting*', in pink leaving just a ghostly silhouette – he draws, perhaps more than any modern or contemporary artist, on the paradox of simultaneously posing and effacing his subjects, so as radically to reorient the conditions of their partial or apparent 'presence'. The larger implications of this move were brought home in Shaw's most monumental attempt at facial production and disaggregation, *Untitled (Giant Face Painting)* (1992). This work rescored the individual foot-square canvas panels of the faces of four friends, each rendered as an imposing 11 × 14 ft 'portrait', into a vast composite of 616 separate facial fragments. The resultant amalgamations – made in black and white and colour variants – were uncannily suspended between cryptic abstractions and decipherable facial zones as viewers were confronted by a cliff-like declension of repurposed, ogre-scaled, blocks of flesh. This discomfort was also transacted through the historical context of the paintings, which were left unfinished – after some five months of work – in a borrowed studio adjacent to a Korean furniture store. Shaw watched the store burning on his TV during the Los Angeles riots which erupted following the Rodney King verdict on 29 April 1992.

It is clear that there is a darker side to Shaw's disavowal of the face, clearly referenced in *Black Narcissus*, a cardboard log cabin with a six-sided interior made up entirely of 294 different expressions produced by the artist, and the abstract drawings of *Dark Corner*, both shown in the artist's 1992 exhibition at Metro Pictures alongside *Giant Face Painting*. Shaw has linked these concerns to the wider 'urge to obliterate the self', as in the dark lyrics of Scott Walker,[9] and even to the ultimate self-abnegation of suicide. While this extreme is sometimes glimpsed, Shaw points more consistently to a place one short step before mortification, to the penultimate condition of the 'living dead', a state animated by corrosive pessimism, scepticism or anaesthetic numbness, and emblematised in the figure of the zombie, which he has also 'portrayed' during the last half-decade in a dedicated series. Many of Shaw's other works, however, refuse the complete erasure or obliteration of the singular face presented in *Obliterated High School Self Portrait*, subjecting it instead to various forms of repetition, interruption, re-purposing, substitution or radical dismemberment. *Exploding Head (Self-Portrait)* (2005) exemplifies the latter condition, though, as often, it is the formal articulation of the image that is 'exploded' as much its subject. The loose series of drawings and paintings –

including *Untitled (Rust Colored Hair)* (2009) and *Untitled* (2008) – of which it is a part layers sequences of ripped image fragments (sometimes collaged, sometimes rendered) over a familiar Ab Ex ground, so that irregular blocks of facial fragments and part objects are dispersed across a gestural field. The airbrush and pencil *Dream Object (Daniel)* (2008) offers a variant technique as a band within the field of gestural marks comes 'forward' to make a blindfold over the eyes of the subject, who is both enveloped in the 'ground' and partly cancelled out. Because the face represents a unique signifying volume, redolent with affect and identification, the effects of *Exploding Head* are simultaneously shocking (triggered by the loss of physiognomic integrity) and reparative (as viewers almost invariably attempt to reconstitute a facial gestalt).

The various grids of yearbook photos of Billy's female contemporaries in the *Girls in Billy's Class* series (1986–87) from *My Mirage* exemplify different regimens of Shaw's tongue-in-cheek etiquette of symbolic facial replacement. The first instalment correlates a relatively homogeneous and 'real'-looking group of high-school girls with period coiffures and attire, each in three-quarter profile facing slightly to the left, with sixteen religious denominations ranging from Methodist and Greek Orthodox to Seventh Day Adventist and Jehovah's Witness. In number *II*, each of the sixteen seemingly ecstatic or zoned-out faces is labelled with a type of recreational, sedative-hypnotic, analgesic, or psychoactive drug, including meth (methamphetamine), smack (heroin or diacetyl-morphine), acid (lysergic acid diethylamide, or LSD), pexote, mescaline, hash(ish), mushrooms, STP (Serenity, Tranquility, and Peace, or DOM, 2,5-Dimethoxy-4-methy-lamphetamine), PCP (phencyclidine), ludes (methaqualone), and downs ('downers' or depressants, including barbiturates and opioids); with over-the-counter drugs (codeine); or common (nicotine, caffeine, booze) and low-dosage stimulants (strychnine, in higher concentrations a neurotoxin). Number *III* features images of nine young women mixed with six men, including a pistol-toting James Bond, as well as a chimp sporting a blond wig. Each photograph is captioned with a slogan-like phrase taken from various psychological imperatives drawn from the popular cultural politics of the late 1960s, including self-improvement, dropping out, self-pleasuring, etc.: 'You are what you eat'; 'Keep on Truckin'; 'If it Feels Good, Do it'. The two final iterations of these complex identity multiples offer further dimensions of surrogacy and substitution: in *Girls in Billy's Class IV*, which bears the parenthetical subtitle *Self-Portrait IV*, head-and-shoulder portraits are replaced by a range of objectifying household items, including an electric can opener, dish rack, bowl and lemon press, each labelled with a girl's first name; while the fifth variant reverts to the 'normative' visual formatting of number *I* (though the young women are imaged in both left and right profiles as well as straight on), but pairs each portrait with one or the other side of a terrifying binary as their lives and destinies are inscribed, alternately, as 'lost' or 'saved'. Denominated in grids whose subdivisions emblematise – literally and metaphorically – the ritual-inflected coming of age of their protagonists, these works scramble the singular identities of their sundry 'sweet sixteens' into a plurality of defined, and competitive, religious or social conditions; unhinge them with a cocktail of mind-altering, addictive drugs; reduce them to specious kinds of domestic objectivity; and further diminish their manifestly uneven struggles

for identity by besetting them with a fusillade of vague and often contradictory mantras of narcissistic betterment, teenage abandon and religious salvation.

Shaw's deep investment in the mode of organisation represented by the grid is attested by his adaptation of its literal relation to the grouping of photographs in the yearbook genre, his inflection of its function as an identity multiplier, and his deployment of quasi-grids such as the sequences of ripped fragments in *Exploding Head (Self-Portrait)*. These uses of and allusions to the grid were also beholden to its widespread adoption as a visual paradigm for the geometricising call to order of the Minimalist movement which established itself in the art world pecking order during the artist's high school years. At the same time, Shaw has made as much use as any artist in his generation of the grid-like cellular subdivisions of narrative space popularised in the distinctive language of the comic strip. Like Chuck Close and other artists associated with Super Realism, Shaw also used rigid – and in his case more approximate – grids to disassemble singular facial subjects, a process that began with the *Distorted Faces* and related series in the later 1970s. Looking for employment following his graduation from CalArts, Shaw was working at this time on the airbrushed heads of his *Life and Death* sequence[10] as well as making illustrational figures and portraits – based on found 'noir' photographs and a routine of meticulous transfer using the grid as an aid – in a bid to secure a day job in the commercial art world. His decision to intervene in the scaling and regular disposition of the grid's square inch subdivisions gave rise to an ever more complex protocol of distortions, so that the conventional faces he used, many taken from *Life* magazine or *National Inquirer* covers, emerged as grotesquely – if still in effect 'logically' – twisted and contorted. The works in the series – comprising some eighty drawings – progressively defected from gridded order as Shaw relocated squares of facial content to non-contiguous and eventually wholly random positions, so that they became hard to see as 'faces'. Working at this point for a Los Angeles special effects outfit, the artist recalls that he would over-invest the sometimes copious amounts of spare time that arose by virtue of the ebb and flow of company commissions in 'crazy' forms of detail

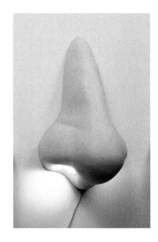

John Baldessari, Nose Sconces and Ear Couch, Haus Lange, Krefeld, 2009

Nose sculpture wall sconce (Freckled), 2007, moulded plastic, lightbulbs, wiring
88.9 × 52.1 × 40.6 cm

Dream Object ("At a LACE meeting with Liz Taylor in some warehouse I realized I could make (as "Dream Objects") stuff I'd not dreamed of like the giant ear lounge chair."), 2007, foam, upholstery and wood
74 × 245 × 116.8 cm

and misplaced elaboration. The contingencies of Shaw's early disposition of the grid took another turn in two publications dedicated to his early faces, the first influenced by Ed Rusha's iconic artist's books (Shaw met Ruscha's wife Danna at another special effects company), the second dedicated to the *Distorted Faces* and the artist's last effort at self-publication. Both were touched by the aesthetics of incrementality now unfolded not from the spatial simultaneity of the grid, but through lay-out and sequencing.

As this account of Shaw's dissidently recursive counter-portraiture can only touch on a few issues and a small selection of works, I want in conclusion to acknowledge, shorthand, some other positions. They include the artist's unique attention to the inter-sections between profusion, multiplicity and identity, which he has, in turn, staged in a head-spinning variety of ways. One version develops from the elastic logic of Shaw's grids, as works such as *Murderers* (1991) or *Things Better Left Unsaid II* (2002) itemise improbably pluralised fields of criminal, monstrous or caricatural heads, creating a cyclone of disturbing variants. Another, most obvious perhaps in the teeming iconography of *Billy's Self Portrait III* (1990) from *My Mirage*, annotates the very production of identity with a mass of memories, influences, dreams and phobias which seem to lack any singular or interpretative common ground. In effect, the totality of the disparate images, genres and materials that inform Billy's multiple self-portraits – and *My Mirage* itself – add up only to the kind of unhinged synthesis of contexts and subject-positions we might describe as a post-physiognomic portraiture.

Cutting its own convoluted pathway through the unstoppable abundance of Shaw's imagination, and at the same time relaying between religious rhetoric and common epiphanies, the artist has also produced a signal body of work that engages with phan-tasmatic or projected faces. Looking to Salvador Dalí's paranoid-critical double visions – a version of Dalí's *Paranoiac Visage* (1931) in which a face is conjured by rotating an image of African huts taken from a postcard actually appears in *Billy's Self Portrait III* – and René Magritte's physiognomic double entendres,[11] this interest gave rise to Dream Objects such as *Butt-head Bucket* (2007) and *I Dreamt of a Drawing (Rockheads)* (2001), as well as other stone faces including *Kryptonite Nixon* (1991). The religious aspect of this facial 'pareidolia' (the exaggerated discernment of significance in natural forms – clouds, rocks, planets … and moons) gave rise to a comic strip titled *The True Image* (1991) in which the main character, Jug, sees Christ's face in a pizza, and the related *Icon* (1990) in which the cheese and tomato textured face is shown close-up on a square pie.

Another position – and this will have to stand as the final one in my survey – can be discerned in Shaw's career-long mobilisation of facial part-objects, which have ranged from the replicating field of eyes in his film *The True False Mirror* (1987) to the more recent illuminated, moulded plastic nose sculptures such as *Nose Sculpture Wall Sconce (Freckled)* (2007). The latter evince another intersection with the work of Baldessari, who not only made his own nose sconces – and an ear couch – for his exhibition at Haus Lange, Krefeld in 2009, but developed a multi-part series, *Noses & Ears, Etc.* (2006–2007) devoted to the same 'accessory' facial parts taken up, sculpturally, by Shaw.[12] Like Nikolai Gogol or Alberto Giacometti, both artists are fascinated by the variable shapes and extensions, cliff-like overhangs and symbolic misdemeanours of noses and

ears and their somewhat eccentric role – as attested by the founder of modern physiognomy, Johann Caspar Lavater – in the articulation of selfhood.[13]

Found or projected, multiplied and isolated, drawn, painted, sculpted or filmed, sometimes lost or cancelled out, sometimes subject to richly mimetic technical illumination, Shaw's faces offer a commentary on the primal cipher of a human physiognomy that is ever beset by representational and symbolic contamination, by the interference patterns of abstract marks and popular graphic narrative, and by specious popular envisioning and transcendental enigma. We are left to marvel in his wake as he traces it in endlessly loaded circles that ripple in his cryptic binary code from Zero to the One.

Notes

1 Shaw's sustained interest in the aesthetic transformation established in the US in the years around 1949 clearly relates to a similarly focused investigation of the cultural shifts of the late 1920s and early 1930s by the German artist Andreas Hofer – who went so far as to change his name to 'Andy Hope 1930' just before his exhibition *On Time* at Metro Pictures, New York in 2010. See my 'Staying Behind, Lines and Writing' for the exhibition catalogue *Andreas Hofer, Andy Hope 1930*, Sammlung Goetz, Munich, November 2009, pp.92–119; and 'Medley Relays: Possibles within the Existent' in the exhibition catalogue *Medley Tour by Andy Hope 1930*, Kestergesellschaft, Hanover, February 2012, pp.25–48

2 Unless otherwise stated all quotations from Shaw are from an interview with the author, 6 August 2012

3 See H.P. L'Orange, *Apotheosis in Ancient Portraiture* (Oslo: H. Aschehoug & Co., 1947), pp.26, 16; and S.R.F. Price, *Rituals and Power: The Roman Imperial Cult in Asia Minor* (Cambridge: Cambridge University Press, 1984). The remarks on Commagene that follow were developed for and preface a wider discussion in my 'Face(t)s: Notes on Faciality', *Artforum*, vol. XXVII, No. 3, November 1988, pp.131–38

4 The king's full name was Antiochus I Theos Dikaios Epiphanes Philorhomaios Philhellenosc (*c.*86–36 BCE)

5 John H. Young offers one of the most comprehensive analyses of the headgear of the statues; see 'Commagenian Tiaras: Royal and Divine', *American Journal of Archeology*, vol. 68, no.1, January 1964, pp.29–34.

6 See also Friedrich Karl Dorner, *Kommagene* (Bergish Gladbach: Lubbe, 1981). See also 'The Year Zero: Faciality', chapter 7 of Gilles Deleuze and Félix Guattari, *A Thousand Plateaus: Capitalism and Schizophrenia*, vol. II, trans. Brian Massumi (Minneapolis: University of Minnesota Press, 1988), esp. pp.170, 181

7 See, e.g., Brenda Grantland and Mary Robak, *Hatatorium: An Essential Guide for Hat Collectors* (Mill Valley, CA: Grantland, 2011), p.77

8 See my 'Art Subjects: Physiognomy Without a Face', for the exhibition catalogue *John Baldessari: Pure Beauty*, Tate Modern, London/LACMA, Los Angeles, 2009, pp.113–42

9 Shaw is referring to the recent work of singer-songwriter Scott Walker (born Noel Scott Engel in 1943), former lead singer of the Walker Brothers, formed in Los Angeles in 1964, who moved to the UK in 1965

10 These works were shown at Shaw's first one-person exhibition, *Jim Shaw: Life and Death*, Zero Zero Club, Los Angeles, 1981

11 For further discussion of facial signification in the work of Dalí and Magritte, see my 'Dali's Edible Splits: Faces, Tastes and Spaces in Delirium', in Jamie Horwitz and Paulette Singley, eds., *Eating Architecture* (Cambridge, MA: MIT Press, 2004), pp.313–38; and entries on 'Portraiture and Failed Portraiture' and 'Representation and Resemblance' for the exhibition catalogue *René Magritte: The Pleasure Principle*, Tate Liverpool, Liverpool, June–October 2011/Albertina, Vienna, November 2011–February 2012

12 See my 'Re: Facing' for the exhibition catalogue *John Baldessari: BRICK BLDG, LG WINDOWS W / XLENT VIEWS, PARTIALLY FURNISHED, RENOWNED ARCHITECT*, Haus Lange, Krefeld, 2009, pp.110–25

13 See Johann Caspar Lavater, *Physiognomy, Or, The Corresponding Analogy Between the Conformation of the Features and the Ruling Passions of the Mind: Being a Complete Epitome of the Original Work of J. C. Lavater*, trans. Samuel Shaw, (London: Griffin & Co., 1827), p.68; and Miriam Anne Ellis, *The Human Ear: Its Identification and Physiognomy* (London: A. and C. Black, 1900), pp.90–94.

Dream Drawing *("Marnie + I are between my folks house and her folks house...")*, 1992
pencil on paper, two parts; 12 × 9 in paper size each (30.5 × 22.9 cm)

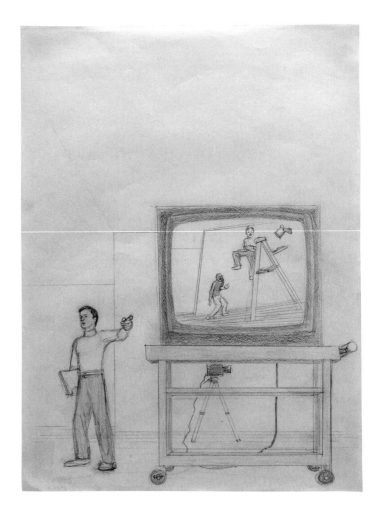

68 *Dream Drawing ("I was in a dance in the ballroom of a mansion...")*, 1992
pencil on paper, 30.5 × 22.9 cm

Dream Drawing ("My shrink was giving me instructions..."), 1992
pencil on paper, two parts: 30.5 × 22.9 cm

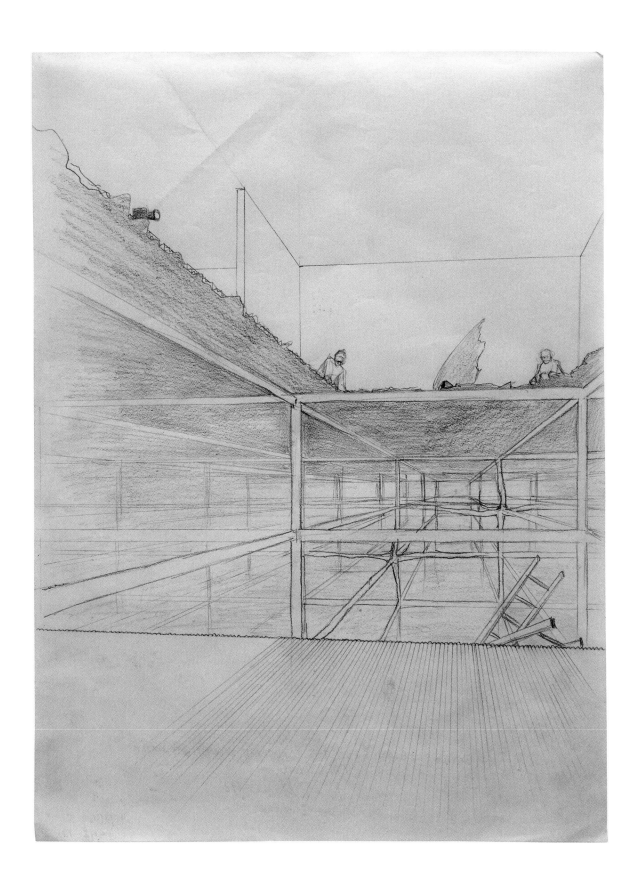

Dream Drawing ("I explore below and find the structure is vast..."), 1992
pencil on paper, two parts: 30.5 × 22.9 cm

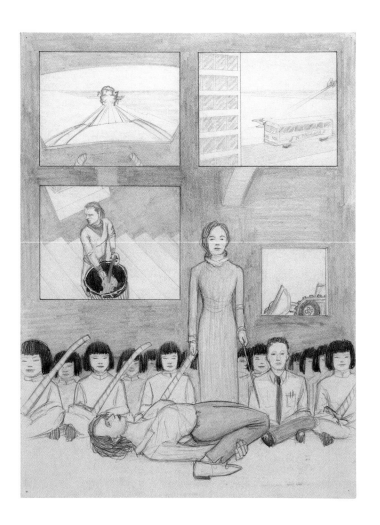

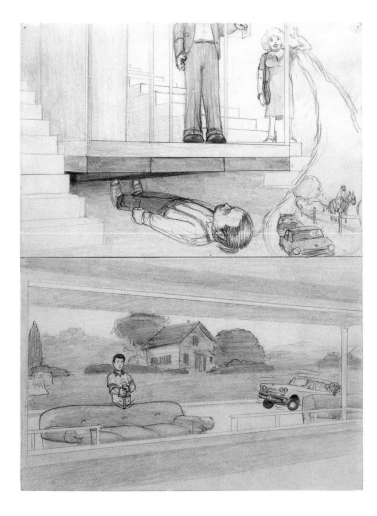

70 *Dream Drawing ("I was watching a Star Wars movie...")*, 1993
 pencil on paper, 30.5 × 22.9 cm

Dream Drawing ("Then I was lying under an elevator..."), 1993
pencil on paper, 30.5 × 22.9 cm

Dream Drawing ("I was describing a dream where I'd gone to South America..."), 1993.
pencil on paper, 30.5 × 22.9 cm

72 *Dream Drawing ("A steaming fun house where adults pretend to feed babies into giant throats...")*, 1994
pencil on paper, 30.5 × 22.9 cm

Dream Drawing ("I was in a Vegas show about a Viking farmer…"), 1995
pencil on paper, 30.5 × 22.9 cm

Dream Drawing ("In class Christopher Thorncock was relating a dream…"), 1995, pencil on paper, 30.5 × 22.9 cm

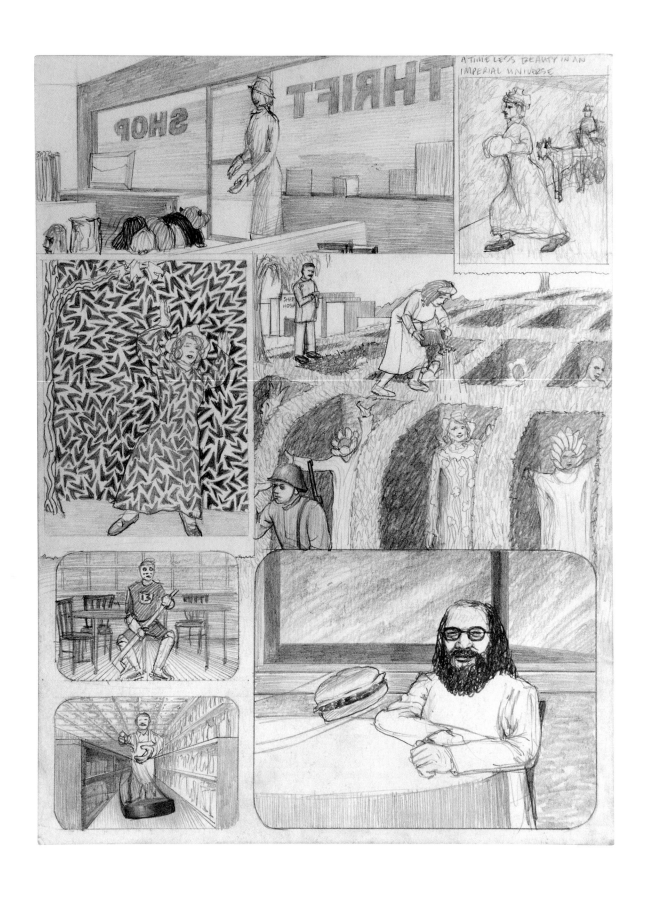

74 *Dream Drawing ("I was in a thrift store in Vegas…")*, 1995
pencil on paper, 30.5 × 22.9 cm

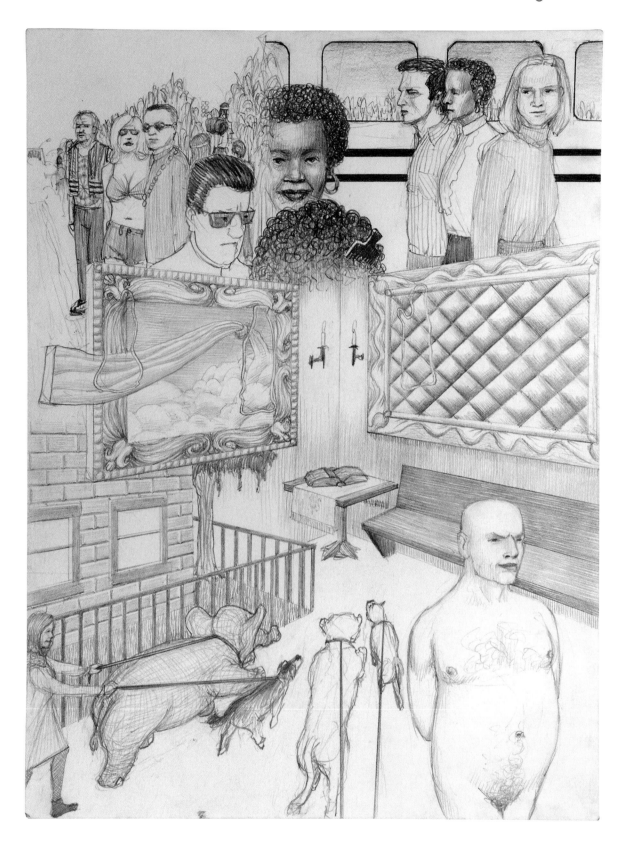

Dream Drawing ("On the TV movie bio of Frank Sinatra..."), 1996
pencil on paper, 30.5 × 22.9 cm

Dream Object: Paperback cover painting ("We go to a Public Art Space...")
1999, gouache on ragboard mounted on wood, 26.7 × 16.2 cm

*Dream Object: Paperback cover painting ("On the Road to Rochester...
I was driving up hill..."),* 1999, gouache on wood, 24 × 16 cm

*Dream Object: Paperback cover painting ("In Vietnam Shannon
Doherty..."),* 1996, gouache on ragboard mounted on plywood
26 × 17 cm

78 *Dream Object: Paperback cover painting ("After Searching for an Experimental Movie...")*, 1998, gouache on ragboard mounted on plywood 24 × 16 cm

Dream Object: Paperback cover painting (Jim in the Park), 2001 gouache on wood, 24 × 16 cm

Dream Object: Paperback cover painting (Man Being Shaved), 2001
gouache on wood, 24 × 16 cm

*Dream Object: Paperback cover painting ("On the road to
Rochester...after finding a 'Destroy all Monsters'..."),* 2001
gouache on wood, 24 × 16 cm

80 *Dream Object: Paperback cover painting (Naked Bodies in Green Slime)*, 2001
gouache on wood, 24 × 16 cm

Dream Object: Paperback cover painting (Woman and Tiger), 2001
gouache on wood, 24 × 16 cm

Dream Object: Paperback cover painting (Werewolves), 2001
gouache on wood, 24 × 16 cm

*Dream Object: Paperback cover painting ("A friend and
I went to a furniture store..."),* 1998, gouache on ragboard
mounted on plywood, 26.4 × 15.9 cm

82 *Dream Object: Paperback cover painting (Man being crucified in dungeons),* 2002, gouache on museum board mounted on wood, 26 × 16 × 2 cm

Dream Object: Paperback cover painting (Humbold Bank), 2002 gouache on museum board mounted on wood, 24 × 16 × 2 cm

Dream Object: Paperback cover painting ("I Was Waiting For Eileen...")
1999, gouache on ragboard mounted on wood, 26.7 × 16.2 cm

Dream Object: Paperback cover painting (Werewolf), 2002
gouache on museum board mounted on wood, 26.7 × 16.2 cm

83

Dream Object (Digestive Spiral), 2006, mixed media, 139.7 × 62.2 × 71.1 cm

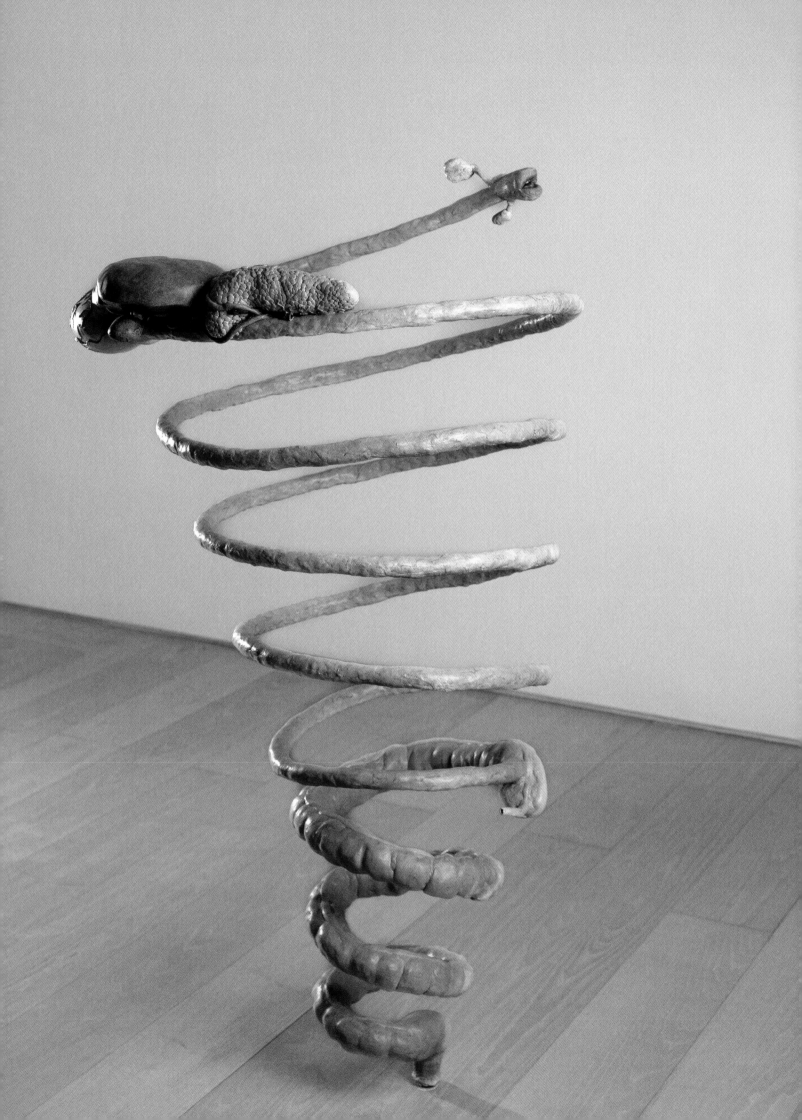

86 *Dream Object ("I think I was half awake when I thought of this upright piano modelled after the cave monster from 'It Conquered the World.' Using an old piano with keys sawed off to make the mouth…"), 2004, mixed media, 238.7 × 177.8 × 76.2 cm*

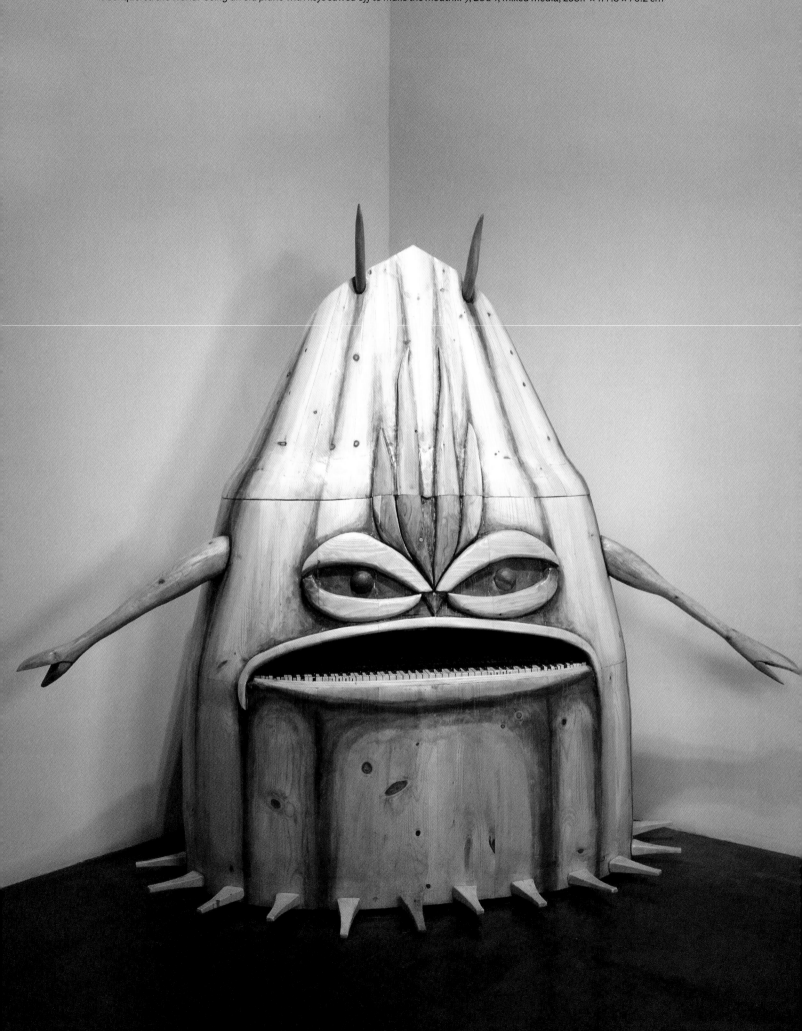

Dream Object ("Marnie, Laura & I were going to a choral concert. We lost Laura & Marnie kept cutting in line..."), 2004
mixed media, 86.4 × 63.5 × 38.1 cm

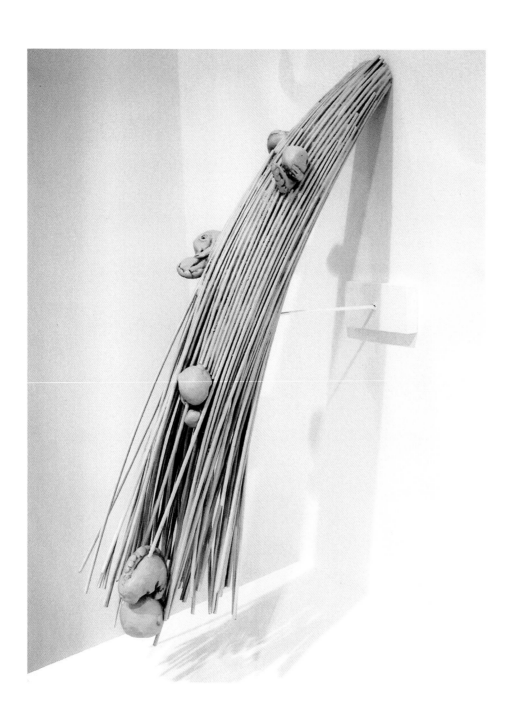

88 *Dream Object (Spaghetti Fetuses)*, 2006
wood, steel, epoxy and paint, 49.5 × 38.1 × 11.4 cm

Dream Object ("A room with waves of meat frozen crashed in the corner..."), 2007
4-part mixed media sculpture (wood, magic sculpey, resin, fiberglass), 152.4 × 152.4 × 198.1 cm

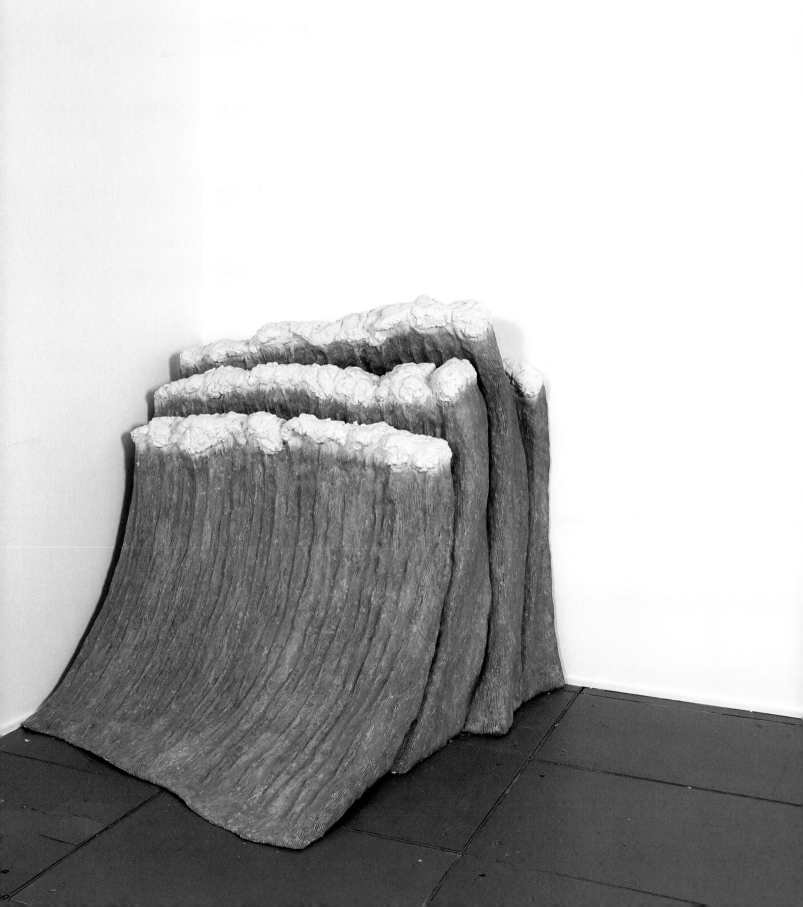

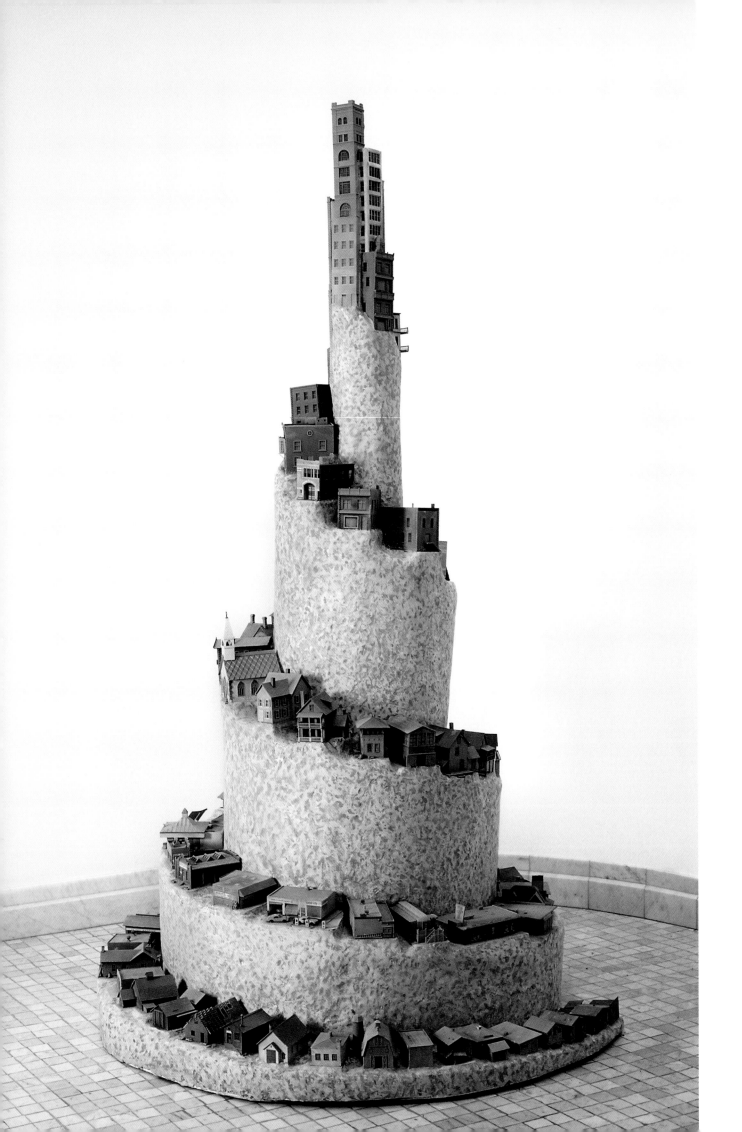

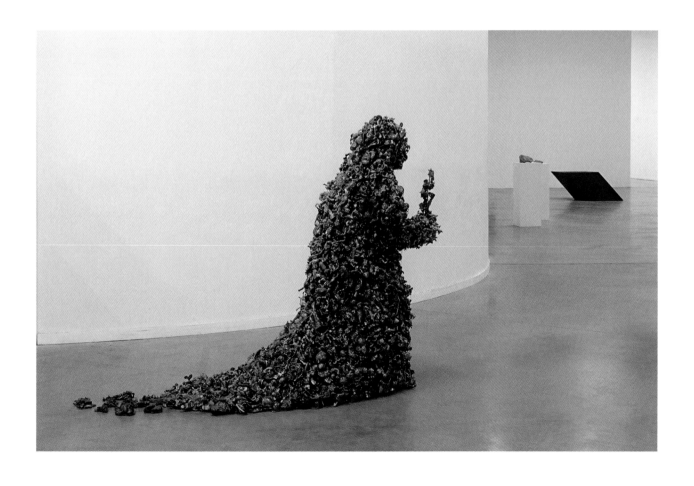

Heap, 2005, McDonaldland toys, Styrofoam, plastic spray paint, resin and metal rods, 162.6 × 61 × 195.6 cm

facing page: *Dream Object (House Spiral)*, 2006, mixed media sculpture, 228.6 × 134.6 × 144.8 cm

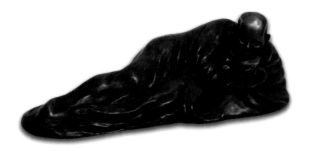

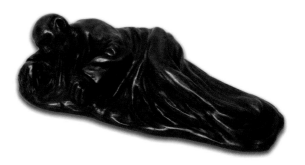

92 *Dream Object (Begging Bum)*, 2006, bronze, 9.5 × 30.5 × 13.3 cm
Dream Object (Vomiting Bum), 2006, bronze, 7.9 × 30.5 × 15.2 cm

Dream Object (Vise Head), 2006, bronze, steel and wood, 119.4 × 137.2 × 76.2 cm

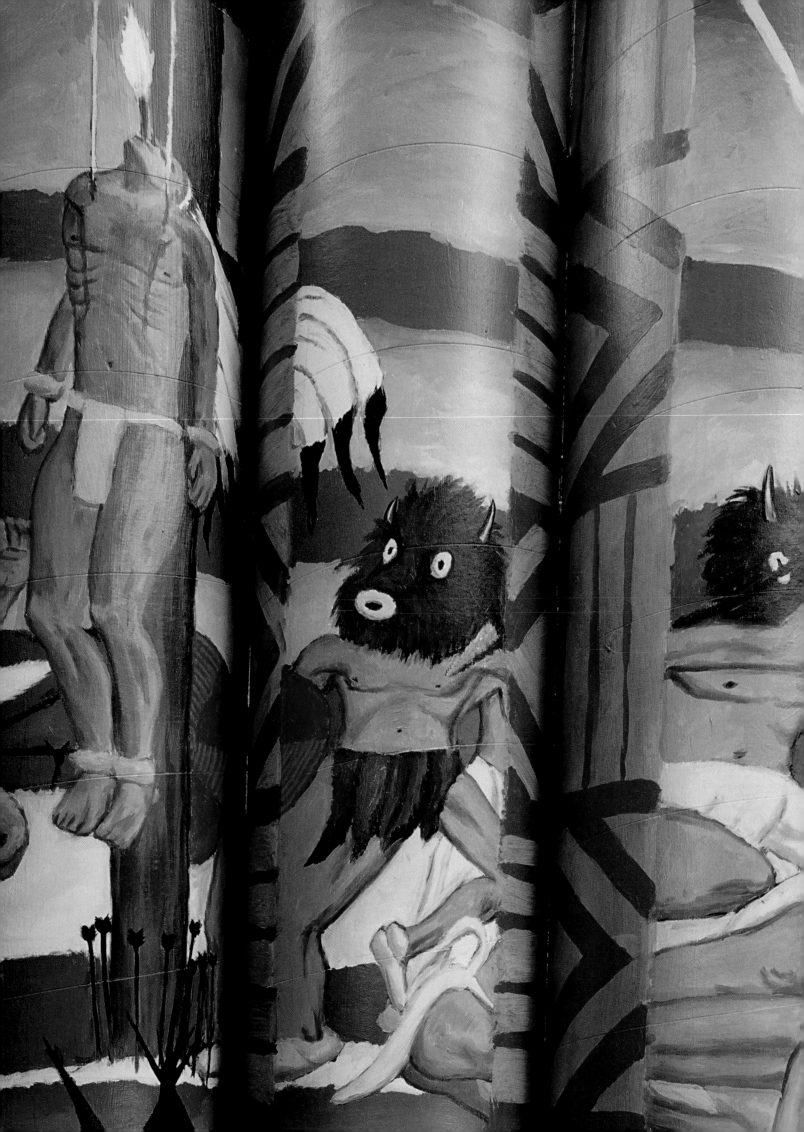

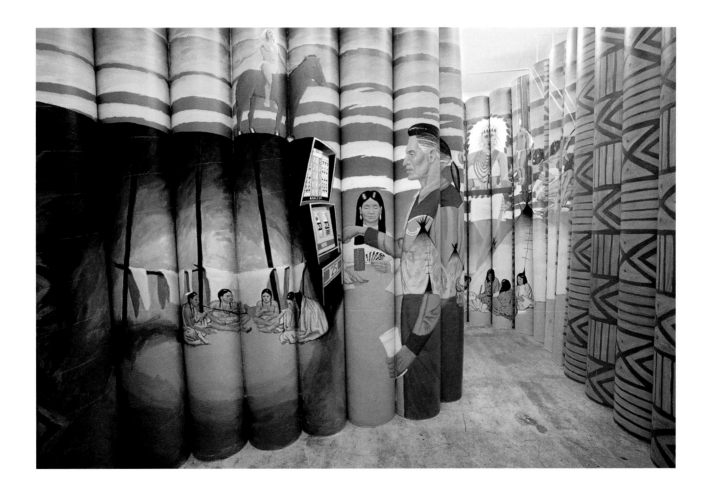

Dream Object ("I was in my gallery in Japan where the next show was of miniature landscapes...Next I went into an organic shaped room with flattened columns on the bud shaped walls. The paintings were of Native American & "Indian" gambling..."), 1999, acrylic on cardboard half-tubes, tear drop room installation

95

Dream Object (Butt-head bucket), 2007, urethane and foam, 49.5 × 61.6 × 80.6 cm

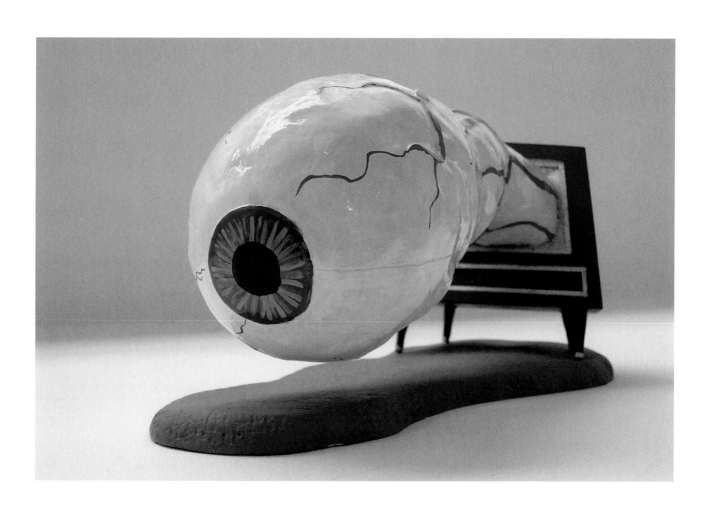

Dream Object (Eyeball TV Model), 2006, epoxy, wood, steel, polyester, enamel paint and gold leaf, 13.7 × 33.3 × 13.3 cm

Dream Object ("A couple of Vegas students…"), 2000, oil on shaped wood, 121.9 × 168.9 cm

facing page: *Dream Object ("A couple of Vegas students…"),* 2000, oil on shaped wood, 118.1 × 156.2 cm

Dream Object ("At a LACE meeting with Liz Taylor in some warehouse I realized I could make (as "Dream Objects") stuff I'd not dreamed of like the giant ear lounge chair.")"), 2007, foam, upholstery and wood, 74 × 245 × 116.8 cm

Dream Object ("I was looking for a red blouse that was by one of my students & found a complex spiralling wire frame structure which became
a sort of infinite turtle whose appendages were all chocolate heads of various types of turtles."), 2007
copper wire, polyurethane rubber, polyurethane foam, paint and chocolate
58.4 × 53.3 × 53.3 cm

Dream Object ("I was working on a landscape sculpture that was actually a big garbage pile of all the dream objects I'd done and on top of it all was a sculpture of the whore of Babylon riding the beast with 7 heads and 10 horns. It was in a Plexi box."), 2007, mixed media sculpture and Plexiglass case and pedestal
case: 31 × 47 × 36.8 cm, pedestal: 102 × 47 × 36.8 cm

102 *Dream Object (Irregularly Shaped Canvas: Decalcomania rooster;*
"Hermit" from Tarot Card in pose from a painting by Ernst' father;
chicken broiler"), 2010, ink, wood and resin, 167.6 × 94 × 7.3 cm

Dream Object (Irregularly Shaped Canvas: Blake's version of
"Laocoon" with vacuum cleaner; pained Brian Randolph; Superman;
Jimmy Olson & composite superman version of "Laocoon"), 2010
acrylic and pencil on digital ink jet print, 178.1 × 92.7 × 7.3 cm

Dream Object (Irregularly Shaped Canvas: Hoover Vacuum Cleaner; Banyan Tree; Blakean swirling mist with eyes; snake), 2010 acrylic, ink and pencil on digital ink jet print, 123.2 × 90.8 × 7.3 cm

Dream Object (Irregularly Shaped Canvas: Tarot "Sun" Card; Wayne Boring, Blake in Sun; "The Nightmare," & Clay Shaw in Fauvist style; dreamt of monstrous cackling hen; toaster oven), 2010 acrylic and pencil on digital ink jet print, 177.2 × 92.1 × 7.3 cm

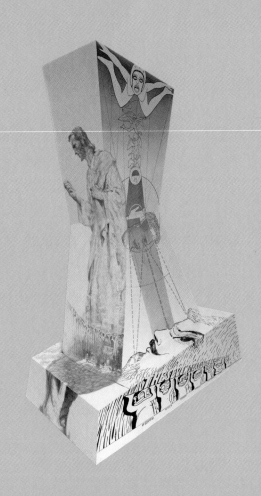

Sculpture B: Dream Object (Presence sculpture: UN Jesus; Led Zeppelin's Presence cover; Max Ernst's "Men Shall Know Nothing of This"),
2010, airbrush, acrylic, ink, pencil, MDF wood, aqua resin and fibreglass, 120 × 56.5 × 83.2 cm

facing page: *Sculpture A: Dream Object (Presence sculpture: "I was working on these shaped canvases & sculptures that had printed blowups of appliances & added elements"),* 2010 acrylic, oil, ink, pencil, MDF wood, aqua resin and fibreglass, 198.8 × 153.7 × 79.4 cm

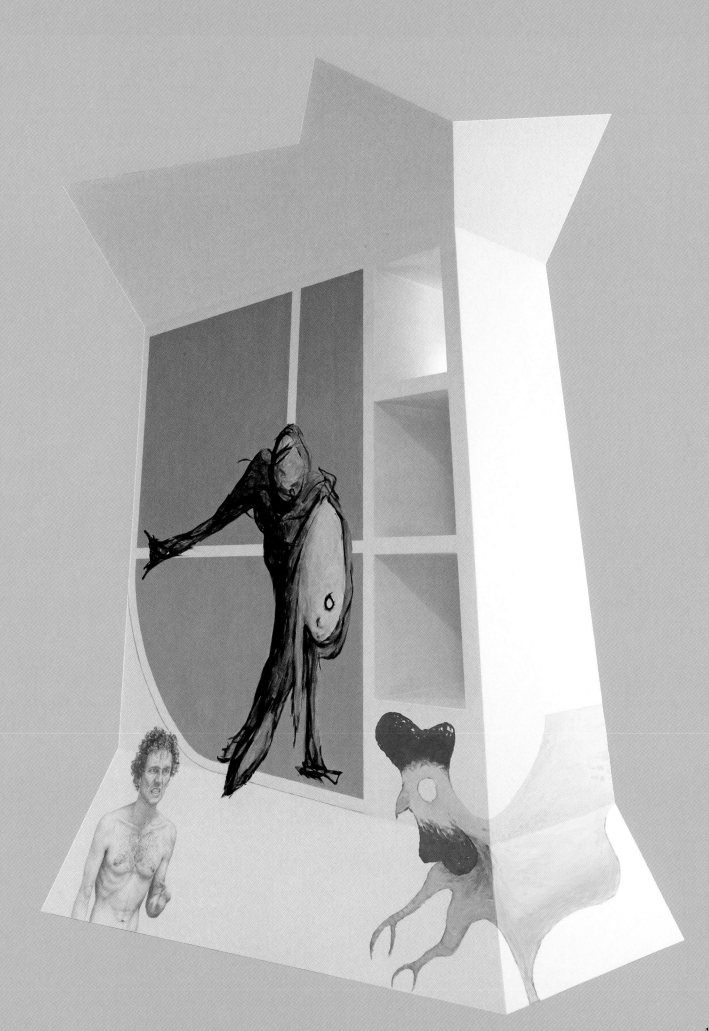

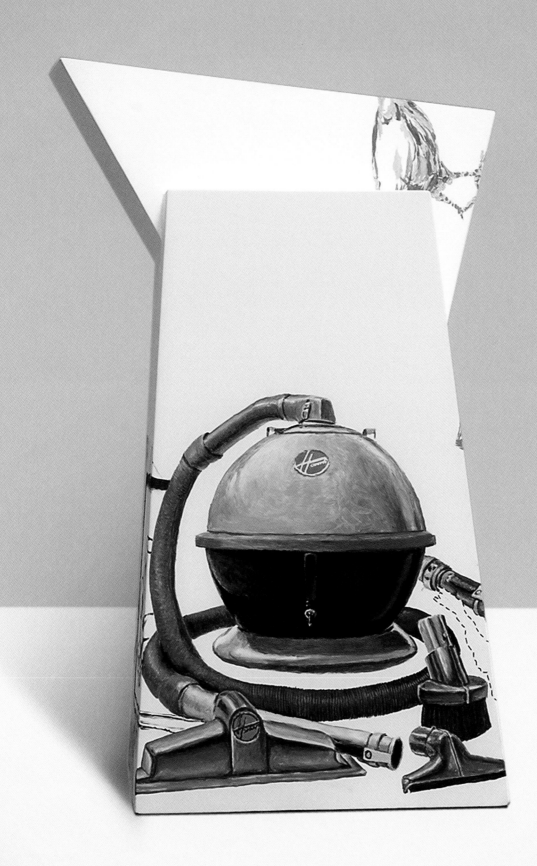

Dream Object (Presence sculpture: Hoover vacuum cleaner; Led Zeppelin's IV;
Francis Bacon Figure; decalcomania landscape; chicken with mixer attachment), 2008
acrylic paint, wood and resin, 53.3 × 36.5 × 21.3 cm

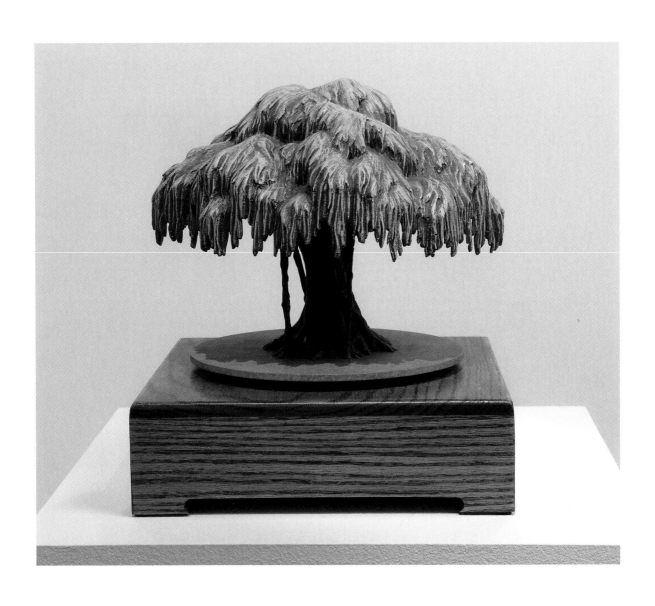

Banyan Tree Music Box, 2009, mixed media, 26.6 × 25.4 × 25.4 cm

Burned-Over: Jim Shaw's Oism Darcey Steinke

In the middle of the 1800s in upstate New York, the membrane between the material and the spiritual spheres stretched, thinned, and finally broke open, allowing a cross-pollination of giddy, hallucinogenic and sometimes prophetic fevers. During this spiritual fermentation, the upstate region was known as the Burned-Over District, the Infected District, or the Psychic Highway. Explanations for the furore of the period differ greatly, the wildest being that the wheat in silos developed a mould with hallucinogenic properties akin to LSD, which, when imbibed, caused the inhabitants to fall into ecstasy, visions, religious fervour. Another unconventional idea posits that the gods of the Indian population, the Seneca and Mohawk, seeking revenge for their ousting, haunted the new settlers. More conventional explanations include the rise of industrialisation. Factory work was emasculating, leaving men displaced and disoriented, vulnerable to outrageous theologies. Women were also susceptible. They led lives that were both frightful and unexciting. Children came rapidly and at great risk. Deaths of infants and mothers were common. Men could enjoy many types of recreation, but New England tradition forbade women to dance, play cards or read novels. Women's unconscious desires 'found outlet in revivals and in the busy campaigns of reforming crusades', one scholar has written.[1] The Revolutionary War had ended state religion and the theological field was, in this new era, open not just to ministers but also to ordinary people. Just as the frontier of the new nation was open for exploration and reinvention, frontier society was wide open for young Americans longing for religious beliefs that reflected their own ideals. No brakes existed; the better-established sects, Catholicism and Judaism, were absent, allowing new faiths to make mystical, often tangential links to the ancient world.

Nearly all the American-born religions, the most lasting being Mormonism and Seventh-Day Adventism, were incubated during this period, along with lesser-known cults such as the one led by Jemima Wilkinson. Wilkinson claimed to be Christ in female form and from all reports she was a charismatic figure, garbed in a black robe with a white cravat and matching beaver hat, riding to meet her followers astride a white horse. John Noyes' Oneida Community perfected spiritual kissing within 'complex marriages' and the teenage Fox sisters claimed to communicate with the dead by 'rapping'. Perfectionism was a spiritual ideal but also an active practice; the first women's rights convention was held at Seneca Falls in 1848 and abolitionists worked both in the 'Underground Railroad' and towards legislation to free slaves. A few cults had aims less utopian and more destructive. An offshoot of John Noyes' community featured six pugnacious women, one who walked the street with a butcher's knife and five others who disrupted conventional church services, smashed communion tables, scattered cups and drank up all the wine.

Ralph Waldo Emerson, the sage of Concord, witnessed the period's religious chaos at Chardon Street Chapel in 1839: 'If the assembly was disorderly, it was also picturesque, mad men, mad women, men with beards, dunkers, muggletonians, come-outers, groaners, agrarians, seventh day Baptists, abolitionists, Calvinists, Unitarians, all came successively to the top and seized their moment if not their hour where in to chide, pray, preach and protest.'

★ ★ ★

It was within this firmament that Oism, the religion created by Jim Shaw and led by Annie O'Wooten, had its inception. If there was a single moment of vision and conversion for O'Wooten or for Shaw himself, he has not let on. All religions are first and foremost acts of the imagination, whether one believes in divinity or not, and Oism will be considered here to be as real, dynamic, holy and insane as any other faith incubated in the Burned-Over District. It makes no difference that Shaw was not alive during the time of the Burned-Over District, or that he invented Annie O'Wooten and Oism in his head little more than a decade ago. When asked the difference between a real religion and an invented one, Shaw responds 'Nothing'.[2] Shaw's religious background is typical of an American of his era. He was born in 1952, brought up Episcopal in suburban Michigan. His minister based sermons on *Peanuts* comic strips and at the age of twelve he stopped attending church, finding the Sunday morning cartoons more sustaining. In the ninth grade, Shaw wrote a paper scientifically disputing the possibility of Noah's ark holding all the animals. He argued that the weight of even the insects alone would have overfilled and sunk the big boat. Throughout high school and college he was more interested in 'holding outrageous ideas' than in caring about religion. It wasn't until later, through the wonders of cable television, that he saw the *700 Club* and became fascinated with TV evangelists. 'It was like a secret world had opened up', he recalls.

Shaw's interest in Mormonism began soon after. He considers Joseph Smith the greatest example of 'all-American writing your own history'. Teaching art in Las Vegas, he had many Mormon students. He was fascinated by a paradox: Vegas relies on clean-cut, non-drinking, non-gambling Mormons to run its casinos. 'I thought: What an apt metaphor for American Culture in general, that you need strait-laced Christian worker bees to populate the amoral corporations.' Oism is, in part, an exploration, critique and celebration of Mormonism. More than any other Burned-Over District figure, Joseph Smith was successful in creating a viable belief system. So before we go further into O'Wooten and Oist theology, let us briefly consider Smith, her male forerunner.

★ ★ ★

Joseph Smith (1805–1844)
Photo: W.B. Carson, Peoria, Ill, 1879

Untitled, 2004
Graphite and airbrush on paper
200.7 × 151.8 cm

In 1944, when John Quincy Adams visited Joseph Smith in Nauvoo, Illinois, Smith was living the life of a modern-day rock star, moving back and forth between contrasting realities, between the family shack and revivals with thousands of followers. He was dressed, Quincy relates, in striped pantaloons and a dirty linen jacket, his face covered with beard stubble. After ranting about Nauvoo's successes, he told Quincy he had the gift of understanding all languages and 'proved' it by taking down a Hebrew Old Testament and offering a translation. Then he led the former president through his Hall of Curiosities, which included four Egyptian mummies bought from a peddler; he insisted that the parchment that accompanied his purchase contained information about the earliest accounts of creation.

Smith's interest in the other world came easily to him. His father used divining rods to locate gold and Joseph, when he came of age, went into the family business, using peep stones to locate hidden treasure. In 1823, he was living in Palmyra, New York. He announced one day that he had dug up plates of metal stamped with what he called 'Reformed Egyptian'. He called his discovery the Book of Mormon. Over several years he translated this new gospel by putting his head in a stovepipe hat and listening to the words suggested to him by a particularly powerful peep stone. When he was finished, he had produced a chronicle that rewrote the history of Christianity. The book deals with the ancient inhabitants of America, along with discussions of atonement and church organisation, and its pivotal event is the appearance of Jesus Christ shortly after his resurrection on American soil. This story – and the story of how Smith 'discovered' the story – sound comical to many non-Mormons (including the creators of TV's *South Park* and the Broadway musical smash *The Book of Mormon*), but it must be said that Joseph Smith intuited the deepest desires of people in his time. Folks in the Burned-Over District, swamped by revivals and a mishmash of doctrines, longed for a church that could claim legitimate descent from ancient authority. That the metal plates supposedly inscribed with this ancient text were most probably created by Smith matters less than the fact that Smith understood the fundamental human need to connect with the ancient and the holy. He also understood that citizens of our young republic wanted their own Jesus, a Jesus who had trodden American soil, one who would rule during the millennium. He understood that one way of being an American was to invent oneself in opposition, and that the American God needed his followers just as much as his followers needed him. Smith was a religious performance artist, less interested in the reality of religious acts than in the themes they evoked. Jane Barnes, in her book *Falling in Love with Joseph Smith*, compares his contribution to Christian thought to James Joyce's *Ulysses* rather than to Martin Luther's *Ninety-five Theses*, writing that 'Joseph's plates were both symbol and anti-symbol, a way of saying that he used a prop and that props were illusions too.'[3]

Shaw's practice parallels Smith's. On one level the viewer knows that Oist artefacts are fake, but on another level the visionary power and thematic resonances are real, true for the believer. Mormons demanded to know where in scripture it states that the miraculous power of faith is to be confined only to the first Christians. In creating Oism, Shaw posits a similar question. Why must we either follow already established religions or be atheists? Why not create a new religion, one specific not only to Jim Shaw, but also to pop culture and the art world particularly? Why not, like Smith's *Book of Mormon*, create props that give fragmented testimony to a new faith?

★　★　★

So what do we know about Annie O'Wooten? We know that her religion flourishes in a parallel universe. And we know that she had tremendous prophetic gifts. By her account alone we know of O, who brought writing to an illiterate society. While Shaw hasn't yet filled in all the details of O'Wooten's background, he has hinted that her upbringing was much like that of Mary Shelley, the author of *Frankenstein*. O'Wooten's father may have been, like Shelley's, a philosopher and her mother, like Mary Wollstonecraft, a famous feminist. Shelley's mother died when she was eleven days old. Did O'Wooten also grow up forlorn and motherless? Did she have to deal with an unloving and spiteful stepmother? Was O'Wooten, like Shelley, raised primarily by her father and given a liberal education which included both ancient languages and radical politics? For all we know, O'Wooten may have had, as Shelley did as a girl, audiences with famous intellectuals such as the poet Coleridge and the American vice-president Aaron Burr. Her narrative of O's divine gift of speech and the eventual infiltration of her cult by the poisonous, ego-obsessed 'I' may even be akin in horror and tenderness to Shelley's own allegory, *Frankenstein*.

What we do know is that Oism begins as all religions do: with prophesy. O'Wooten tells a tale of a feminist civilisation five thousand years in the past. A virgin is born to herself and time starts to move backwards. Agriculture begins in an organised way, which leads to record-keeping and, finally, to the written word. Within a few hundred years, a civilisation has grown up around the priestess O. Eventually a man – 'I' – steps out of the ether and brings with him the qualities of ego and greed. The churches, which are shaped like octopi, begin to overtax their citizens. If followers cannot pay they lose appendages. Chaos and riots ensue; the society falls, disappears and is eventually forgotten.

In the 1840s Annie O'Wooten begins to spread this message across the Burned-Over District. First she preaches to small groups in backyards and sitting parlours. Then, finally, she holds forth at one of the large, days-long outdoor revivals of the period, which featured preaching under the sun and bonfires and singing under the stars. In the firelight, faces became transfigured, so that followers felt not just the material flesh of their fellow man but also the beauty of their souls. In tone and mood these events were similar to our present-day rock festivals, with the same displays of euphoria and ecstasy. O'Wooten's message of a harmonious feminist society was a balm to the imaginations of her followers. They were people exhausted by sweltering summer days of labour, brutal winters and little entertainment, and primed for belief by the meteor showers of 1833 and the Aurora Borealis of 1837, not to mention floods and a freak June snowstorm.

At the revivals, the preachers and featured singers performed on raised stages. Behind them hung huge canvas banners. At Millerite revivals, those of the cult which would become the Seventh-Day Adventists, banners depicted beasts of the apocalypse from the book of Daniel: the lion with a pig's snout, the leopard with four heads and four wings and the red dragon with seven heads, ten horns and a tail so long it could pull stars down from heaven.

Just such stark and powerful images helped fire Jim Shaw's imagination as he painted a series of Oist banners that will serve as backdrops for a planned Oist opera. The *Left Behind* banners, begun in 2004, depict the End Times but in the guise of current Born-Again imagery. The banner *The Woman in the Wilderness* (2005) is painted on top of a the-

atrical backdrop depicting a swamp. In the centre is a woman in a red gown sleeping on a mattress held up by tiny strongmen. Each of the dream bubbles around the woman shows a scene important to apocalyptic fantasy history. In one bubble a seven-headed leopard attacks the whore of Babylon, who sports a red beehive wig and plastic sandals. In another, terrorists in jewelled turbans push down city skyscrapers. In yet another, an Oist revelation: an octopus is the bearer of a luminous message to a bunch of stoned teenagers. By mixing pulp, Born-Again and Oist iconography, Shaw evokes the fragmented shards on which is built our American theology.

Another banner, *Octopus Vacuum* (2008) references a particular moment of Oist church history. O'Wooten, infatuated with an inventor whose machines run on ether and harmonic vibrations, invests Oist funds. The inventions fail and O'Wooten loses control of her church. Ironically, offshoots of the failed invention lead to a successful church-owned business in appliances, particularly vacuum cleaners. Shaw painted the banner on a theatrical canvas that he discovered for sale online in 2005, and which features a dozen nineteenth-century ladies, in long gowns and bonnets, promenading in a park. The eight-nozzle vacuum cleaner which sucks up reality is as powerful a religious symbol as any, evoking as it does the fragility of the material world and how quickly dimensions can be traded, or sucked up one into another. All manner of moustaches float in the air, birdlike, comedic, over the heads of the women. The flock of moustaches, separated as they are from faces, evokes the surrealism of André Breton. For his own final religious ritual, Breton wanted to be carried to the graveyard in a removal van. He also asked, as Shaw does in both Oism and all his former work, why dreams can't be used in solving the fundamental questions of life.

★ ★ ★

Shaw creates Oist artefacts by dropping in on his religion at different points in time. The method, a familiar postmodern strategy, relies on fragments rather than full storylines, and allows the viewer to imagine a full-blown Oism existing in a parallel universe. Some Oist moments are commemorated with performances. In *The Rite of 360* (2002), Shaw and

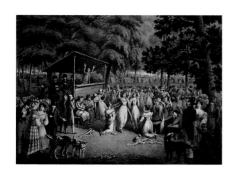

Camp Revival, Kennedy & Lucas, lithography, c.1829

Seventh-day Adventist prophetic time chart from 1863, about the prophecies of Daniel and Revelation. Originally published by the Seventh-day Adventist publishing association. Scanned from P. Gerard Damsteegt, *Foundations of the Seventh-day Adventist Message and Mission*, Grand Rapids, Michigan: Eerdmans (1977), p.311

his artist and critic friends, play instruments in the shape of body parts, in ritual remembrance of when O'Wooten lost control of her cult to men. In *The Whole: A Study in Oist Integrated Movement* (2009), young women in Isadora Duncan-style shifts swirl in exercises of communal ritual. This Oist phase is influenced by Gurdjieff, the nineteenth-century guru, who created dances to strengthen the inner watcher by bringing body, mind and heart into common vibration.

Art holds a special status in Oist mythology. In his imagination, Shaw has birthed a number of artists who receive credit for the art that their creator has created. Many of them are doubting and conflicted. Take Adam O. Goodman, whose round abstract paintings try to balance the prevailing art style of his time, abstract expressionism, with his Oist beliefs. Goodman, under the name Archie Gun, is also the illustrator responsible for the Oist movie posters. These 'posters' depict actors who star in films about different aspects of Oist history. *Kill Your Darlings #2* (2002) features O and her nemesis I, as well as Djed Okampu, first priestess of Oism, in full headdress. The heads, with their heavy eye make-up and orange skin tones, evoke classic Hollywood films such as *The Ten Commandments* (1956).

The most contemporary of the Oist artists, Mandy Omaha, is the creator of *The Donner Party* (2003), an installation inspired by the human-flesh-eating Donner Party of the 1840s, Judy Chicago's watershed feminist installation work *The Dinner Party* (1974–9), and America's rich history of alternative faiths. The work features twelve arrow-ridden covered wagons that serve as tables surrounded by painted banners. Rather than evoking historical women as in Chicago's work, Omaha (aka Shaw) commissioned a slew of younger artists to make small installations. Each small table-setting installation contains an appliance and makes reference to the USA's historical proximity to a wide variety of imaginative and in some cases psychotic religious 'meals'. The backdrop shows mythic members of Oism, as well as minor religious figures such as Ruth Noman, prophet of Space Brothers Arrival, Anton Levy, founder of the Church of Satan, and more familiar visionaries such as, L. Ron Hubbard, founder of Scientology, and Wallace Fard, founder of the Nation of Islam.

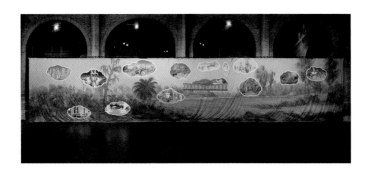

The Woman in the Wilderness, 2005, acrylic on muslin, 457.2 × 2400 cm
Private Collection, courtesy Metro Pictures, New York

The Donner Party, 2003, mixed media installation, dimensions variable.
Installation view, Le Magasin, Grenoble, Fance, 2003

Shaw first heard about the Donner Party from the film *The Shining* (1980). Later, when he was teaching in Las Vegas, a graduate student's installation which harkened unthinkingly to the work of Ericson and Ziegler made him think about the ways art is continually cannibalising itself. In 1846, eighty people left Independence, Illinois for a new and better life in California. Poor navigation, internal squabbles and bad luck found them trapped in the Sierra Nevada Mountains, in snow that sometimes drifted up to thirty feet deep. During the first few months they ate what little livestock they had, then the animal hides they had previously used as blankets. Eventually, desperate for survival, they ate their own dead, crudely butchering the bodies of relatives sunk into snow. *The Donner Party* serves as an extreme example of how the frontier American utopian impulse can turn dark, even hellish. This pattern of a desired heaven trending down towards hell reverberates through American life, from our foreign policy interests to our nation's high divorce rate. Omaha, a sort of art world Riot Grrl, wants viewers to acknowledge the dark side of spirituality in general and to make a place at the table not just for conventional religious figures, but also for mystics, spiritualists, wizards, cranks, quakes and imposters, for America's religious lunatic fringe.

★ ★ ★

Today, Shaw considers himself an agnostic-animist. He has studied the effects of ceremonies where the drug DMT is used to conjure visionary states. His interest in mind-altered states, he says, comes from the need to experience the divine in some way 'in order to make effective art about it'. Shaw speculates that the visions experienced are similar to the idea of the Holy Spirit. 'Ego death is a very important part of it, which I suppose has corollaries in being Born Again and losing one self to God.' This theme of the lost and fragmented self is evoked most plainly in Shaw's ripped up self portrait *Untitled* (2006). A drawing of the artist hangs in shreds before a smoky abyss. The work, while not directly connected to Oism, functions as subtext. In breaking down the self, the habitual, nature's rigid laws, he breaks his own meta-narratives, destroying what he knows for unknowing. It is only in this fragmentation that we can attempt to connect to the divine, or 'the More' as William James has called it. Conduits to 'the More' are not success, power or happiness but failure, self-loathing, brokenness, all long-term thematic underpinnings of Shaw's work. All along his art has been fuelled by the combination of self-hatred and intense vision that are the very cornerstones of conversion.

All religions, including Oism, are attempts to prop up a form of realism that has been undermined. In our own time this colossal act of the imagination is nearly impossible, in part because God has been replaced by nothingness, an abyss, an O. What's most moving about Oism is Shaw's restlessness, his struggle to find ways, through art, to exist in relation to this holy void.

Notes

1 Whitney R. Cross, The Burned-Over District (New York: Cornell University Press), p.88

2 All quotations from Shaw are from interviews with the artist in August 2012

3 Jane Barnes, Falling in Love with Joseph Smith: My Search for the Real Prophet (New York: Tarcher, 2012), p.93

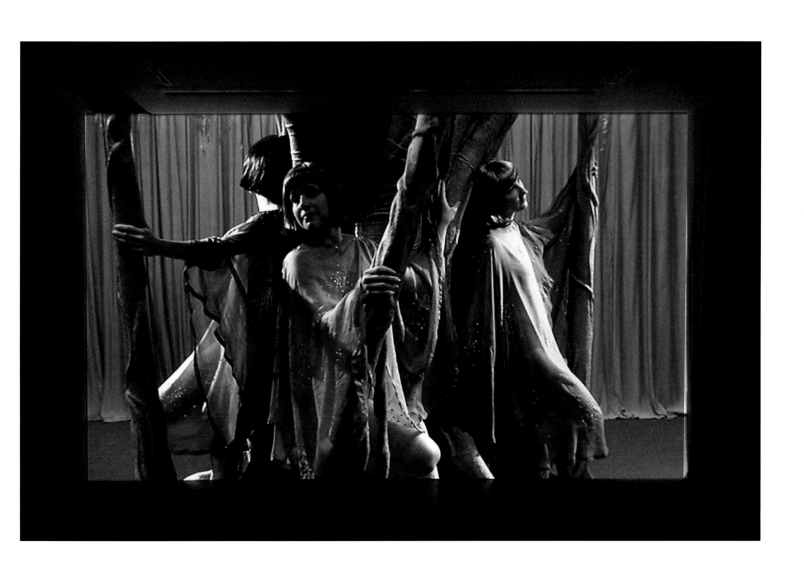

The Whole: A Study in Oist Integrated Movement, 2009, high-definition video with sound, 16 minutes 40 seconds

facing page: *Oist Integrative Movement,* 2009, instructional video with sound, 17 minutes 2 seconds

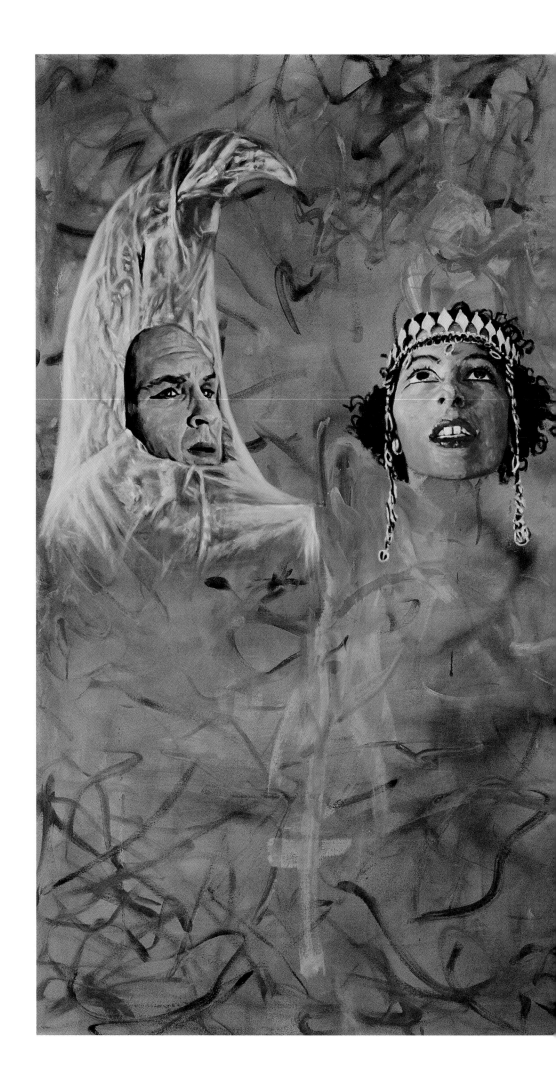

118 *Kill your Darlings #2*, 2002
 oil on canvas, 182.9 × 243.8 cm

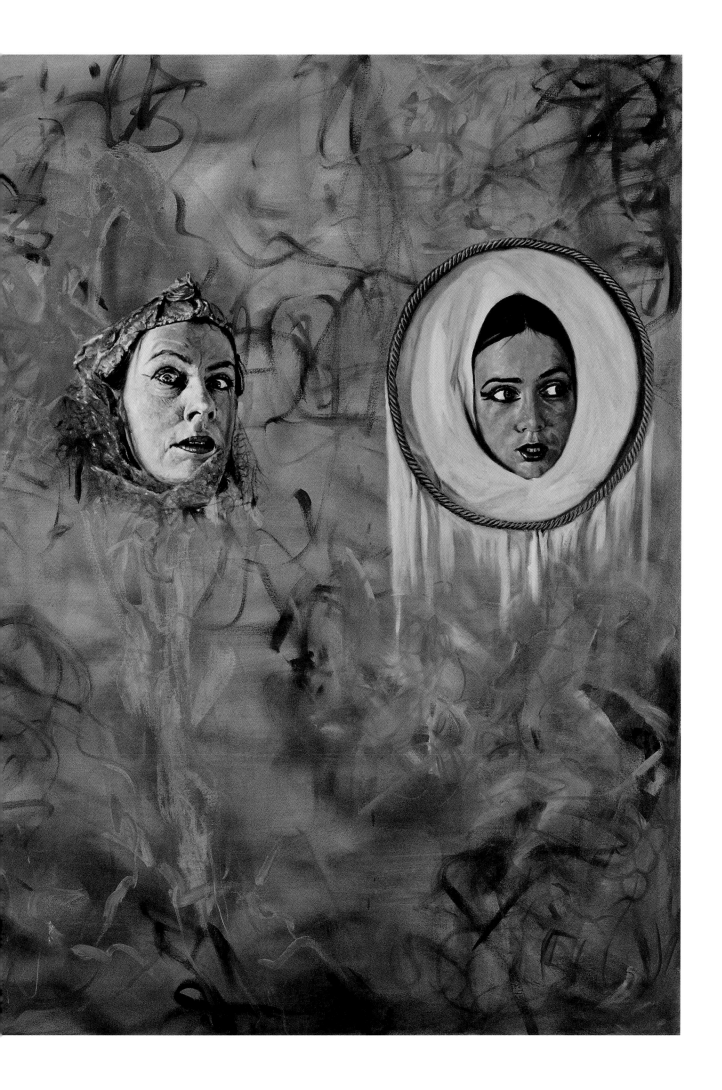

120 *The Land of the Octopus #2*, 2003
oil on canvas, 182.9 × 243.8 cm

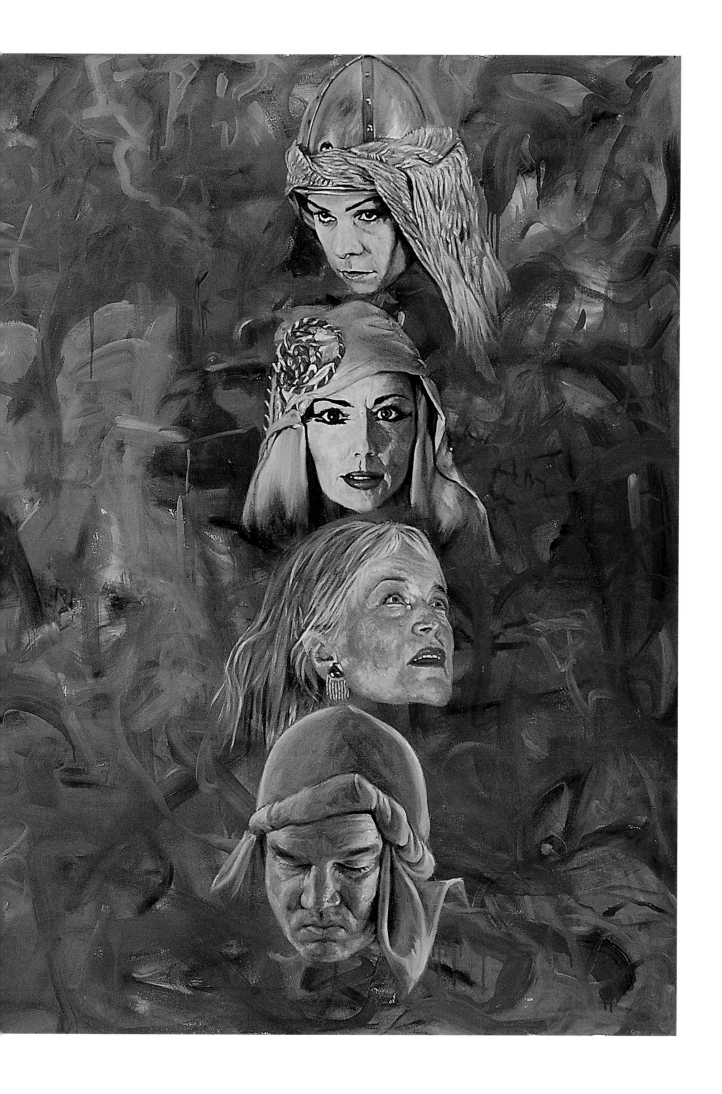

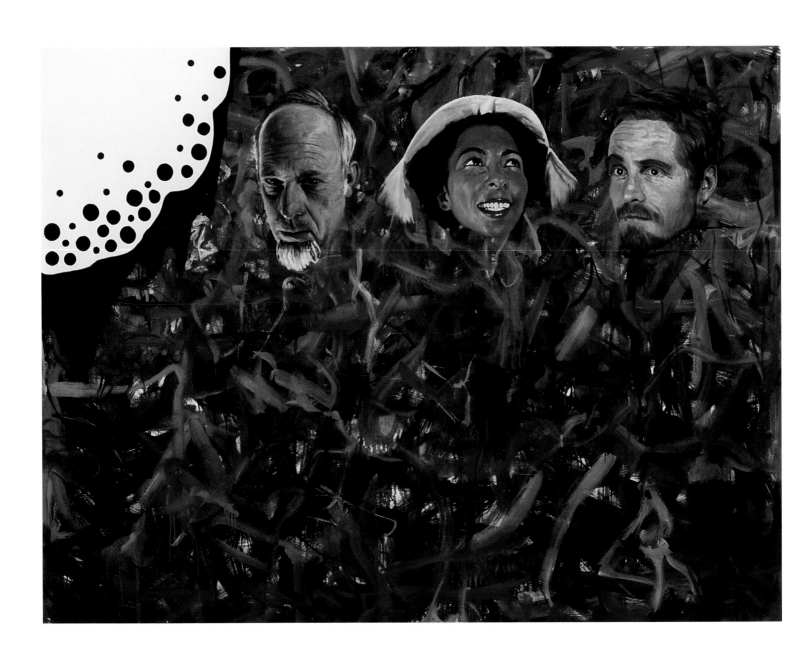

Dream Object ("I dreamt of this Oist movie poster painting with overlays in the corner..."), 2004
acrylic, ink, oil crayon on canvas with silicone and cloth element, 152.5 × 203 cm

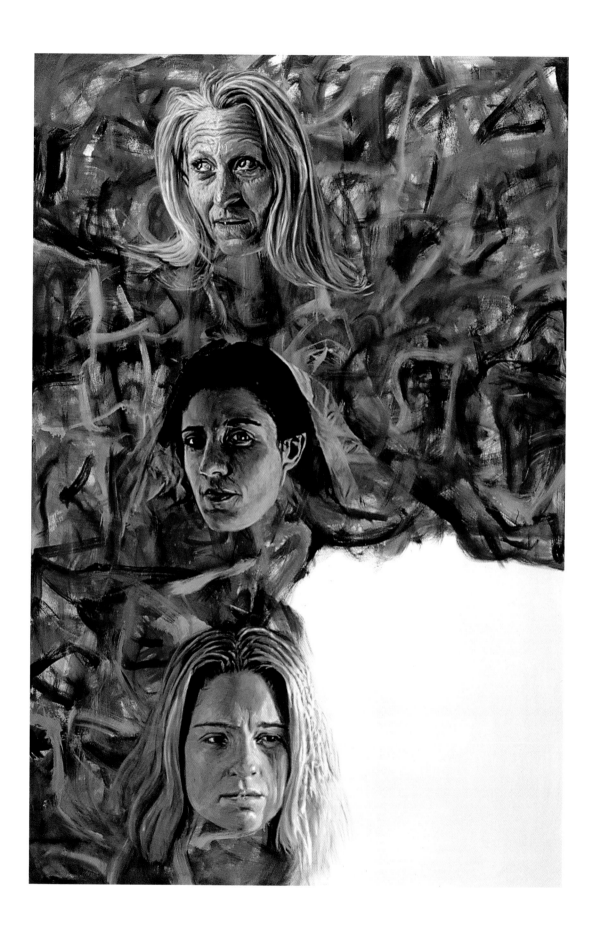

The Woman with No Name, 2004, acrylic on canvas, 182.9 × 121.9 cm

124 *Untitled (Trunk horizontal)*, 2009, airbrush and pencil on paper, 86 × 203 cm

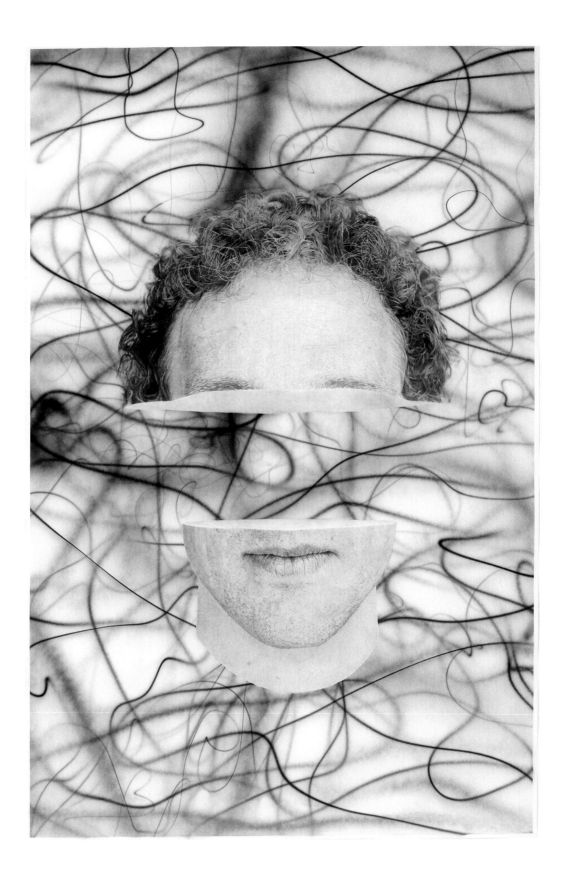

Dream Object ("On a Sunday Morning in W. HWD..."), 2008
airbrush and pencil on paper, 203.2 × 134.6cm

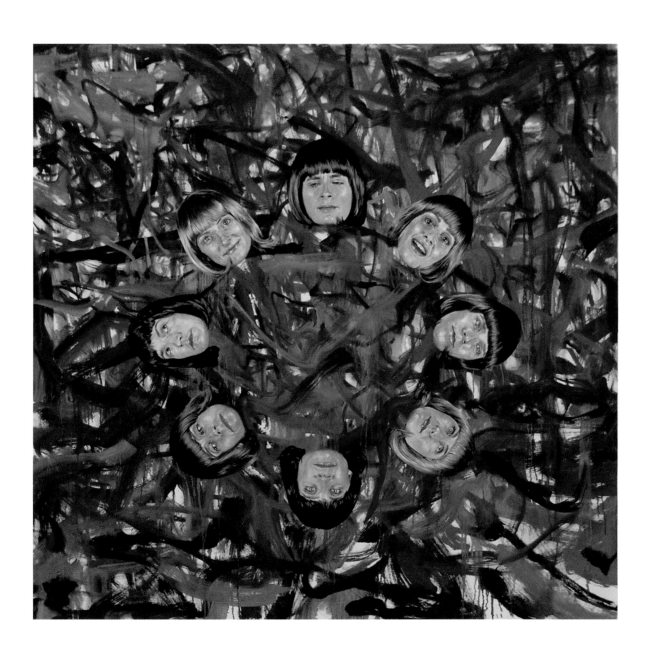

Untitled (Faces in circle), 2009, oil on canvas, 152.4 × 152.4 cm

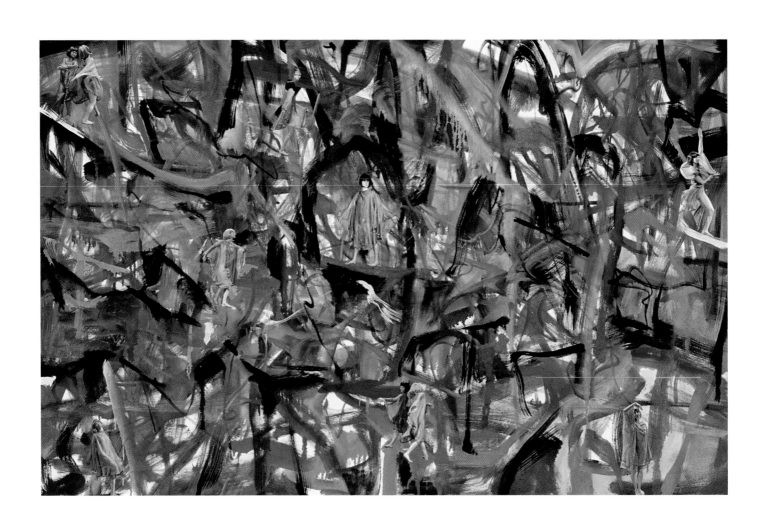

128 *Whole Dancers*, 2010, oil on canvas, 116.8 × 182.9 cm

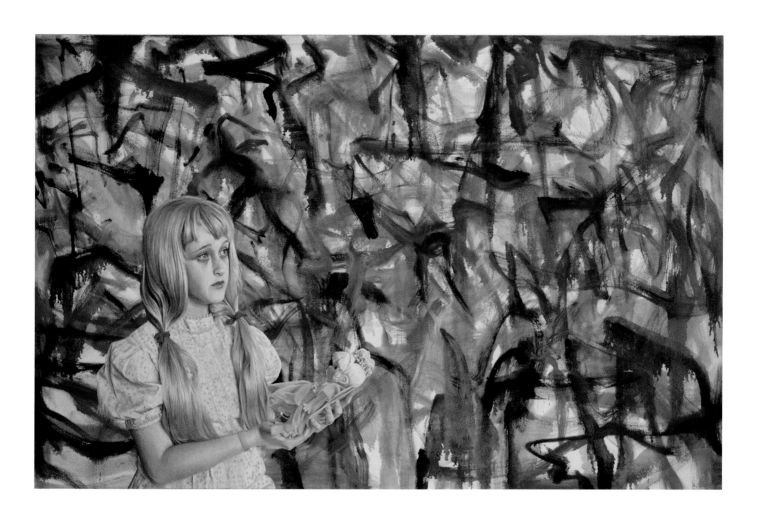

Oist Children Portrait (Girl & Doll), 2011, oil on canvas, 111.8 × 177.8 cm

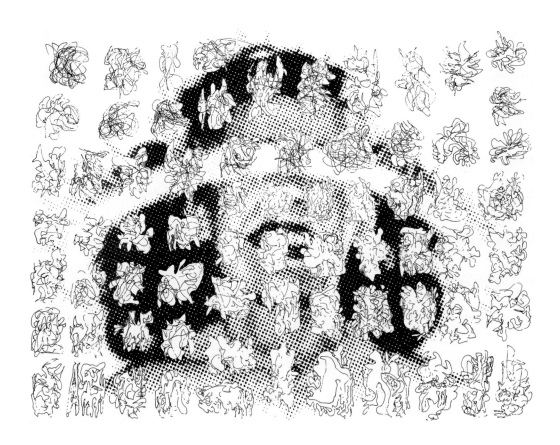

Dream Objects (O-ism drawings), 2001, graphite and ink on paper, 57 × 76 cm

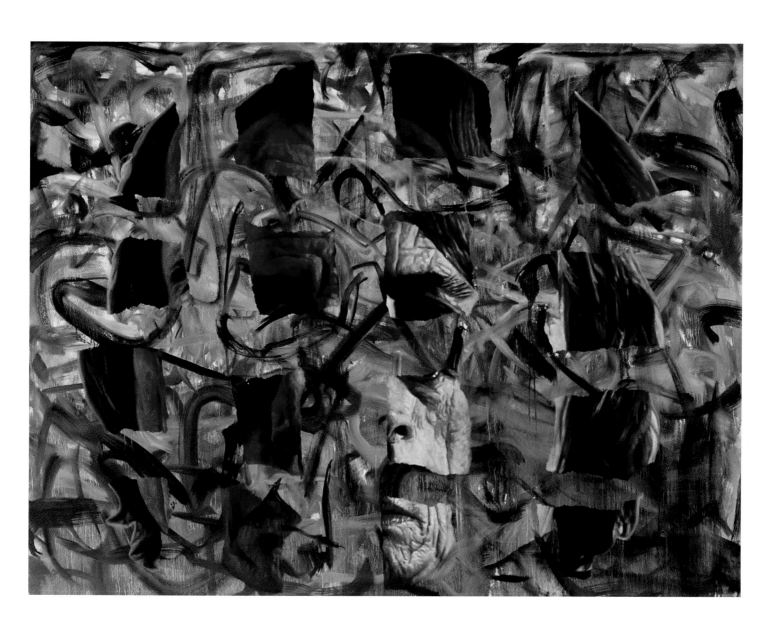

Untitled (Robbie), 2004, acrylic on canvas, 152 × 203 cm

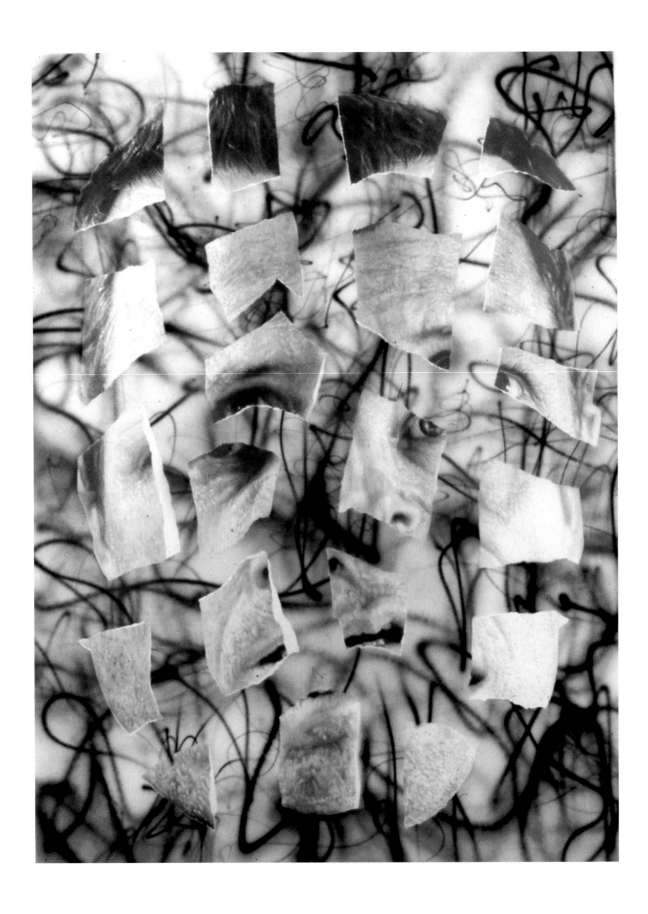

132 *Untitled*, 2006, airbrush and graphite on paper, 203.2 × 137.2 cm

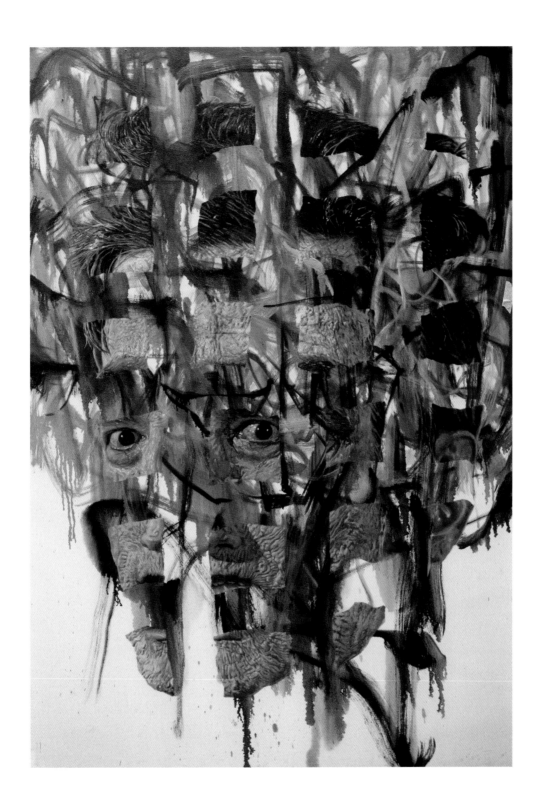

Untitled, 2008, acrylic on canvas, 178 × 117 cm

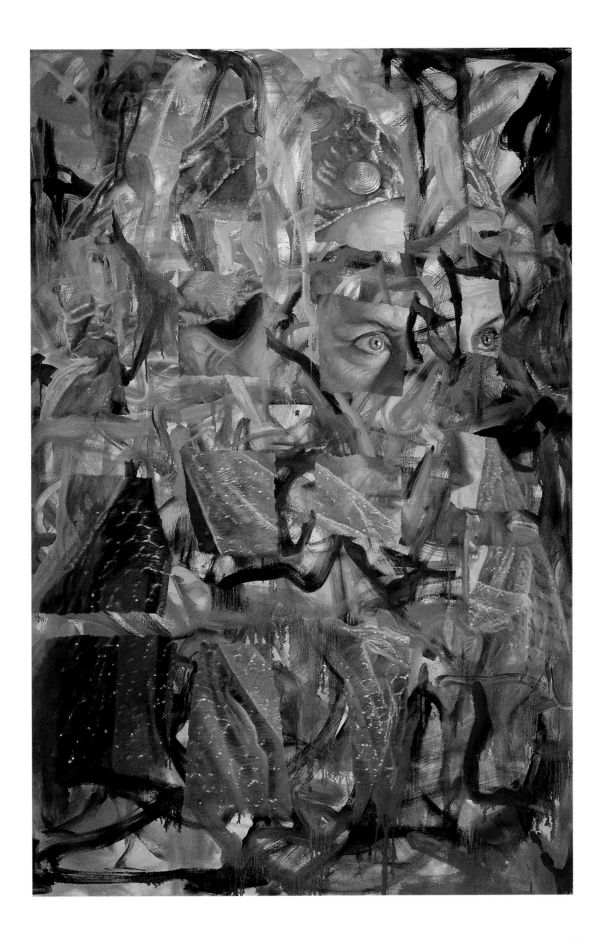

Untitled (Lorrie), 2004, oil on canvas, 183 × 121 cm

Anne Carson and Robert Currie

THE ARTIST SEARCHES etc. *Water Log*

[1] The way a songbird alters its song to include car alarms and greedy children it remains a song of stone, silent earth

[2] The bottom a shifting pearl bed The body a small fawn drifting by sun leaps dapple to dapple Overhead crows anticipate the invention of the water tool

[3] Fire bursts the floorboards shimmed by heat racing a dusty vessel

[4] At eighteen thick in party favours, hats, napkin rings Who was there? The picnic table sunbleached a rascal, a pet

[5] You're drawn in by the deals – price rounded down and all those guns and poisons piled on roll on roll of canvas resistant against the back wall

THE ARTIST SEARCHES THE UNDERWORLD ~~THRIFT STORE~~

R I V E R B Y ~~T H R I F T S T O R E~~ R I V E R F O R A S L E E P C U R E

There is no such thing as a sleep cure
What would that mean
a cure for sleep?
Or sleep
as a cure for everything else?
Either way what's left of your life
I used to hear this murmuring mysterious emanation
light like an ocean breeze magical like moonlight which was her sleep

The artist dreams he has to join the army
It is no dream
He calls a shrink to get a deferment
During the appointment the shrink has a call from a patient
whom he gruffly advises to try her husband
and not
bother him when he's with patients five minutes later
his receptionist comes in
Says it's Mrs W again she's
just slit her wrists
W for wits' end
Don't bother hanging up
Some of his art is about listening he'll make

a sculpture of a big ear for example
A big blue ear
(Yves Klein blue)
Can you hear better with a big blue ear
Can you hear men swimming to the other side of sleep
Can you hear your own narcissism pattering around
in its little pearl slippers
but I never for an instant had any suspicion so naturally did she –
every entrance is an exit

The artist writes a letter to his sleep
And in the letter says [weird oversized] things
And he puts it through the sleep flap
as though by falling asleep she had become a plant
How many thrift stores
are there
in Hades
Excuse me please

There's [1] the Thrift Store of Grief *(Acheron)*
[2] the Thrift Store of Lamentation
(Kokytos)
[3] the
Thrift Store of Something Burning
(Phlegethon)
then [4] everyone's favourite
(Lethe)
the Thrift Store of Forgetting
and finally
[5] Hatred
(Styx)

Can you hear those waters
thundering in the backyard like ancient Greeks?
When the Greeks say
'sleep cure'they mean
something more like
'sleep intelligence'
It's not sleep itself that cures but
Liz Taylor arriving
Her manlicker heels
loud on the cement floor
Liz to artist:
put on the holosync headphones sweetie
it's time to descend

All the rivers of the underworld
lead to that Final Thrift Store
where maimed appliances and cakes in pain
can be bought
for the price of a frontal cortex
or a lick of regret
(Yves Klein blue)
The artist has every faith his cure is there
on the rack with the thousand darknesses of idiot thinking
Call the sleep cab!
Button your contrafactual!
Here we go

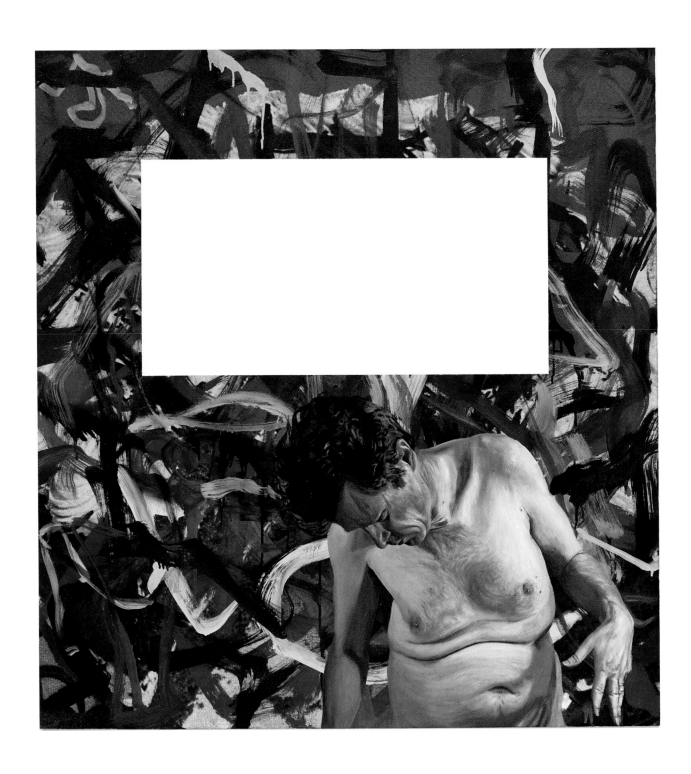

138 *Cake (Jim Bent)*, 2011, oil on digital ink jet print, acrylic and ink panel
painting: 100.3 × 95.3 cm, panel: 31.8 × 62 cm

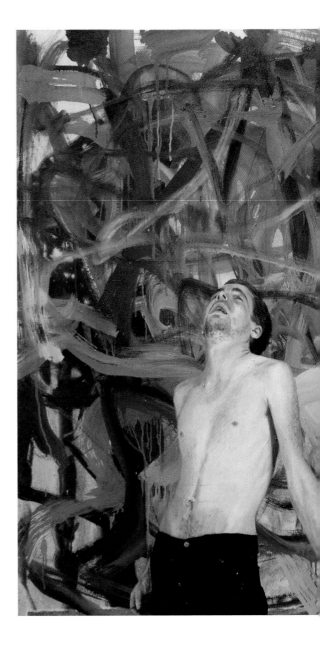

Cake (Double Brian), 2011, oil on digital ink jet print, acrylic and ink on panel
painting: 94.9 × 170 cm, panel: 38 × 55.4 cm

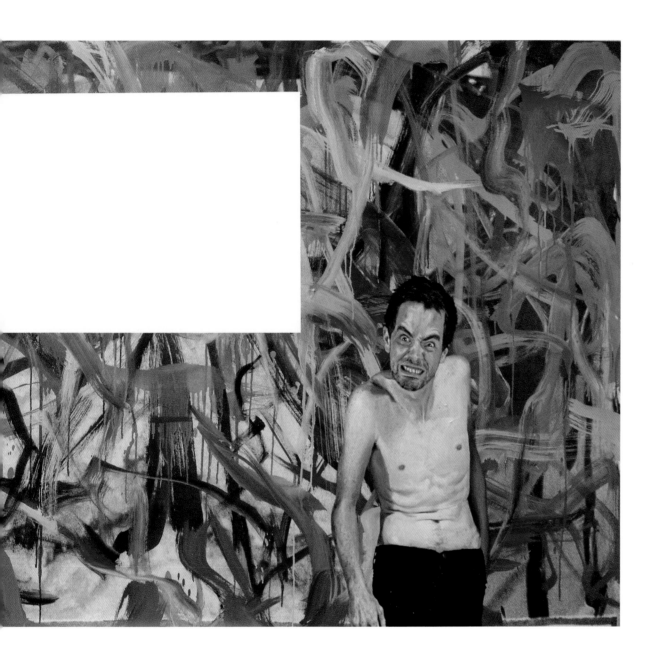

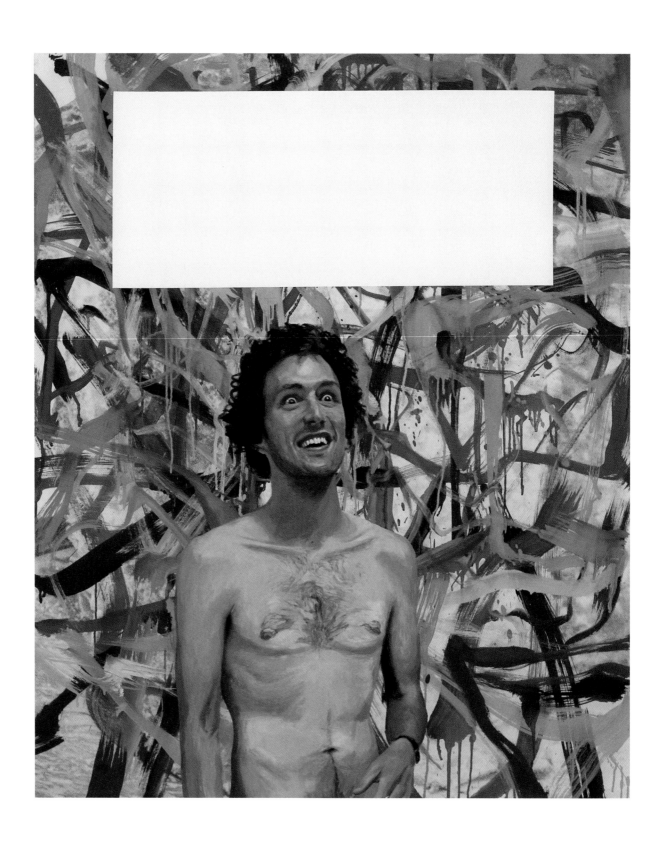

Cake (Daniel), 2010, oil on digital ink jet print and acrylic and ink on panel
painting: 116 × 95 cm, panel: 70 × 29.5 cm

Jim Shaw in conversation with Tony Oursler

TO: Let's talk about your interest in prog rock and the form of the rock opera, something I know you're involved in making. You're one of the few people that I can imagine working in that form. How did you come up with that as a mode of production, for lack of a better term?

JS: Well, I'm not really sure that I exactly believe in it. I've long been interested in the states of creativity and how creativity dies out, partly because I don't want it to die out in me. As I've looked at the art produced before me I've tried to figure out how I can avoid the pitfalls of these artists that I admire, how I can avoid becoming a signature artist and get stuck doing giant things. The sort of things that rock musicians would produce, like *Sgt. Pepper* [The Beatles, 1967], or *The Lamb Lies Down on Broadway* [Genesis, 1974]. Yes managed to coalesce these complex forms a few times, and then they kind of gave up and just went back to normal song structures for the most part. Then later on they would try to do it again and it would never quite work out.

TO: The Yes album you're talking about is *Topographic Oceans*?

JS: Well, that's the one where they theoretically failed, but they 'succeeded' more on *Close to the Edge* and *Awaken*, where they'd put together a 17minute piece of music that has all these different elements and it all fits together.

TO: I saw the epic *Ring* [Richard Wagner] recently at the Met, and it was a transcendent experience for me, something one could dream into for hours. Yet the music was incredibly ambient through a lot of it, there seemed to be a lot of filler used to float the narrative, so maybe failure is part of these undertakings.

I was perplexed that some very good parts actually weren't even drawn out. The part of the Valkyries that everyone knows, with the dissonant singers where the woman are screeching 'ooooaah, ooooaah!' – it's about four minutes long out of, I don't know, a four-hour opera. It's incredible, and it's not repeated as far as I know. It's very interesting how that particular section of music is pulled out and appears in *Apocalypse Now*. Even Elmer Fudd sings a version, 'Kill the wabbit, kill the wabbit', in a Bugs Bunny cartoon. You are playing with the idea of serious music and popular forms: what are your thoughts about that? Because opera was at one time a popular form.

JS: Well, I'm not really trying to renew it. In a way, it was an absurd thing, to choose something that I really wasn't skilled at and try to pursue that, because I'm not a composer, I don't know how to play an instrument. I can come up with simple melodies, and occasionally, in my head, I can hear complex things, harmonic stuff, but I can't figure out what the chords are. So part of it was giving myself something I couldn't do.

TO: Yeah, well I would say that you play music in a different way and that you are a musician and composer. But not knowing the correct method of making something seems to have worked for you, it's a good strategy.

JS: Yeah, that strategy. Because I know how to draw and paint and do that kind of stuff. You know, it may end up never getting done; it's mostly at this point I think, 'I can do something with my cohorts, I could create something. And using computers we can put something together that sounds really slick. I can make up sort of melodic stuff.' I think the big downfall of opera

is when they're telling the story – that's where the boring part comes about. I heard a part of this opera by Howard Shore based on David Cronenberg's *The Fly* and it was all this expository stuff. The stuff I heard – people singing on and on in a sing-song-y voice, the declamatory stuff, hearing it in English only makes it worse.

TO: Ha ha. Yeah, definitely. It's almost like to crack it you'd have to approach it in a completely different way, which I guess a lot of people have tried to do. But I agree with you, with the whole idea of storytelling via the singing human voice, melodically on stage from far away is problematic. But people are trying. Damon Albarn and Rufus Norris' opera last year was a kind of take on John Dee, the sorcerer or British soothsayer sorcerer from the 1700s. So, do you have a story that you're working on?

JS: I have the basic outline and I have some of the music. I have ideas for some of the musical elements. I don't have a libretto. I'm wondering if I can come up with some way to use a computer to create a language, so it can all be sung in this other language. That way I don't have to worry about the embarrassment of understanding what's being said, directly.

TO: Ha ha.

JS: I could fall back on it being like *The Plan* by the Osmond Brothers, which is a concept album about Mormon theology. It's clunky. By all rights it should be clunky, there are clunky elements.

TO: But do you want to talk a little bit about your story?

JS: I started with the first two acts as comic books. It begins with the birth of the Oist mythology and pre-history, the birth of agriculture, and writing. It's the whole past, present, and future. The first two halves take place in the Oist fictional pre-history, and from the not yet written *Book of Oism*. In a way I'm doing the opera and the comics in order to avoid that tome. I think it's like that book about the history of New York, *An Oral History of Our Time*, that a character Joe Gould was carrying around for twenty years or so. Gould was a fixture in the New York bohemian scene. It turned out that it was just gibberish, that he hadn't written it. But he talked a good talk.

TO: The contrast of gibberish and profundity is often at the core of the belief problem.

JS: There are four album sides and four eras, and each one ends with a different sort of calamity. The first one ends with an apocalypse of earth as these miners are crushed by their own rebellion against the cruel overlord priestesses who are making them mine their power source of crystals, which then get put to use as a weapon of war against the invading Atlantans. The increase in ego from the evil influence of 'I' adds so much gravity to their civilisation that it sinks under the waves, a deluge of water. Then in the second album, the first side begins with the discovery of the *Book of Oism* and its growth into a religion in the 1800s, and comes to a head when the female creator of the book is removed from power during a debacle over the use of this crackpot inventor's inventions, one of which accidentally ignites the great Chicago fire. And then in the end, the final side takes place say, in the late 80s, which would have been the future at the point when this fictional prog rock opera would have been performed in the 70s. It takes place at a university where an experiment goes awry at the end and the whole university and the surroundings of earth are atomised by an updated version

of the crackpot's inventions. In keeping with the Wagnerian theme, the main protagonists are a professor and his student girlfriend who, unbeknownst to each other, are father and daughter from a tryst that takes place 22 years earlier during the heady days of the 1968 Chicago convention, which inspires some radical Oist students to revert to 1840s' Oist mating and other practices in which fathers' identities are obscured by a blanket or wall with a hole in it…

TO: Ohhh, so it's an epic story over hundreds or thousands of years?

JS: It starts in 3000 BC, so it's 5000 years.

TO: So it's longer than Christianity and around the same length as Judaism?

JS: Something like that.

TO: You've been working on this for how many years?

JS: I started working out the ideas back in the mid-90s while I was working on the dream stuff. I started actually making artwork around 1999 for the Oism series.

TO: Ah, the beginning of the new millennium. I wanted to ask you what your relationship is to the meaning of the narrative of Oism. Because it seems to me like a sort of critique of magical thinking and religious belief; like this kind of stepping off that I've often thought was related to art-making itself, and that is implicit in religious activities: a sort of faith in something that's not really provable, such that by submitting yourself to it you're able to transcend the mundane, the everyday, and then it filters back into daily life by giving you a different perspective, whether that be through rose-coloured glasses or a darker perspective, as

with the millennialists. So it's really a two-part question: what are your thoughts on the relationship between art and religion and what are your thoughts on the meaning of the religion that you started? Are there hidden messages that you want to impart to people?

JS: I hope so. I don't think I can remember what they all are. Part of my research is into religions where they ingest DMT [the psychedelic drug Dimethyltryptamine], so there you're really getting into some magical thinking and some direct magic. I do think there is a relationship with artwork and magical thinking and I think it's everywhere. Without magical thinking, the stock market could not exist. Real estate bubbles could not happen; a house is not worth a gazillion dollars. Have you heard of *Word Jazz* 60s beatnik comedy records?

TO: I don't think so.

JS: They're by Ken Nordine who was the voice of Levi's psychedelic commercials in the 70s. There are two bits that are pretty great. One of them is called *Flippity Jib* and it's a story about a small town where this stranger showed up and gathered all the people together in the small auditorium. He would start doing this chanting, going 'flippity-jib-bob, flippity-bop, flippity-jib-bob, flippity-bob', and everyone would chant with him, and he would be saying 'yesss, yesss, yesss'. And everyone would get excited. But eventually a few people started criticising it and everyone stopped believing and the guy had to leave town. He was found out in a sense.

TO: I can see why you are drawn to this allegory.

JS: The other one was about how his father was a preacher – I don't know if this is true or not –

and he was challenged to a public debate by an atheist and he failed to counter the atheist's arguments and then the son ends up being this guy who sells dog food. Which is basically what Nordine did for a living because he was a commercial announcer. I thought those two things were interesting; beatnik summations of the way people can buy into things and then the audience loses interest, and they lose their belief in things. They skulk away from it. It can happen to art, it can happen to cults, it can happen to politicians.

TO: So you are saying that magical thinking moves beyond religious thought and is the rule, not the exception, in America. I read something about Europe being basically a secular continent and America is religious through and through. Any thoughts on that?

JS: Well, one of the reasons is that in many parts of Europe there are official religions that get tax money, and people are very unreligious in those countries. We were like Afghanistan a hundred years ago, we were an almost completely rural society where people lived with dirt floors in the middle of nowhere and were a bunch of farmers. People believed in religion and had a more direct relationship with death. There are still a ton of people who believe that the earth is 5000 years old, and that Adam and Eve were real. It's not unusual for Americans to say that they believe in heaven and God. It's very hard to erase. It's like we're trying to erase it in Afghanistan, and that's not going to work. We haven't been able to erase it here. It just keeps roaring back.

TO: What do you see happening with your religion? Would you like people to practise it, or is it designed to act as a critique of the magical thinking process, or imparting morality?

JS: Well, I was thinking of it as just a storyline in a way, the arc of religion as it goes from one thing, becomes successful, and inevitably fails through success as opposed to what it started out as. But I was also working within the American tradition of the self-made-up religion.

TO: Yeah, it's a beautiful form.

JS: Mormonism being the shining example, or Scientology a more recent one that hasn't neutered itself yet.

TO: I recently read a Scientology book that was pretty interesting. I guess at their best, these new religions are about people creating their own destiny and sort of figuring out ways to organise their lives, to fight the chaos that they feel they're stuck in. Mormonism obviously and strangely was begun by a schizophrenic, I think, or a manic depressive, I'm not sure which.

JS: I think that the schizophrenic and the religious mystic, and the ayahuasca-taker, are all experiencing variations on the same thing. The schizophrenic is lost in it; the person taking DMT can usually step back from it, although people can get lost in the belief that everything that they've experienced is indeed real. Because it certainly seems real when it's happening to you. I'm sure that's what Joseph Smith [founder of the Latter Day Saint movement] was going through.

TO: So your thinking process goes something like this: the reaction to the chaos of contemporary life, the schizoid state, is the formation of religious or magical narrative. So you could take the drug to understand the process. A classic epiphany. One of the things I love about Joseph Smith was that he used these gems to look in the ground somehow…

JS: Yeah, peep stones.

TO: And when he looked in the ground, he found treasures. He had been convicted of doing that and I don't know if he went to jail or what, but he was definitely convicted in a court in upstate New York, for this kind of treasure hunting.

JS: One of the terms that I came across in my 'mining the dictionary' project was 'Bezoar stones', which are gall stones that you pass, but they were used like peep stones as a treasure-hunting or fortune-telling device.

TO: One of the funny things about our man Smith was that when he finally met the angel Moroni and got the golden tablets shown to him he was no longer with the guys he was originally convicted with. And one of the reasons he moved away from upstate New York was because those guys heard him talking about these golden plates, and they wanted their percentage of the gold… [laughs] Isn't that great? So they're hunting him down to get the gold [laughs].

JS: Maybe they stole them and melted them down?

TO: Yeah, that could be what happened to him. But you've said that your dream states led you to DMT?

JS: I was reading about ayahuasca [a psychoactive infusion of DMT] and thinking, 'If there's any way to have a religious experience, this is it.' And it is, basically. I mean it's so similar to fundamentalist Christian states of mind that I've read about. One experience that's very common is known as 'Alice in Wonderland syndrome' – the feeling that your body is changing shape, like getting bigger and stretching out. It's something that schizophrenics often refer to. And there's a feeling of general well-being, and

a glowing feeling afterwards… there's a tingling that goes through one's body. These are things that occur in Christian ecstatics, and I can understand why people want to do this, it's an addictive thing. Not everyone's going to experience Alice in Wonderland syndrome though. Every ayahuasca trip is a little bit different but there are certain things (I've talked to my friends who've done it) that occur often. Tessellation is another one, where everything has a patterning all over it, and it's usually iridescent. I've discovered that if I've had a really good dream I'll physically feel the same sort of sensation that one does on DMT. It's the same thing; it's just not in such abundance. To me it has a lot to do with the creative states, which are probably also related to manic depression. In these manic states you can come up with lots of ideas and they all seem to make sense even if they really don't.

TO: A real mystery also allows people to read endlessly into the work, so to speak. One of the things I've really enjoyed about art made by mentally ill people is that there's a different sort of logic built into it. We are looking for new ways of reading information as artists we also want new ways of seeing the world. I know both of us really appreciate that there's a way of reading symbols which is almost like conceptual art in a way, a kind of juxtaposition of information that can't be 100% decoded, but spurs the viewer on. You know, my feeling is that a good art work will have something inexplicable in it, which is carried on by the viewer, which makes it a stronger art work.

JS: Sometimes it has to be explicable at some level to the artist, though, because otherwise they won't have a reason to make it, you know? That's part of the structure. And sometimes if you explain the structure, or all your reasons why something was done, it's not as interesting.

I would like to talk a little bit about madness in society… or the madness *of* society, and how normality is its own madness, you know? It's a madness that works up to a point, until the society crumbles, and we seem to be going into a state like that. And we're part of the art world, and the art world has a system that works if you're one of the winners, but you know… who knows what's going to happen when it all falls apart. You might have this great moment when you're in your twenties where you were doing wonderful crazy stuff, and then after that, people stop paying for it… but somehow you've got to keep going; you've got to pay the bills. I've just turned 60, and there's no retirement plan for an artist; what are you going to do?

TO: Well, you're making plenty of work, and it seems to be getting much richer and more complicated. One lovely thing about being an older artist is that you can really keep working, unlike a lot of other facets of society where they want you to stop at 65. You know, a lot of artists can do their best work later. I mean, I think John Baldessari is a good example of a guy who's been able to make incredible work as he's got older, and really remain vital.

JS: I'll try. I'm trying to force myself to be more of a writer, but I think I'm more of a visual person; I'm not a word person.

TO: But you're also a very ambitious artist. A lot of artists are just happy to do a similar thing over and over again with minor changes. So I guess part of it is learning to reign in certain things and focus on others.

JS: Sometimes when you have a deadline you can let go of something, but usually I go 'Oh, that's not quite right, I've got to keep working on it…', and that's part of my personality, all that anal-retentive self-hating workaholic aspect… I don't want to die from this stuff.

TO: So, you've talked about a sort of puncture in reality, and then mediating your own reality with the stuff of dreams and then maybe provoking a full breach in consciousness with ayahuasca. Where is it leading you? What's your relationship to art and personal fulfilment, now that you're just turning 60?

JS: I'm happier than I was. The hardest thing is that you've got to make sure the artwork doesn't just look like stoner art, but it's inspired by these crazy experiences. Meanwhile, I was going through some personal problems where there were no good outcomes, a lose/lose situation, which is what some shrinks think brings on schizophrenic episodes, and nervous breakdowns… One day, it just clobbered me and I was feeling really crazy for a while.

TO: So you did have a kind of breakdown?

JS: I mean, it lasted the afternoon, but it was an interesting thing to feel.

TO: The outer edges.

JS: Yeah.

TO: It seems like you want to feel the outer edges.

JS: As long as you come back, it's good. It's when you have to stay there that it's bad. In any case, someone like the artist should be a shaman, you know; we're supposed to sort of burn ourselves out for society.

TO: I'm a believer in artifice. Because you know, I've had a lot of personal drug issues over the years and have completely abstained for years. I've seen the damage done, lost people, known a lot of mentally ill people, and I try to shy away. I try, not to lead a monastic life

exactly, but to have as much reality as I can. I try poetry and other mental activity and let the art become the operating substance. And to do that I need as stable a life as possible. Also, being a dad, you know…

JS: I try. I try to have a stable life, that's for sure.

TO: Yeah. And you come back, because you're a responsible dad yourself. But you have to take these journeys. In the 60s, though, you were really too young to be part of the acid culture…

JS: I had friends in high school who dropped acid all the time.

TO: But you weren't into it?

JS: I was just too afraid to.

TO: I've never taken it.

JS: I'm too paranoid.

TO: I've never taken it, you know, Salvador Dalí said, 'I don't need LSD. I am LSD.' And I kind of felt like, yeah, I agree with that.

JS: The more I learn about Dalí, the weirder he is. I was just reading something about the history of publicity about anti-depressants, starting with Thorazine, and then Miltown, which was a tranquilliser, very popular in the 50s. And at one of the psychological conventions they hired Salvador Dalí to create an environment that would reflect the effect of taking Miltown. You would enter this tube, and he said it was like entering through the intestines of a caterpillar but you come out into the world of a butterfly… I would love to see some documentation of that.

TO: That's fantastic. What's the name of that book? Is it a pretty recent book about medication?

JS: I think it was quoted in *Lapham's Quarterly*. It's an issue on magical thinking. It's called 'Magic Shows'. Louis Lapham was the editor of *Harper's* and he started putting out this digest, like a *Reader's Digest* for would-be intellectuals of quotations about a certain subject from ancient times to the present.

TO: So there's one on magic?

JS: Well, it's not magic, it's magical thinking. The opening editorial is all about how magical thinking was so important in the recent collapse of the US economy. And the delusions of the [George W.] Bush administration, which is what the whole *Left Behind* project I did was specifically about.

TO: How far do you plan out your stuff, Jim? Do you envision big projects you want to do in the next ten years, or five years?

JS: God knows, but it always looks as though each project will get done in about six months and it takes six years. And there are projects you never do in the meantime.

TO: What do you think about appropriation today? I'm not talking about any specific artist, but for instance the fluidity of all these images that you can now find on the internet. And arcana, because we're both interested in some subjects that are hard to research, and you're a master at unearthing things. Do you have some thoughts on the way that that's changed over time and also how images continue historically?

JS: I've got a lot of thoughts. I've just answered a question for a magazine about what I collect, and I said that I'd got tired of collecting things. I was thinking about how it used to be that you had to own stuff to have the reference material, and now you can just look online. It's not the same quality as having it in a reference book but you don't actually have to own things, you can collect images without actually buying anything.

TO: I find myself collecting a lot more images offline then I did in the past. Even on eBay there are some stupid copyright things, so it can be hard to just grab images.

JS: I was trying to get these magazines of 50s and 60s beehive hairdos, and I kept getting outbid and sniped at the last second. But then I discovered that somebody had been putting the same stuff on YouTube, so you can just see it there and do a frame grab. So if you're not looking for perfect image quality for production, probably that same person who was sniping me just saved me a lot of energy and time. I mean, some of the stuff that's in that thing of Christian reference material, I'm the only one who bid on that stuff. It's so uncool…You know, if you're going to collect something, it should be something that no one else wants.

TO: Yeah, it's not even a good idea to mention it in print actually [laughs].

JS: Well, I knew when Ed and Danna Ruscha approached me about doing the thrift store book that would make a market for this stuff that previously just nobody cared about. On the other hand I felt that it really should be a book, so I went ahead and did it. But I knew it was going to screw the market up eventually…

TO: Yeah, that's a beautiful book. But did this kind of collecting, did you ever think of doing that like a giant resource library or any online thing?

JS: I wanted to do one of all the Christian records and put the covers and the music up, because only a few of them are available online. That stuff is about as obscure as you can get in the modern world. It's an independent release, an edition of 1,000 records that can then be sold at somebody's church performance.

TO: Reading your explanations to the banner paintings it seems almost like your brain is evolving into a sort of cut-up in a way, a sort of finely tuned cut-up machine!

JS: Oh, did it? That's just the way my thought processes work. Called ADHD, I think.

TO: Ha ha. Yeah, but it's very finely tuned!

JS: Alan Moore talks about how reading a comic book is different from the way you see a movie or the way you read a book because you're combining words and images and doing this sort of political cartooning where it's pretty much the same. Maybe that's what Deleuze and Guattari mean when they talk about rhizomes as a different organising principle. Maybe jumping around like that is the only way that you can sum up concepts that aren't linear. It's on a surface and you're seeing it all at once, or more than once.

TO: You've followed the thread of using painted installation in your work, through Jonathan Borofsky who synthesised a lot of approaches. I think he was really ahead of the curve in opening up traditional two-dimensional stuff to installation. And I can see that there's a lot of reference to him in one of the *Left Behind* pieces.

JS: The problem was that his students did such awful work, so it kind of tarred the image of Borofsky himself. But when he had a survey at MOCA years later, it was quite beautiful to see the works that had come out of those dreams that he was referencing. And so my piece was partly a pun on his piece *I Dreamed I Was Taller Than Picasso* (1991), which of course he was… His students were doing these political murals, the members of the Nightwatch wearing gas masks, and we were looking down our noses at this stuff because the 60s were gone and the 70s were wearing on, and it just seemed to be invested in something in the past. But here I was going back and starting to work again in the same realms. Also, I was influenced, in that piece, by the type of political cartoons that would crop up in the 1800s in national magazines and newspapers. A lot of it's based on historical painting, on religious reference points such as Belshazzar's *Feast*, the hand writing on the wall, that kind of stuff. As well as the actual political elements, I was trying to reference the way my own career had in some ways replaced Borofsky's career… you know, he got older, and I was coming along and drawing my dreams, and so people forgot that Borofsky existed, because that's the convenient way that the art world works – let a new person in and just ignore the one that came before. I mean, my dreams, my dream drawings and dream objects, were different from his, but the art world likes to indulge in this convenient forgetting, erasing people from history.

One thing that I'd like to go back to, but I don't think I can articulate it very well, is the madness of everyday life…

TO: I would love to hear more about that.

JS: Well, I guess it goes back to *Howl* [Allen Ginsberg, 1955], or probably it goes back to *An Enemy of the People* [Henrik Ibsen, 1882].

In an unsustainable world, eventually the status quo will kill us all. What it comes down to is that if you say 'Global warming is going to kill us all', somebody comes up with the opposite, and hires some scientists to back him up, since extraction of fossil fuels is his business, and then it becomes a matter of opinion. The art world is going to get killed by its practices. It's like during the housing bubble. All the real estate experts said it would go on forever, since it was in their best interests to believe that it would. Fannie Mae didn't partake in any of the weird loans until the very end, and they did it because everyone else was doing it. If you're part of a system that needs to generate money in a certain way, they all become like drug dealers in the end. Because the drug dealer knows that the product will kill the consumer eventually. Certain drugs, anyway…

TO: I'm interested in what propels us back and forth over the blurry border between accepted behaviour and the unacceptable.

JS: I just think that there is a great deal of insanity in the world, but a lot of it is societal, a lot of it's based on sociopathic corporate culture. Then you have the truly insane schizophrenics, some of whom just live in a bubble and may have been shamans in a different time and place. I guess I'm trying to become something like that. I'm trying to open up the channels to whatever… In this sense Blake would be a kind of strange ideal. And yet, now, there's an industry of people studying William Blake. He died in poverty but he was a great visionary, a kind of fiery prophet of doom. I'm not a genius like him or like Rudolf Steiner, but at least I can at some level try to emulate them.

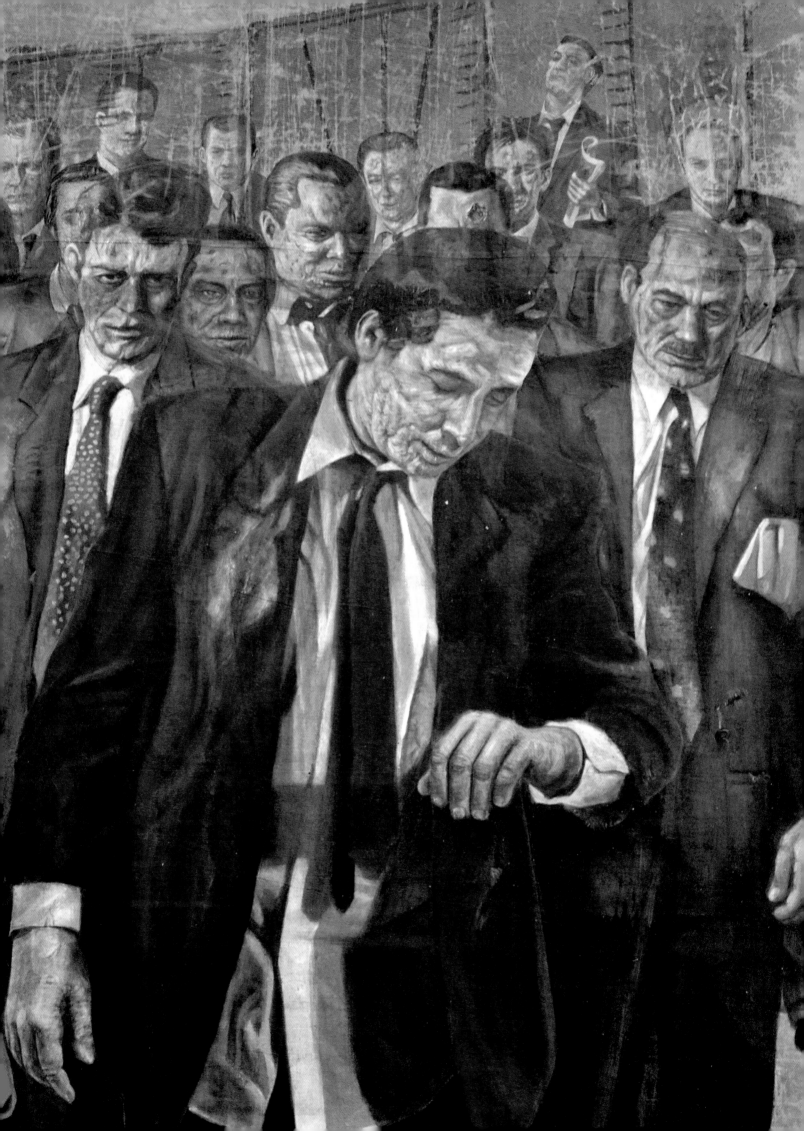

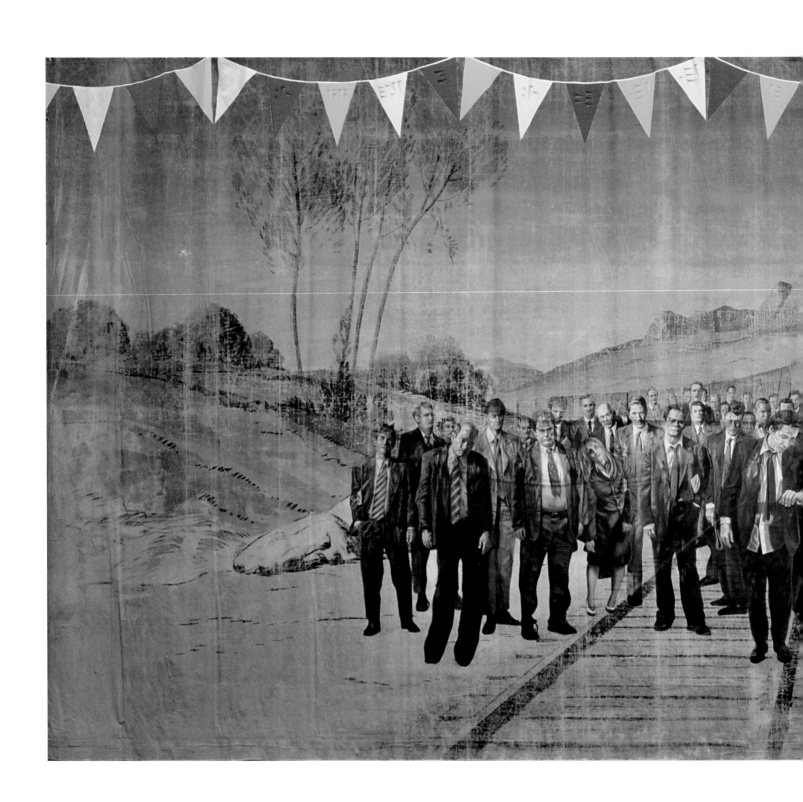

154 *Untitled*, 2006, acrylic on muslin, 485 × 1188.7 cm

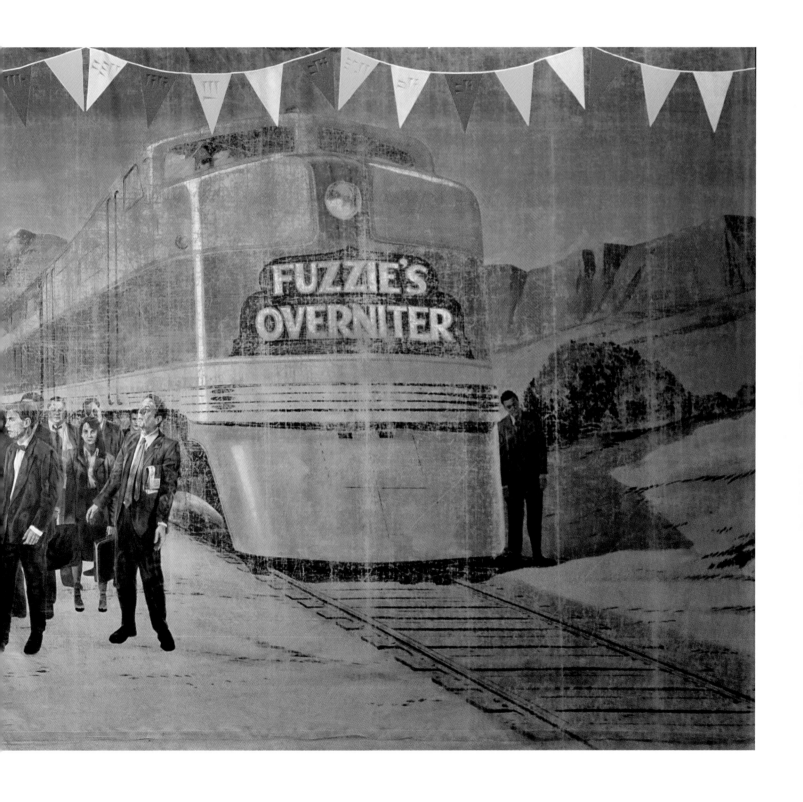

following double page: *Octupus Vacuum*, 2008, acrylic on muslin, 489.6 × 720 cm

Untitled (U.S. Presidents), 2006, acrylic on muslin, 487.6 × 1158.2 cm

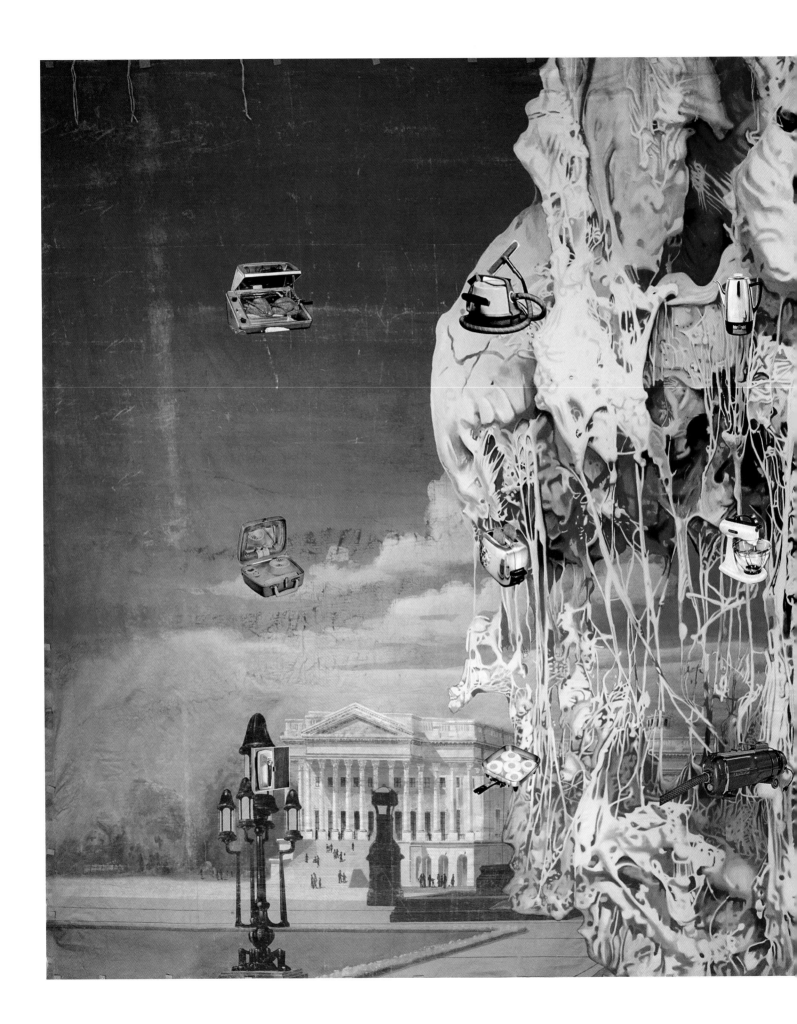

162 *Capitol Viscera Appliances mural*, 2011, acrylic on muslin, 500 × 1016 cm

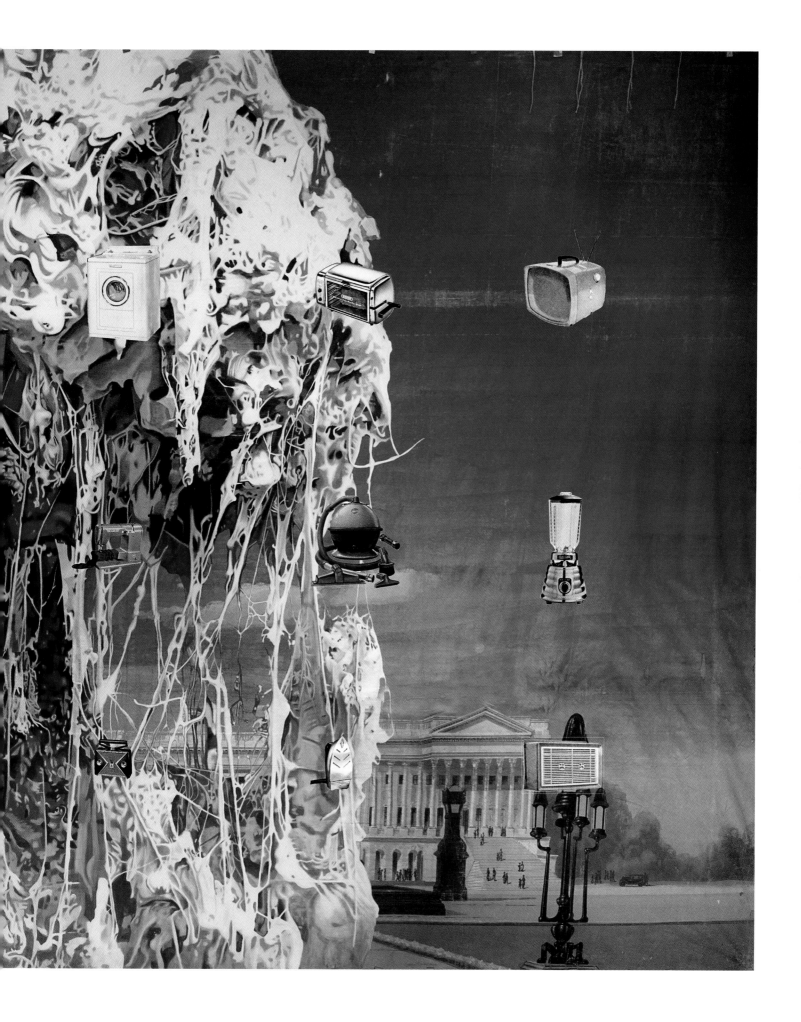

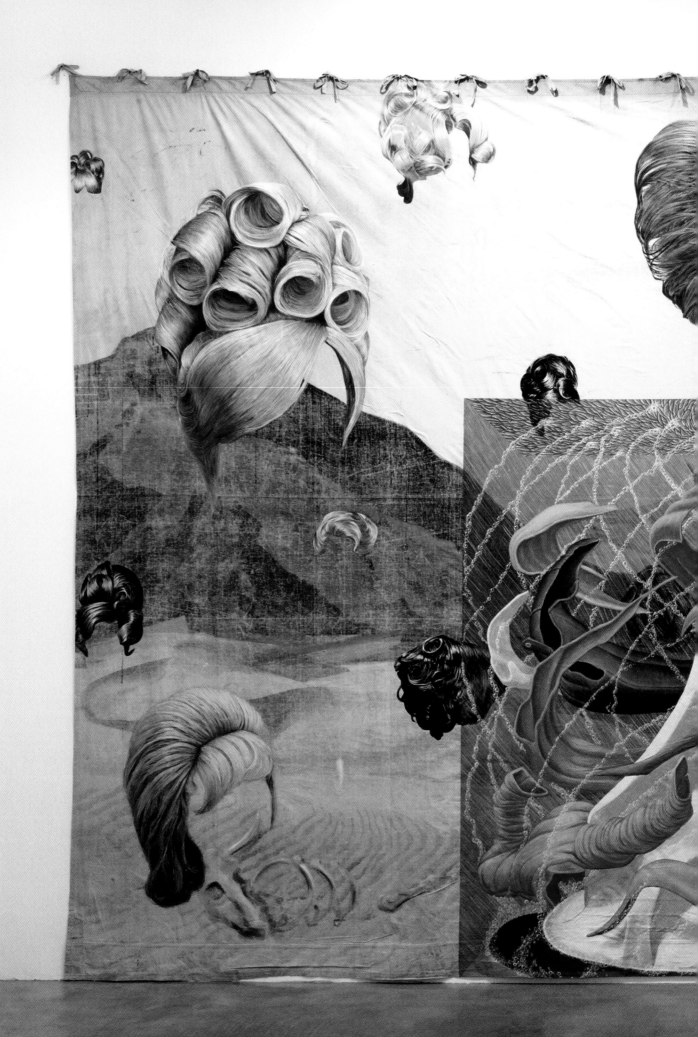

Rinse Cycle, 2012, acrylic on muslin, 381 × 584.2 cm

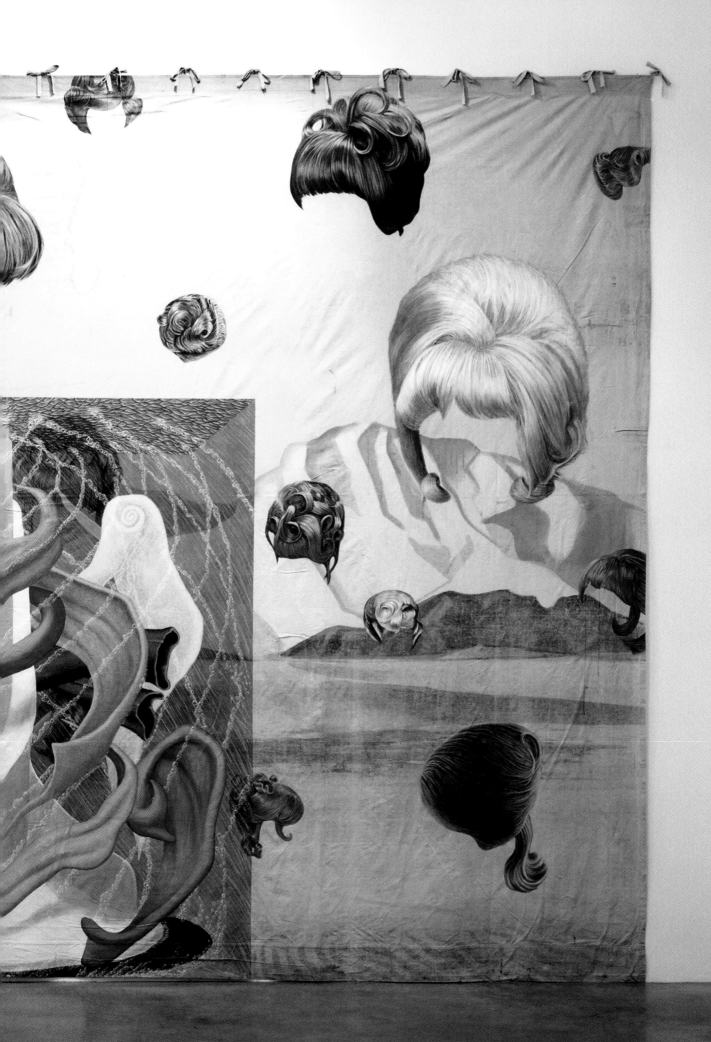

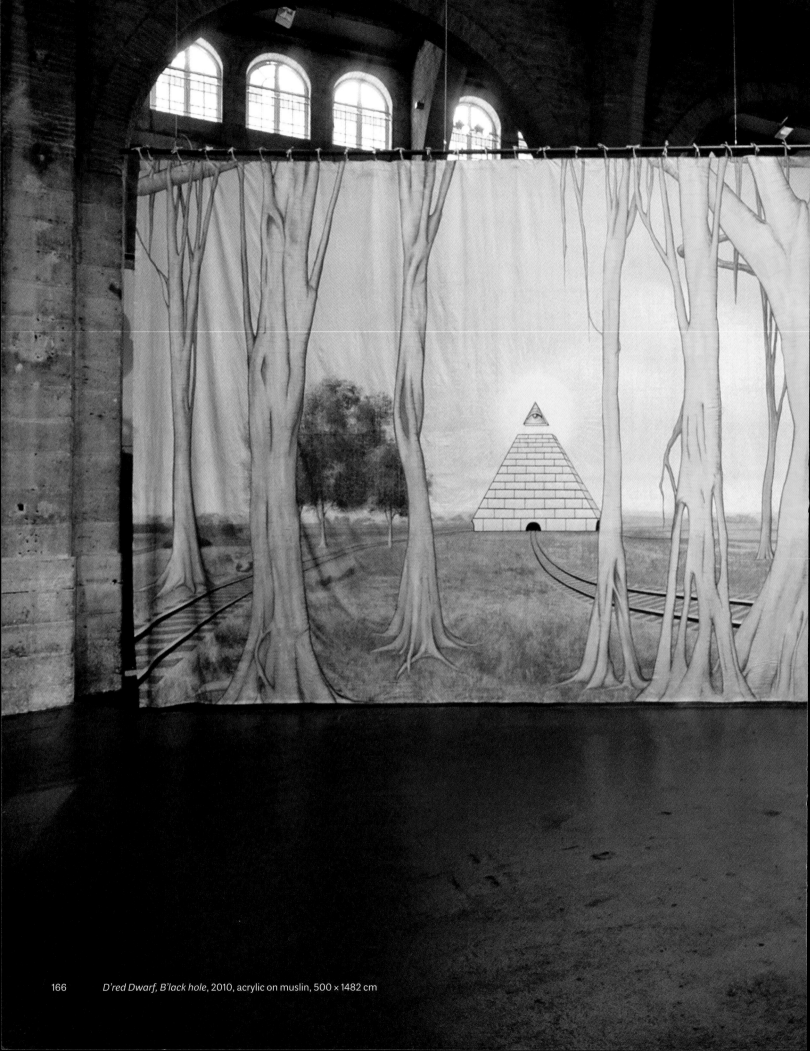

D'red Dwarf, B'lack hole, 2010, acrylic on muslin, 500 × 1482 cm

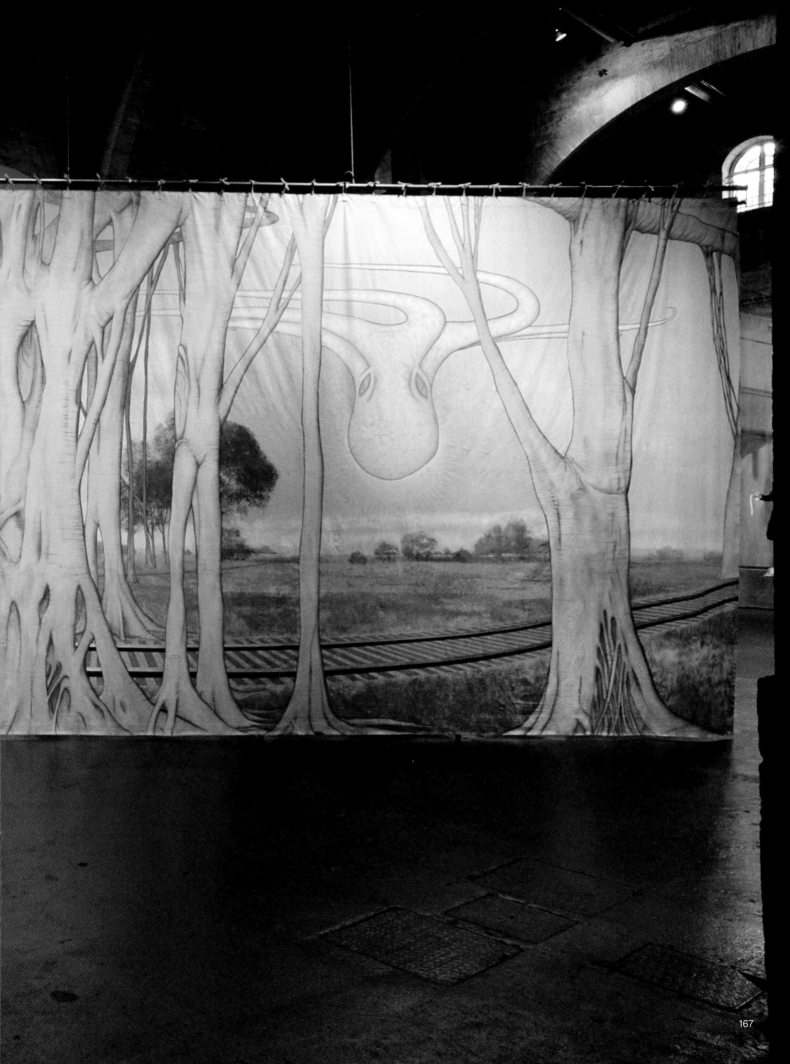

Exhibited Works

* Exhibition copy

Untitled 1978
Retouched photograph
25.3 × 20.2 cm (10 × 8 in.)
Collection Praz-Delavallade, Paris
(p.8)

Untitled 1979
Graphite, airbrush and
prismacolor on paper
35.5 × 27.9 cm (14 × 11 in.)
Jim Shaw, Los Angeles
(p.57)

Untitled 1985
Graphite, airbrush and
prismacolor on paper
35.5 × 27.9 cm (14 × 11 in.)
Jim Shaw, Los Angeles
(p.57)

All Consuming Guilt 1986 *
Photostat on paper
43.2 × 35.6 cm (17 × 14 in.)
Jim Shaw, Los Angeles
(p.39)

The Andersons 1986
Analogue video transferred to DVD
Colour, sound, 2:33
Courtesy Jim Shaw, Los Angeles

Anima I (Earth) 1986
Oil on canvas
43.2 × 35.6 cm (17 × 14 in.)
Jim Shaw, Los Angeles
(p.24)

Billy Goes to a Party I 1986
Watercolour and Xerox on rag
43.2 × 35.6 cm (17 × 14 in.)
Collection of Barry Sloane,
Los Angeles
(p.22)

Artwork for *On Beyond Wednesday*
1986
Xerox and airbrush on rag paper
mounted on board
43.2 × 35.6 cm (17 × 14 in.)
Jim Shaw, Los Angeles

Study for *"Jesus' Life as a Boy"* 1986
Duo-tone on board mounted
on Photostat on paper
43.2 × 35.6 cm (17 × 14 in.)
Jim Shaw, Los Angeles
(p.25)

Pandora's Box 1986
Oil on canvas
43.2 × 35.6 cm (17 × 14 in.)
Ed & Danna Ruscha, Los Angeles
(p.20)

*Sometimes He Found Disturbing
Things on the Street* 1986
Pencil on board
43.2 × 35.6 cm (17 × 14 in.)
Collection of Barry Sloane,
Los Angeles
(p.31)

Anima IV (Combustion) 1987
Oil on canvas
43.2 × 35.6 cm (17 × 14 in.)
Ed & Danna Ruscha, Los Angeles
(p.27)

Billy Goes to a Party #4 1987
Analogue video transferred to DVD
Colour, sound, 5:30
Courtesy Jim Shaw, Los Angeles

My Mirage Logo III 1987
Silkscreen print on paper
edition of 50
43.2 × 35.6 cm (17 × 14 in.)
Jim Shaw, Los Angeles

My Mirage Logo V (Blood of God)
1987
Watercolour on plaster
43.2 × 35.6 cm (17 × 14 in.)
Courtesy Marc Jancou
Contemporary, New York
(p.55)

Teenagers Talking 1987 *
Photostat on paper
43.2 × 35.6 cm (17 × 14 in.)
Jim Shaw, Los Angeles

The True False Mirror 1987
Analogue video transferred to DVD
Colour, sound, 21:14
Courtesy Jim Shaw, Los Angeles

Beach Boys Weekend 1988
Pencil on paper
43.2 × 35.6 cm (17 × 14 in.)
Collection of Barry Sloane,
Los Angeles
(p.26)

Faithful Cad 1988 *
Photostat on paper
43.2 × 35.6 cm (17 × 14 in.)
Jim Shaw, Los Angeles
(p.46)

Jesus in Dalí Vision 1988 *
Photostat on paper
43.2 × 35.6 cm (17 × 14 in.)
Jim Shaw, Los Angeles
(p.51)

News Clippings 1988 *
Photostat on paper
43.2 × 35.6 cm (17 × 14 in.)
Jim Shaw, Los Angeles
(p.42)

Oil on Velvet 1988
Oil on velvet with stage blood
43.2 × 35.6 cm (17 × 14 in.)
Collection of John Baldessari,
Los Angeles
(p.52)

Sin of Pride 1988
Watercolor on paper
43.2 × 35.6 cm (17 × 14 in.)
Collection of Barry Sloane,
Los Angeles
(p.23)

Bon Idee 1989
Oil on canvas
43.2 × 35.6 cm (17 × 14 in.)
Courtesy Marc Jancou
Contemporary, New York
(p.36)

Classics Illustrated 1989
Gouache and ink on board
43.2 × 35.6 cm (17 × 14 in.)
Collection of Barry Sloane,
Los Angeles
(p.30)

Fumetti 1989 *
Photostat on paper
43.2 × 35.6 cm (17 × 14 in.)
Jim Shaw, Los Angeles
(p.47)

Pink Eggs Crack 1989
Silly putty, hydrocal plaster
in plexiglass
43.2 × 35.6 cm (17 × 14 in.)
Courtesy Marc Jancou
Contemporary, New York

Space 1989
Photostat on paper
43.2 × 35.6 cm (17 × 14 in.)
Skarstedt Gallery, New York
(p.33)

The Golden Book of Knowledge
1989
Gouache on board
43.2 × 35.6 cm (17 × 14 in.)
Collection of Eileen Harris Norton,
Santa Monica
(p.21)

The Soft Margarine 1989 *
Photostat on paper
43.2 × 35.6 cm (17 × 14 in.)
Jim Shaw, Los Angeles
(p.49)

Un Mois de Dimanches 1989 *
Photostat on paper
43.2 × 35.6 cm (17 × 14 in.)
Jim Shaw, Los Angeles
(p.35)

What's Happening 1989
Analogue video transferred to DVD
Colour, sound, 10:17
Courtesy Jim Shaw, Los Angeles

Chakra Corollary Chart 1990 *
Photostat on paper
43.2 × 35.6 cm (17 × 14 in.)
Jim Shaw, Los Angeles

Charcoal Drawings 1990
Cibachrome print
43.2 × 35.6 cm (17 × 14 in.)
Courtesy Marc Jancou
Contemporary, New York
(p.41)

Foreword 1990
Photostat on paper
43.2 × 35.6 cm (17 × 14 in.)
Jim Shaw, Los Angeles
(p.19)

Heretical Cross 1990
Gouache on board
43.2 × 35.6 cm (17 × 14 in.)
Collection of Barry Sloane,
Los Angeles

Icon (Pizza Face) 1990
Gouache on board
43.2 × 35.6 cm (17 × 14 in.)
Collection of Barry Sloane,
Los Angeles
(p.53)

Monster Chakra Chart 1990
Gouache and Mylar on board
43.2 × 35.6 cm (17 × 14 in.)
Skarstedt Gallery, New York
(p.38)

The Temptation of Doubting Olsen
1990
Gouache on board
43.2 × 35.6 cm (17 × 14 in.)
Private Collection, courtesy Marc
Jancou Contemporary, New York
(p.29)

The Adam and Eve Show 1991 *
Inkjet print on paper
43.2 × 35.6 cm (17 × 14 in.)
Jim Shaw, Los Angeles

Billy Goes to a Christian Conference
1991 *
Photostat on paper
43.2 × 35.6 cm (17 × 14 in.)
Jim Shaw, Los Angeles
(p.50)

Fabric Design 1991
Silkscreen on fabric
43.2 × 35.6 cm (14 × 17 in.)
Jim Shaw, Los Angeles
(p.44)

Study for *"Manlicker"* 1991
Graphite and collage on paper
43.2 × 35.6 cm (17 × 14 in.)
Courtesy Marc Jancou
Contemporary, New York

Spiral Creation Myth 1991 *
Photostat on paper
43.2 × 35.6 cm (14 × 17 in.)
Jim Shaw, Los Angeles

Tie-Dye 1991 *
Ink and silkscreen on fabric
43.2 × 35.6 cm (17 × 14 in.)
Jim Shaw, Los Angeles
(p.45)

World of Pain (Silver Version) 1991
Photostat on Mylar with
cardboard back
43.2 × 35.6 cm (17 × 14 in.)
Jim Shaw, Los Angeles
(p.43)

*Dream Drawing ("I explore below
and find the structure is vast...")*
1992
Pencil on paper
Two parts: 30.5 × 22.9 cm (12 × 9 in.)
Courtesy the artist and Blum & Poe,
Los Angeles
(p.69)

*Dream Drawing ("I was in a dance
in the ballroom of a mansion...")*
1992
Pencil on paper
30.5 × 22.9 cm (12 × 9 in.)
Courtesy the artist and Blum & Poe,
Los Angeles
(p.68)

*Dream Object ("Marnie + I are
between my folks house and her
folks house...")* 1992
Pencil on paper
Two parts: 30.5 × 22.9 cm (12 × 9 in.)
Courtesy the artist and Blum & Poe,
Los Angeles
(p.67)

*Dream Drawing ("My shrink was
giving me instructions...")* 1992
Pencil on paper
Two parts: 30.5 × 22.9 cm (12 × 9 in.)
Courtesy the artist and Blum & Poe,
Los Angeles
(p.68)

*Dream Drawing ("I was describing
a dream where I'd gone to South
America...")* 1993
Pencil on paper
30.5 × 22.9 cm (12 × 9 in.)
Courtesy the artist and Blum & Poe,
Los Angeles
(p.71)

*Dream Drawing ("I was watching
a Star Wars movie...")* 1993
Pencil on paper
30.5 × 22.9 cm (12 × 9 in.)
Courtesy the artist and Blum & Poe,
Los Angeles
(p.70)

*Dream Drawing ("Then I was lying
under an elevator...")* 1993
Pencil on paper
30.5 × 22.9 cm (12 × 9 in.)
Courtesy the artist and Blum & Poe,
Los Angeles
(p.70)

*Dream Drawing ("A steaming fun
house where adults pretend to feed
babies into giant throats...")* 1994
Pencil on paper
30.5 × 22.9 cm (12 × 9 in.)
Courtesy the artist and Blum & Poe,
Los Angeles
(p.72)

*Dream Drawing ("I was in a
thrift store in Vegas...")* 1995
Pencil on paper
30.5 × 22.9 cm (12 × 9 in.)
Courtesy the artist and Blum & Poe,
Los Angeles
(p.74)

*Dream Drawing ("I was in a Vegas
show about a Viking farmer...")* 1995
Pencil on paper
30.5 × 22.9 cm (12 × 9 in.)
Courtesy the artist and Blum & Poe,
Los Angeles
(p.73)

*Dream Drawing ("In class
Christopher Thorncock was
relating a dream...")* 1995
Pencil on paper
30.5 × 22.9 cm (12 × 9 in.)
Courtesy the artist and Blum & Poe,
Los Angeles
(p.73)

*Dream Drawing ("On the TV movie
bio of Frank Sinatra...")* 1996
Pencil on paper
30.5 × 22.9 cm (12 × 9 in.)
Courtesy the artist and Blum & Poe,
Los Angeles
(p.75)

*Dream Object: Paperback cover
painting ("In Vietnam Shannon
Doherty...")* 1996
Gouache on ragboard mounted
on plywood
26 × 17 cm (10 ¼ × 6 ⅝ in.)
Private Collection
(p.77)

*Dream Object: Paperback cover
painting ("A friend and I went to
a furniture store...")* 1998
Gouache on ragboard mounted
on plywood
26.4 × 15.9 cm (10 ⅜ × 6 ¼ in.)
Private Collection
(p.81)

*Dream Object: Paperback cover
painting ("After Searching for an
Experimental Movie...")* 1998
Gouache on ragboard mounted
on plywood
24 × 16 cm (9 ⅜ × 6 ¼ in.)
Private Collection
(p.78)

*Dream Object ("I was in my gallery
in Japan where the next show was
of miniature landscapes ... Next
I went into an organic shaped room
with flattened columns on the
bud shaped walls. The paintings
were of Native American & "Indian'
gambling...")* 1999
Acrylic on cardboard half-tubes
Tear drop room installation
Courtesy the artist and Blum & Poe,
Los Angeles
(pp.94–95)

*Dream Object: Paperback cover
painting ("I Was Waiting For
Eileen...")* 1999
Gouache on ragboard
mounted on wood
26.7 × 16.2 cm (10 ½ × 6 ⅜ in.)
Private Collection
(p.83)

*Dream Object: Paperback cover
painting ("On the Road to
Rochester...I was driving up hill...")*
1999
Gouache on wood
24 × 16 cm (9 ⅜ × 6 ¼ in.)
Private Collection
(p.77)

*Dream Object: Paperback cover
painting ("We go to a Public Art
Space...")* 1999
Gouache on ragboard
mounted on wood
26.7 × 16.2 cm (10 ½ × 6 ⅜ in.)
Private Collection
(p.76)

*Dream Object ("A couple of Vegas
students...")* 2000
Oil on shaped wood
122 × 169 cm (48 × 66 ½ in.)
Private Collection, courtesy BFAS
Blondeau Fine Art Services
(p.98)

*Dream Object ("A couple of
Vegas students...")* 2000
Oil on shaped wood
118.1 × 156.2 cm (46 ½ × 61 ½ in.)
Private Collection, courtesy BFAS
Blondeau Fine Art Services
(p.99)

Dream Objects (O-ism drawings)
2001
Graphite and ink on paper
57 × 76 cm (24 ½ × 30 in.)
Collection de Bruin-Heijn
(p.130)

*Dream Object: Paperback cover
painting (Jim in the Park)* 2001
Gouache on wood
24 × 16 cm (9 ⅜ × 6 ¼ in.)
Private Collection
(p.78)

*Dream Object: Paperback cover
painting (Man Being Shaved)* 2001
Gouache on wood
24 × 16 cm (9 ⅜ × 6 ¼ in.)
Private Collection
(p.79)

*Dream Object: Paperback cover
painting (Naked Bodies in Green
Slime)* 2001
Gouache on wood
24 × 16 cm (9 ⅜ × 6 ¼ in.)
Private Collection
(p.80)

*Dream Object: Paperback cover
painting ("On the road to
Rochester...after finding a
'Destroy all Monsters'...")* 2001
Gouache on wood
24 × 16 cm (9 ⅜ × 6 ¼ in.)
Private Collection
(p.79)

*Dream Object: Paperback cover
painting (Werewolves)* 2001
Gouache on wood
24 × 16 cm (9 ⅜ × 6 ¼ in.)
Private Collection
(p.81)

*Dream Object: Paperback cover
painting (Woman and Tiger)* 2001
Gouache on wood
24 × 16 cm (9 ⅜ × 6 ¼ in.)
Private Collection
(p.80)

Money Bags 2001
Foam, acrylic, paint and resin
58.4 × 67.9 × 50.8 cm
(23 × 26 ¾ × 20 in.) and
59.7 × 60.3 × 66.7 cm
(23 ½ × 23 ¾ × 26 ¼ in.)
Private Collection
(p.4)

Dream Object: Paperback cover painting (Humbold Bank) 2002
Gouache on museum board mounted on wood
24 × 16 × 2 cm (9 ⅜ × 6 ¼ × ¾ in.)
Private Collection
(p.82)

Dream Object: Paperback cover painting (Man being crucified in dungeons) 2002
Gouache on museum board mounted on wood
26 × 16 × 2 cm (10 ¼ × 6 ¼ × ¾ in.)
Private Collection
(p.82)

Dream Object: Paperback cover painting (Werewolf) 2002
Gouache on museum board mounted on wood
26.7 × 16.2 cm (10 ½ × 6 ⅜ in.)
Private Collection
(p.83)

Kill your Darlings #2 2002
Oil on canvas
182.9 × 243.8 cm (72 × 96 in.)
Private Collection, Geneva, courtesy Art & Public Geneva
(pp.118–9)

The Land of the Octopus #2 2003
Oil on canvas
182.9 × 243.8 cm (72 × 96 in.)
Collection of Isabelle and Charles Berković, Belgium
(pp.120–1)

Dream Object ("I dreamt of this Oist movie poster painting with overlays in the corner...") 2004
Acrylic, ink and oil crayon on canvas with silicone and cloth element
152.5 × 203 cm (60 ⅛ × 79 ⅞ in.)
GFL Collection, London
(p.122)

Dream Object ("I think I was half awake when I thought of this upright piano modelled after the cave monster from 'It Conquered the World.' Using an old piano with keys sawed off to make the mouth...") 2004
Mixed media
238.7 × 177.8 × 76.2 cm
(94 × 70 × 30 in.)
Galerie Guy Bärtschi, Geneva
(p.86)

Dream Object ("Marnie, Laura & I were going to a choral concert. We lost Laura & Marnie kept cutting in line...") 2004
Mixed media
86.4 × 63.5 × 38.1 cm
(34 × 15 × 25 in.)
Collection Patricia Marshall, Los Angeles
(p.87)

The Woman with No Name 2004
Acrylic on canvas
182.9 × 121.9 cm (72 × 48 in.)
Private Collection, courtesy Marc Jancou Contemporary, New York
(p.123)

Untitled (Lorrie) 2004
Oil on canvas
183 × 121 cm (72 ⅛ × 47 ⅝ in.)
Collection of Isabelle and Charles Berković, Belgium
(p.135)

Untitled (Robbie) 2004
Acrylic on canvas
152 × 203 cm (59 ¾ × 79 ⅞ in.)
Collection H. Lebrun
(p.131)

Heap 2005
McDonaldland toys, Styrofoam, plastic spray paint, resin and metal rods
162.6 × 61 × 195.6 cm
(64 × 24 × 77 in.)
Private Collection
(p.91)

Dream Object (Begging Bum) 2006
Bronze
9.5 × 30.5 × 13.3 cm
(3 ¾ × 12 × 5 ¼ in.)
Courtesy the artist and Simon Lee Gallery London/Hong Kong
(p.92)

Dream Object (Digestive Spiral) 2006
Mixed media
139.7 × 62.2 × 71.1 cm
(55 × 24 ½ × 28 in.)
D.Daskalopoulos Collection
(p.85)

Dream Object (Eyeball TV Model) 2006
Epoxy, wood, steel, polyester, enamel paint and gold leaf
13.7 × 33.3 × 13.3 cm
(5 ⅜ × 13 ⅛ × 5 ¼ in.)
Private Collection, courtesy Marc Jancou Contemporary, New York
(p.97)

Dream Object (House Spiral) 2006
Mixed media sculpture
228.6 × 134.6 × 144.8 cm
(90 × 52 × 57 in.)
Collection of Isabelle and Charles Berković, Belgium, courtesy Marc Jancou Contemporary, New York and Bernier/Eliades Gallery, Athens
(p.90)

Dream Object (Spaghetti Fetuses) 2006
Wood, steel, epoxy and paint
49.5 × 38.1 × 11.4 cm
(19 ½ × 15 × 4 ½ in.)
D.Daskalopoulos Collection
(p.88)

Dream Object (Vise Head) 2006
Bronze, steel and wood
Edition 3 of 5
119.4 × 137.2 × 76.2 cm
(47 × 54 × 30 in.)
Private Collection, courtesy Marc Jancou Contemporary, New York
(p.93)

Dream Object (Vomiting Bum) 2006
Bronze
7.9 × 30.5 × 15.2 cm (3 ⅛ × 12 × 6 in.)
Ringier Collection, Switzerland
(p.92)

Untitled 2006
Airbrush and graphite on paper
203.2 × 137.2 cm (80 × 54 in.)
Collection of Nancy and Stanley Singer
(p.132)

Untitled 2006
Acrylic on muslin
485 × 1188.7 cm (190 ⅞ × 468 in.)
Courtesy Marc Jancou Contemporary, New York
p.153 (detail) pp.154–5

Untitled (U.S. Presidents) 2006
Acrylic on muslin
487.6 × 1158.2 cm (192 × 456 in.)
Courtesy Marc Jancou Contemporary, New York
pp.156–7 (detail) p.159

Dream Object ("A room with waves of meat frozen crashed in the corner...") 2007
4-part mixed media sculpture (wood, magic sculpey, resin and fiberglass)
152.4 × 152.4 × 198.1 cm
(60 × 60 × 78 in.)
Galerie Guy Bärtschi, Geneva
(p.89)

Dream Object ("At a LACE meeting with Liz Taylor in some warehouse I realized I could make (as "Dream Objects") stuff I'd not dreamed of like the giant ear lounge chair.") 2007
Foam, upholstery and wood
74 × 245 × 116.8 cm
(29 × 96 ½ × 46 in.)
Courtesy the artist and Blum & Poe, Los Angeles
(p.99)

Dream Object (Butt-head bucket) 2007
Urethane and foam
49.5 × 61.6 × 80.6 cm
(19 ½ × 24 ¼ × 31 ¾ in.)
Courtesy the artist and Blum & Poe, Los Angeles
(p.96)

Dream Object ("I was looking for a red blouse that was by one of my students & found a complex spiralling wire frame structure which became a sort of infinite turtle whose appendages were all chocolate heads of various types of turtles.") 2007
Mixed media (copper wire, polyurethane rubber, polyurethane foam, paint and chocolate)
53.3 × 55.5 × 53.3 cm
(23 × 21 × 21 in.)
Private Collection
(p.100)

Dream Object ("I was working on a landscape sculpture that was actually a big garbage pile of all the dream objects I'd done and on top of it all was a sculpture of the whore of Babylon riding the beast with 7 heads and 10 horns. It was in a Plexi box.") 2007
Mixed media sculpture and Plexiglass case and pedestal
Plexi case: 31 × 47 × 36.8 cm
(12 ⅛ × 18 ½ × 14 ½ in.)
Pedestal: 102 × 47 × 36.8 cm
(40 ⅛ × 18 ½ × 14 ½ in.)
Courtesy the artist and Galerie Praz-Delavallade, Paris
(p.101)

The Hole 2007
High-definition video
Colour, sound, 10:58
Courtesy Jim Shaw, Los Angeles

*Nose sculpture wall sconce
(Freckled)* 2007
Molded plastic, lightbulbs
and wiring
88.9 × 52.1 × 40.6 cm
(35 × 20.5 × 16 in.)
Helena & Leslie Monoson Collection,
Switzerland
(p.2)

*Dream Object ("On a Sunday
Morning in W. HWD...")* 2008
Airbrush and pencil on paper
203.2 × 134.6cm (80 × 53 in.)
Private Collection Geneva, courtesy
Galerie Praz-Delavallade, Paris
(p.125)

*Dream Object (Presence sculpture:
Hoover vacuum cleaner; Led
Zeppelin's IV; Francis Bacon Figure;
decalcomania landscape; chicken
with mixer attachment)* 2008
Acrylic paint, wood and resin
53.3 × 36.5 × 21.3 cm
(21 × 14 ⅜ × 8 ⅜ in.)
Private Collection, courtesy Simon
Lee Gallery, London/Hong Kong
(p.107)

Octopus Vacuum 2008
Acrylic on muslin
489.6 × 720 cm (192 ¾ × 283 ⅜ in.)
Courtesy the artist and Galerie
Galerie Praz-Delavallade, Paris
(pp.160–1)

Untitled 2008
Acrylic on canvas
178 × 117 cm (70 ⅛ × 46 ⅛ in.)
André Sakhai, New York, courtesy
Galerie Praz-Delavallade, Paris
(p.133)

Banyan Tree Music Box 2009
Mixed media
26.6 × 25.4 × 25.4 cm
(10 ½ × 10 × 10 in.)
(p.108)

Oist Integrative Movement 2009
High-definition video, colour, sound,
17:02
Courtesy the artist and Simon Lee
Gallery, London/Hong Kong
(p.116)

Untitled (Faces in circle) 2009
Oil on canvas
152.4 × 152.4 cm (60 × 60 in.)
Courtesy the artist and Simon Lee
Gallery, London/Hong Kong
(p.127)

Untitled (Trunk horizontal) 2009
Airbrush and pencil on paper
86 × 203 cm (33 ¾ × 79 ⅞ in.)
Ringier Collection, Switzerland
(p.124)

*The Whole: A Study in Oist
Integrated Movement* 2009
High-definition video, colour, sound,
16:40
Courtesy the artist and Simon Lee
Gallery London/Hong Kong
(p.117)

Cake (Daniel) 2010
Oil on digital ink jet print,
acrylic and ink on panel
Painting: 116 × 95 cm
(45 ⅝ × 37 ⅜ in.)
Panel: 70 × 29.5 cm
(27 ½ × 11 ⅝ in.)
Courtesy the artist and Simon Lee
Gallery London/Hong Kong
(pp.142–3)

*Dream Object (Irregularly Shaped
Canvas: Blake's version of "Laocoon"
with vacuum cleaner; pained Brian
Randolph; Superman; Jimmy Olson
and composite superman version
of "Laocoon")* 2010
Acrylic and pencil on digital
ink jet print
178.1 × 92.7 × 7.3 cm
(70 ⅛ × 36 ½ × 2 ¾ in.)
Courtesy the artist and
Bernier/Eliades Gallery, Athens
(p.102)

*Dream Object (Irregularly Shaped
Canvas: Decalcomania rooster;
"Hermit" from Tarot Card in pose
from a painting by Ernst' father;
chicken broiler")* 2010
Ink, wood and resin
167.6 × 94 × 7.3 cm (66 × 37 × 2 ⅞ in.)
Courtesy the artist and
Bernier/Eliades Gallery, Athens
(p.102)

*Dream Object (Irregularly Shaped
Canvas: Hoover Vacuum Cleaner;
Banyan Tree; Blakean swirling mist
with eyes; snake)* 2010
Acrylic, ink and pencil on
digital ink jet print
123.2 × 90.8 × 7.3 cm
(48 ½ × 35 ¾ × 2 ⅞ in.)
Courtesy the artist and
Bernier/Eliades Gallery, Athens
(p.103)

*Dream Object (Irregularly Shaped
Canvas: Tarot "Sun" Card; Wayne
Boring, Blake in Sun; "The
Nightmare," & Clay Shaw in Fauvist
style; dreamt of monstrous cackling
hen; toaster oven)* 2010
Acrylic, ink and pencil on
digital ink jet print
177.2 × 92.1 × 7.3 cm
(69 ¾ × 36 ¼ × 2 ⅞ in.)
Courtesy the artist and
Bernier/Eliades Gallery, Athens
(p.103)

D'red Dwarf, B'lack hole 2010
Acrylic on muslin
500 × 1482 cm (196 ⅞ × 583 ⅜ in.)
Courtesy the artist and Galerie
Praz-Delavallade, Paris
(pp.166–7)

*Sculpture A: Dream Object
(Presence sculpture: "I was working
on these shaped canvases &
sculptures that had printed blowups
of appliances & added elements")*
2010
Acrylic, oil, ink, pencil, MDF wood,
aqua resin and fibreglass
198.8 × 153.7 × 79.4 cm
(78 ¼ × 60 ½ × 31 ¼ in.)
Courtesy the artist and
Bernier/Eliades Gallery, Athens
(p.105)

*Sculpture B: Dream Object
(Presence sculpture: UN Jesus;
Led Zeppelin's Presence cover;
Max Ernst's "Men Shall Know
Nothing of This")* 2010
Airbrush, acrylic, ink, pencil, MDF
wood, aqua resin and fibreglass
120 × 56.5 × 83.2 cm
(47 ¼ × 22 ¼ × 32 ¾ in.)
Pedestal: 40 × 95 × 95 cm
(15 ¾ × 37 ⅜ × 37 ⅜ in.)
Courtesy the artist and
Bernier/Eliades Gallery, Athens
(p.104)

Whole Dancers 2010
Oil on canvas
116.8 × 182.9 cm (66 × 48 ¼ in.)
Mr. Michael Gary Rosenfeld
(p.128)

Cake (Double Brian) 2011
Oil on digital ink jet print, acrylic
and ink on panel
Painting: 94.9 × 170 cm
(37 ⅜ × 67 in.)
Panel: 38 × 55.4 cm
(15 × 21 ¾ in.)
Courtesy the artist and Blum & Poe,
Los Angeles
(p.140)

Cake (Jim Bent) 2011
Oil on digital ink jet print, acrylic
and ink on panel
Painting: 100.3 × 95.3 cm
(39 ½ × 37 ½ in.)
Panel: 31.8 × 62 cm
(12 ½ × 24 ⅜ in.)
Courtesy the artist and Simon Lee
Gallery London/Hong Kong
(pp.138–9)

Capitol Viscera Appliances mural
2011
Acrylic on muslin
500 × 1016 cm (198 ¼ × 400 in.)
Courtesy the artist and Simon Lee
Gallery London/Hong Kong
(p.162–3)

Oist Children Portrait (Girl & Doll)
2011
Oil on canvas
111.8 × 177.8 cm (44 × 70 in.)
Courtesy the artist and Metro
Pictures, New York
(p.129)

Stellaktite and Stalagmite 2011
18 ink on board panels
50.8 × 40.6 × cm (20 × 16 in.)
Courtesy the artist and Galerie
Galerie Praz-Delavallade, Paris
(pp.172–3)

Into the Void 2012
20 ink on board panels
53.3 × 38.1 cm (21 × 15 in.)
Courtesy the artist and Metro
Pictures, New York
(pp.181–3)

Rinse Cycle 2012
Acrylic on muslin
381 × 584.2 cm (150 × 230 ¼ in.)
Courtesy the artist and Metro
Pictures, New York
(p.164–5)

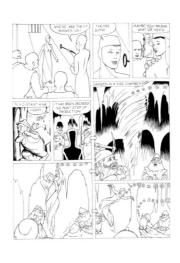

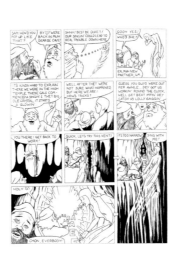

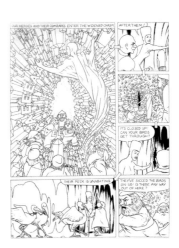

172 *Stellaktite and Stalagmite*, 2011, 18 ink on board panels, each 40.6 × 50.8 cm

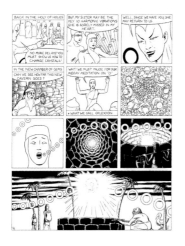

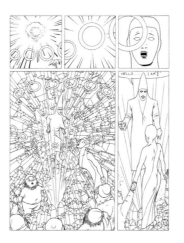

Biography

Born 1952 in Midland, Michigan, USA. Lives and works in Los Angeles, California, USA.

Education
1974
BFA, University of Michigan, Ann Arbor, USA.

1978
MFA, California Institute of the Arts, Los Angeles, USA.

Solo exhibitions
2012
Jim Shaw, Metro Pictures, New York, USA.

2011
Cakes, Men in Pain, White Rectangles, Devil in the Details, Patrick Painter Inc., Santa Monica, USA.
Thrilling Stories from the Book of "O", Galerie Praz-Delavallade, Paris, France.

2010
Left Behind, CAPC Musée d'art Contemporain, Bordeaux, France.
Jim Shaw: New Works, Bernier/Eliades Gallery, Athens, Greece.

2009
Wet Dreams: Erotic Dream Drawings by Jim Shaw, Praz-Delavallade, Paris, France (and 1997, 1999, 2000, 2005, 2007).
The Whole: A Study in Oist Integrated Movement, Simon Lee Gallery, London, UK.

2008
Jim Shaw: New Arrivals, Metro Pictures, New York, USA.
Extraordinary Rendition, Patrick Painter Inc., Santa Monica, USA; Patrick Painter, Los Angeles, USA (2008–2009).

2007
Dr. Goldfoot and His Bikini Bombs, Metro Pictures, New York, USA.
The Hole, Praz-Delavallade, Berlin, Germany.
Distorted Faces & Portraits, Blondeau Fine Art Services, Geneva, Switzerland (cat.).
The Donner Party, P.S.1, New York, USA.
Jim Shaw, Galleria Massimo de Carlo, Milan, Italy (and 1992, 1996, 2002).

2006
Jim Shaw, My Mirage, 1986–9, Skarstedt Fine Art, New York, USA; Bernier/Eliades Gallery, Athens, Greece (and 2003).
Jim Shaw, Emily Tsingou Gallery, London, UK (and 2001, 2004).

2005
Jim Shaw, Galerie Praz-Delavallade, Paris, France.

The Inky Depths/The Woman in the Wilderness, Metro Pictures, New York, USA.
The Dream That Was No More A Dream, Patrick Painter Inc., Santa Monica, USA.
Jim Shaw, Art & Public, Geneva, Switzerland.

2004
Jim Shaw, Emily Tsingou Gallery, London, UK.

2003
O, Magasin Center of Contemporary Art, Grenoble, France; Kunsthaus Glarus, Switzerland (cat.).
Kill Your Darlings, Patrick Painter Inc., Santa Monica, USA.
Kill Your Darlings, Bernier/Eliades Gallery, Athens, Greece.
Jim Shaw: Drawings, Studies, O-ism, Art & Public, Geneva, Switzerland.
Drawings, Metro Pictures, New York, USA.

2002
The Goodman Image File and Study, Swiss Institute, New York, USA.
The Rite of the 360°, Praz-Delavallade, Paris, France.
Jim Shaw, Galleria Massimo de Carlo, Milan, Italy.
O-ist Thrift Store Paintings, Metro Pictures, New York, USA.
Jim Shaw: Thrift Store Paintings (Tableaux de Brocante), 1974–2000, Mamco, Musee d'Art Moderne et Contemporain, Geneva, Switzerland.

2001
Dreamt of Drawings, Emily Tsingou Gallery, London, UK.
Jim Shaw, Metro Pictures, New York, USA.
Jim Shaw, Massimo de Carlo, Milan, Italy.
Jim Shaw, Praz-Delavallade, Paris, France.

2000
Jim Shaw: Thrift Store Paintings, Institute of Contemporary Arts, London, UK.
Jim Shaw, Patrick Painter Inc., Santa Monica, USA.
Jim Shaw, Johnen & Schottle, Cologne, Germany.

1999
Jim Shaw, Galerie Praz-Delavallade, Paris, France.
Jim Shaw, Metro Pictures, New York, USA.
Jim Shaw Everything Must Go! 1976–1999, Casino-Luxembourg, Forum d'Art Contemporain, Luxembourg (exh. cat.), travelled to Musée d'Art Moderne et Contemporain, Geneva, Switzerland (2000); and The Contemporary Arts Center, Cincinnati, USA (2000).

1998
Drawing, Rupertinum – Musée d'Art Moderne et Contemporain, Salzburg, Austria
Eccentric Drawing, Frankfurt Kunstverein, Frankfurt, Germany

1997
Jim Shaw, Rosamund Felsen Gallery, Santa Monica, USA.
Jim Shaw, Galerie Praz-Delavallade, Paris, France.
Jim Shaw, Bookbeat, Detroit, USA.

1996
Jim Shaw, Galleria Massimo de Carlo, Milan, Italy.
The Sleep of Reason, Metro Pictures, New York, USA.
Dreams, Cabinet Gallery, London, UK.

1995
What Exactly is a Dream and What Exactly is a Joke…, Donna Beam Fine Art Gallery, Las Vegas, USA.
I Dreamed I was performing in an Alternative Space w/ my Maidenform Bra, Rosamund Felsen Gallery, Santa Monica, USA.

1994
Dreams that Money Can Buy, Rena Bransten Gallery, San Francisco, USA.

1993
Dreams that Money Can Buy, Linda Cathcart Gallery, Santa Monica, USA (and 1990, 1992).
Dreams that Money Can Buy, Metro Pictures, New York, USA.

1992
Horror A Vacui, with Benjamin Weissman, Linda Cathcart Gallery, Santa Monica, USA.
Jim Shaw, Metro Pictures, New York, USA.
Life and Death, Texas Gallery, Houston, USA.
Jim Shaw, Galleria Massimo de Carlo, Milan, Italy.

1991
Jim Shaw: My Mirage, St. Louis Museum of Art, St. Louis, USA.
Thrift Store Paintings, Metro Pictures, New York, USA.
Jim Shaw, Feature Inc., New York, USA.

1990
My Mirage, Linda Cathcart Gallery, Santa Monica, USA.
Jim Shaw: My Mirage, Matrix Gallery, University Art Museum, University of California, Berkeley, CA, USA, travelled to St. Louis Museum of Art, St. Louis, USA (1991); and Feature Inc., New York, USA.
Jim Shaw, Feature Inc., New York, USA.

1989
Jim Shaw, Dennis Anderson Gallery, Los Angeles.

1986
The Nuclear Family, EZTV, Los Angeles, USA.

1981
Life and Death, Zero Zero Club, Los Angeles, USA.

Selected group exhibitions
2012
After Photoshop: Manipulated Photography in the Digital Age, Metropolitan Museum of Art, New York, NY, USA.
Poule! Fundacion/Coleccion Jumex, Mexico City, Mexico.
In the Waiting Room, Simon Lee Gallery, London, UK.
Lost In LA, Presented by FLAX, Los Angeles Municipal Art Gallery at Barnsdall ArtPark, Los Angeles, USA.

2011
Return of the Repressed: Destroy All Monsters, 1973–1977, Prism Gallery, Los Angeles, USA.
Jim Shaw: Fumetto, International Comix-Festival Luzern, Kunstmuseum Luzern, Lucerne, Switzerland.
Incongogru: Quand l'art fait rire, Musée cantonal des Beaux-Arts de Lausanne, Lausanne, Switzerland.
Interchange, Exchange LA, Los Angeles, USA.
All of the above (carte blanche à John Armleder), Palais de Tokyo, Paris, France.
Secret Societies: to know, to dare, to will, to keep silence, Schirn Kunsthalle, Frankfurt, Germany (exh. cat.), travelled to CAPC – Musée d'Art Contemporain de Bordeaux, Bordeaux, France.
California Dreamin': Myths and Legends of Los Angeles, Galerie Almine Rech, Paris, France.
All That Is Unseen, Allan Nederpelt Gallery, Greenpoint, USA.
Echoes, Centre Culturel Suisse, Paris, France (exh. cat.).
The Archaic Revival, Las Cienegas Projects, Los Angeles, USA.
Musique plastique, Galerie du jour Agnes B, Paris, France.
Citysonic – Festival des Arts sonores, Grande Halle, Mons, Belgium.
The Spectacular of Vernacular, Walker Art Center, Minneapolis, USA (exh. cat.), travelled to Montclair Art Museum, Montclair, USA.

2010
Insiders: pratiques, usages, savoir-faire, CAPC – Musée d'Art Contemporain de Bordeaux, Bordeaux, France.
The Artist's Museum, Museum of Contemporary Art, Los Angeles, USA.
Move: Choreographing You, Hayward Gallery, London, UK (exh. cat.),

travelled to Haus der Kunst, Munich (2011); and K20 Kunstsammlung Nordrhein-Westfalen, Düsseldorf, Germany (2011).

Skin Fruit: Selections from the Dakis Joannou Collection, New Museum, New York, USA.

Psychedelic: Optical and Visionary Art Since the 1960s, San Antonio Museum of Art, San Antonio, USA.

Rive Gauche/Rive Droite, Breton & Blondeau Associates, Paris, France (exh. cat.).

BigMinis: Fetishes of Crisis, CAPC – Musée d'Art Contemporain de Bordeaux, Bordeaux, France (exh. cat.).

2009

Labyrinth: I Dreamed I Was Taller Than Jonathan Borofsky, Printemps de Septembre, Toulouse, France.

Les Années 80 – Second volent: Images & (re)présentation, MAGA-SIN, Centre National d'Art Contemporain de Grenoble, Grenoble, France.

Spy Numbers, Palais de Tokyo, Paris, France, travelled to CA2M – Centro de Arte Dos de Mayo, Madrid, Spain.

Les Enfants Terribles, Fundacion/Colleccion Jumex, Ecatepec, Mexico.

Why Painting Now?, Blondeau Fine Art Services, Geneva, Switzerland.

Los Angeles, Aspects of the Archaic Revival, Galerie Haus Schneider Uschi Kolb, Karlsruhe, Germany.

You Can't Expect to Get Back to Normal, Las Cienegas Projects, Los Angeles, USA.

The Sculpture Show, Patrick Painter Inc., Santa Monica, USA.

Depression, Marres Centre of Contemporary Culture, Maastricht, The Netherlands.

Regift, The Swiss Institute, New York, USA.

2008

Amateurs, CCA Wattis Institute for Contemporary Art, San Francisco, USA.

In Geneva No One Can Hear You Scream, Blondeau Fine Art Services, Geneva, Switzerland (exh. cat.).

The Third LA Weekly Biennial: Some Paintings, Track 16 Gallery, Santa Monica, USA.

Sonic Youth etc.: Sensational Fix, Lieu, International des Formes Emergentes, St Nazaire, France (exh. cat.), travelled to Museion Bolzano, Bolzano, Italy; Kunsthalle Düsseldorf, Düsseldorf, Germany (2009); and Konsthall Mälmo, Mälmo, Sweden.

Index: Conceptualism in California from the Permanent Collection, The Geffen Contemporary, Los Angeles, USA.

Collecting Collections: Highlights from the Permanent Collection of The Museum of Contemporary Art, Museum of Contemporary Art, Los Angeles, USA (exh. cat.).

Less is less and more is more, CAPC – Musée d'Art Contemporain de Bordeaux, Bordeaux, France.

Glossolalia: Languages of Drawing, Museum of Modern Art, New York, USA.

The Unruly and the Humorous: Imagery from Inner Consciousness, Angles Gallery, Santa Monica, USA.

Political Correct, Blondeau Fine Art Services, Geneva, Switzerland.

Homage to Modern Art, Galleria Massimo de Carlo, Milan, Italy.

Zuordnungsprobleme, Johann König Gallery, Berlin, Germany

Mel's Hole, CFSU Grant Central Art Center, Santa Ana, USA.

Blasted Allegories – Works from the Ringier Collection, Kunstmuseum Luzern, Lucerne, Switzerland (exh. cat.).

Amateurs, CCA Wattis Institute for the Contemporary Arts, San Francisco, USA.

Martian Museum of Terrestrial Art, Barbican Art Centre, London.

Nobody Puts Baby in a Corner, Isabella Bortolozzi Gallery, Berlin, Germany.

The Brotherhood of Subterranea, Kunstbunker, Nuremberg, Germany.

In the Land of Retinal Delights: The Kuxtapoz Factor, Laguna Art Museum, Laguna Beach, USA.

Dreaming/Sleeping, Passage de Retz, Paris, France, travelled to the Petah Tivka Museum of Art, Tel Aviv, Israel.

Animation/Fictions: Works from the FNAC Collection, FNAC, Paris, France, travelled to MNAC, Bucharest, Romania.

Faces and Figures (Revisited), Marc Jancou Contemporary, New York, USA.

It's A Celebration, Circus Gallery, Los Angeles, USA.

The Third LA Weekly Biennale: Some Paintings, Track 16, Santa Monica, USA.

Ne pas jouer avec des choses mortes, Villa Arson, Nice, France.

Experimental: Folklore, Frankfurter Kunstverein, Frankfurt, Germany.

Heroes and Villains, Marc Jancou Contemporary, New York, USA.

Glossolalia: Languages of Drawing, Museum of Modern Art, New York, USA.

Collecting Collections: Highlights from the Permanent Collection of the Museum of Contemporary Art, Los Angeles, The Museum of Contemporary Art, Los Angeles, USA.

2007

Sympathy for the Devil: Art and Rock and Roll Since 1976, Museum of Contemporary Art, Chicago, USA (exh. cat.), travelled to Museum of Contemporary Art, Miami, USA (2008); and Musée d'Art Contemporain, Montreal, Canada (2008–2009).

Strange Events Permit Themselves the Luxury of Occurring, Camden Arts Centre, London, UK.

If Everybody Had an Ocean – Brian Wilson: An Art Exhibition, Tate St Ives, St Ives, UK (exh. cat.), travelled to CAPC, Musée d'Art Contemporain de Bordeaux, Bordeaux, France.

Ten Years, Emily Tsingou Gallery, London, UK.

Middle School: Smart Art Press, The First Thirteen Years, Track 16, Santa Monica, USA.

Art Unlimited, Art Basel, Basel, Switzerland.

Eden's Edge: Fifteen LA Artists, The Hammer Museum, Los Angeles, USA (exh. cat.).

Hammer Contemporary Collection, The Hammer Museum, Los Angeles, USA.

Olaf Breuning, Mike Kelley, Louise Lawler, John Miller, Tony Oursler, Sterling Ruby, Jim Shaw & Andreas Slominski, Metro Pictures, New York, USA.

Group Show: Peter Callesen, Karen Kilimnik, Jim Shaw, Marnie Weber, Emily Tsingou Gallery, London, UK.

Sound Art Limo, AC Institute, New York, USA.

Refugees of Group Selection, Franklin Parrasch Gallery, New York, USA.

Group Show, Bernier/Eliades Gallery, Athens, Greece.

A Fantasy for the Moment, Kunsthalle Bern, Bern, Switzerland.

De Leur Temps (2) Art Contemporain et Collections Privées, Musée de Grenoble, Grenoble, France.

945+11, FRAC-Collection Aquitaine, Bordeaux, France.

L'Homme-Paysage, Villa Oppenheim, Berlin, Germany.

Panic Room – Works from the Dakis Joannou Collection, Deste Foundation, Centre for Contemporary Art, Athens, Greece.

From Close To Home – Recent Acquisitions of Los Angeles Art, MOCA, Los Angeles, USA.

2006

Magritte and Contemporary Art: The Treachery of Images, Los Angeles County Museum of Art, Los Angeles, USA (exh. cat.).

Multiplicity: Prints and Multiples from the Collection of the Museum of Contemporary Art and the

University of Wollongong, The Museum of Contemporary Art, Sydney, Australia (exh. cat.).

Red Eye: Artists from the Rubell Family Collection, Rubell Family Collection, Miami, USA (exh. cat.).

Works on Paper, Patrick Painter, Inc., Santa Monica, USA.

Twice Drawn, The Frances Young Tang Teaching Museum and Art Gallery at Skidmore College, Saratoga Springs, USA.

A Selected State, Emily Tsingou Gallery, London, UK.

Chain Letter, High Energy Constructs, Los Angeles, USA.

Slow Burn, Galerie Edward Mitterrand, Geneva, Switzerland.

The Aesthetics of Art and Music/Punk, Magasin, Grenoble, France.

Los Angeles 1955–1985, Musée National d'Art Moderne, Centre Georges Pompidou, Paris, France.

Olaf Breuning, Jim Shaw, Cindy Sherman, Metro Pictres, New York, USA.

JSA (Jim Shaw's Army), Rental Gallery, Los Angeles, USA.

Faces, Blondeau Fine Art Services, Geneva, Switzerland.

Somnambulist/Fabulist, The Frances Young Tang Teaching Museum and Art Gallery at Skidmore College, Saratoga Springs, USA.

Made in USA, Galerie Multiples, Paris, France.

Noir c'est la Vie, Abbay St Andre – Centre d'Art Contemporain, Meymac, France.

Hundert Küsse sind besser als einer (A Hundred Kisses are Better than One), Krinzinger Projekte, Vienna, Austria.

Dormir, Rever...et d'autres nuits, CAPC – Musée d'Art Contemporain Bordeaux, Bordeaux, France.

2005

Self Portraits, Skarstedt Fine Art, New York, USA.

Mike Kelley, Martin Kippenberger, Louise Lawler, Robert Longo, John Miller, Jim Shaw, Cindy Sherman, Gary Simmons, Metro Pictures, New York, USA.

Very Early Pictures, Luckman Gallery, California State University, Los Angeles, USA.

Drunk vs. Stoned 2, Gavin Brown Enterprises, New York, USA.

Catherine Sullivan, Jim Shaw, Tony Oursler, Lucy McKenzie, Martin Kippenberger, Mike Kelley, Metro Pictures, New York, USA.

The Meeting, Center for the Arts, Eagle Rock, Los Angeles, USA.

WivesHusbands, Domestic Setting, Los Angeles, USA.

Superstars: Von Warhol bis Madonna, BA-CA Kunstforum Wien, Vienna, Austria.

Looking at Words, Andrea Rosen Gallery, New York, USA.
Closing Down, Bortolami, New York, USA.
Boost in the Shell, AEROPLASTICS Contemporary, Brussels, Belgium; Lucas Shoormans Gallery, New York, USA.
The Anniversary Show, Rena Bransten Gallery, San Francisco, USA.

2004
Walking on Elbows, Anna Helwing Gallery, Los Angeles, USA.
Information and the Mythological Machine, Mead Gallery, Coventry, UK.
Self Portraits, Angles Gallery, Santa Monica, USA.
The Dogs, Karyn Lovegrove Gallery, Los Angeles, USA.
Paper, Emily Tsingou Gallery, London, UK,
Disparities & Deformations, SITE Sante Fe, Santa Fe, USA (exh. cat.).
100 Artists See Satan, Grand Central Art Center, Santa Ana, USA (exh.cat.).
Diaries and Dreams – Contemporary Drawings, Galleria d'Arte Moderna, Bologna, Italy (exh. cat.).
Selected Works..., Marc Jancou Fine Art, New York, USA.
100 Artists See God, organised by Independent Curators International, Naples Museum of Art, Naples, Italy (exh. cat.), travelled to The Jewish Museum San Francisco, USA; Laguna Art Museum, Laguna Beach, USA; Institute of Contemporary Arts, London, UK (2004–5); Memorial Art Gallery, Rochester, USA (2005); Contemporary Art Center of Virginia, Virginia Beach, USA (2005); Albright College Freedman Art Gallery, Reading, USA (2005–6); Cheekwood Museum of Art, Nashville, USA (2006).
Tauchfahrten – Zeichnung als Reportage, Kunstverein Hannover, Hanover, Germany.
Diaries and Dreams, Ursula Blickle Stiftung, Kraichtal-Unteröwisheim, Germany.
Drawings, Galerie Praz-Delavallade, Paris, France.

2003
Ivan Morley, Christian Schumann, Jim Shaw, Patrick Painter Inc., Santa Monica, USA.
Variations on the Theme of Illusion, Emily Tsingou Gallery, London, UK.
Drawings, Metro Pictures, New York, USA.
Il Passato Non Esiste, Aurora, Rovereto, Italy.
Extra, Swiss Institute, New York, USA (exh. cat.).
Group Show, Patrick Painter Inc., Santa Monica, USA.

LA Post Cool, Ben Maltz Gallery at Otis College of Art and Design, Los Angeles, USA.
Still Waters, Roberts & Tilton, Culver City, USA.
War (What Is It Good For?), Museum of Contemporary Art Chicago, Chicago, USA.

2002
Group Show, Metro Pictures, New York, USA.
L.A. Post-Cool, San Jose Museum of Art, San Jose, USA (exh. cat.).
2002 Biennial Exhibition, Whitney Museum of American Art, New York, USA (exh. cat.).
Elvis has just left the building, Kunstlerhaus Bethanien, Berlin, Germany and Perth Institute of Contemporary Arts, Perth, Australia.
Super Heroes, Galerie Edward Mitterand, Geneva, Switzerland.
Shoot the Singer: Music on Video, Institute of Contemporary Art, Philadelphia, USA.
French Connection, Mamco – Musee d'Art Contemporain et Moderne, Geneva, Switzerland.
Doublures, FRAC – Haute-Normandie, Sotteville-lés-Rouen, France (exh. cat.).
(The World May Be) Fantastic, Biennale of Sydney 2002, International Festival of Contemporary Art, Sydney, Australia

2001
22nd Annual Benefit Art Auction, L.A.C.E, Los Angeles, USA.
Amused, Carrie Secrist Gallery, Chicago, USA.
The Magic Hour, Neue Galerie Graz im Künstlerhaus, Graz, Austria.
The Artist's World, Logan Galleries, CCAC Institute, San Francisco, USA (exh. cat.).
All Work and No Play Makes Jack a Dull Boy, Kunsthalle Bern, Bern, Switzerland.
Tony Oursler, Jim Shaw, John Miller, Mike Kelley, Galerie Biedermann, Munich, Germany.
Pop & Post-Pop (On Paper), Texas Gallery, Houston, USA.
Comic Relief, Rena Branstein Gallery, San Francisco, USA.
Heads or Tails, Galerie Praz-Delavallade, Paris, France.
Artists Take On Detroit: Projects for the Tricentennial, The Detroit Institute of Arts, Detroit, USA.

2000
Jim Shaw, Yoshitomo Nara, Johnen + Shottle, Cologne, Germany.
Destroy All Monsters, CoCa, Seattle, USA.
La Bienniale de Montréal 2000, Montreal, Canada.

Made in California, LACMA, Los Angeles, USA.
Representing LA, Friart Museum, Seattle, USA.
El Podar del Nar, MUSAC – Museo de Arte Contemporáneo de Castilla y León, León, Spain.
Diary, Cornerhouse Gallery, Manchester, UK, travelled to The Minories, Colchester, UK.
Projection 24/7, curated by Yvonne Force, The Standard, Hollywood, USA.
The Power of Narration: Mapping Stories, EACC – Espai d'Art Contemporani de Castelló, Castellón de la Plana, Spain.
Projections, FRAC Bourgogne, Dijon, France.
Art in the Early 90s: ReCharge, Laguna Art Museum, Laguna Beach, USA.
Dreaming Machines, Hayward Gallery, London, UK.

1999
Drawn by..., Metro Pictures, New York, USA.
Basement Series #1, curated by N. Roussel and M. Corompt, Pasadena, USA.
In Sickness and in Health: Jim Shaw and Marnie Weber, Recent Works, Project Gallery, Wichita, USA.
Drawn from the Artist's Collections, UCLA Hammer Museum, Los Angeles, USA.
I, Me, Mine, Luckman Gallery at California State University, Los Angeles, USA.
God Don't Make No Junk, Angstrom Gallery, Dallas, USA.
Videos of Artist Discussions, Rupertinum, Salzburg, Austria.
Pasadena Adjacent, Richard Heller Gallery, Santa Monica, USA.
Anisi de Suite 3, Centre Regional d'art Contemporain, Languedoc-Roussillon, France.
At Century's End, Museum of Contemporary Art, Lake Worth, USA.
A Girl Like You, Galerie Praz-Delavallade, Paris, France.
On Paper, Stalke Gallerie, Kirke Saaby, Denmark.

1998
Tell Me a Story, MAGASIN, Centre National d'Art Contemporain de Grenoble, Grenoble, France.
Time After Time..., Emily Tsingou Gallery, London, UK.
Pop Surrealism, Aldrich Museum of Contemporary Art, Ridgefield, USA (exh. cat.).
I Rip You, You Rip Me (Honey, We're Going Down in History), Museum Boijmans Van Beuningen, Rotterdam, The Netherlands.
Eccentric Drawing, Frankfurter Kunstverein, Frankfurt, Germany.

Everybody Loves a Clown, Baby, Why Don't You?, Guggenheim Gallery at Chapman University, Orange, USA (exh. cat.).
Night Vision, Junior Arts Center Gallery at Los Angeles Municipal Art Gallery, Los Angeles, USA.
Spread, Rena Bransten Gallery, San Francisco, USA.
The Bean Show, Dirt Gallery, Hollywood, USA.
Slip Stream, Modern Institute, Glasgow, UK.
Life Lessons: How Art Can Change Your Life: The Judy and Art Spence Collection, Laguna Art Museum, Laguna Beach, USA.
Affinities and Collections, California Center for the Arts, Escondido, USA.
Fictional Biographies, Rio Hondo College, Whittier, USA.
LA on Paper: Relax, Galerie Krinzinger, Vienna, Austria.
Educating Barbie, Trans Hudson Gallery, New York, USA (exh. cat.).
From Head to Toe: Concepts of the Body in 20th Century Art, LACMA, Los Angeles, USA (exh. cat.).
Carte Blanche, Institut Français in association with Galerie Praz-Delavallade, Turin, Italy.
Graphic, Monash University Gallery, Victoria, Australia.
The New Surrealism, Pamela Auchincloss, New York, USA.
Performance Anxiety, SITE Santa Fe, Santa Fe, USA.

1997
DAM, Deep Gallery, Tokyo, Japan.
Slad, Apex Art, New York Metro Pictures, New York, USA.
Angel: Angel, Kunsthalle Wien, Vienna, Austria (exh. cat.), travelled to Galerie Rudolfinum, Prague, Czech Republic.
Display, The Charlottenborg Exhibition Hall, Copenhagen, Denmark (exh. cat.).
Drawings, Meyerson and Nowinski, Seattle, USA.
Performance Anxiety, Museum of Contemporary Art, San Diego, USA.
Sunshine & Noir, Louisiana Museum of Modern Art, Humlebaek, Denmark (exh. cat.), travelled to Kunstmuseum Wolfsburg, Wolfsburg, Germany (1998); Castello di Rivoli, Museo d'Arte Contemporanea, Rivoli, Italy (1998); UCLA Hammer Museum of Art, Los Angeles, USA (1998).
I Have a Dream, Richard Telles Fine Art, Los Angeles, USA.
Kunstlerinnen, Kunsthaus Bregenz, Bregenz, Austria.
A Last Legacy: Selections from the Lannan Foundation Gift, The Geffen Contemporary, Los Angeles, USA.

Bring your Own Walkman, W139, Amsterdam, The Netherlands,
Now on View 2, Metro Pictures Gallery, New York, USA.
Group Show, Metro Pictures Gallery, New York, USA.

1996
Psy-Fi, Real Art Ways (RAW), Hartford, USA.
Anomalies, The Contemporary Arts Collective, Las Vegas, NV, USA.
The Comic Depiction of Sex in American Art, Sabine Knust Gallery, Munich, Germany.
Haus 19, Andreas Binder Gallery, Munich, Germany.
Be Specific, Rosamund Felsen Gallery, Los Angeles, USA.
Popcultural, South London Gallery, London, UK, travelled to Southampton City Art Gallery, London, UK.

1995
It's Only Rock and Roll, Contemporary Arts Center, Cincinnati, USA (exh. cat.), travelled to Lakeview Museum of Arts and Sciences, Peoria, USA; Virginia Beach Center for the Arts, Virginia Beach, USA; Tacoma Art Museum, Tacoma, USA; Jacksonville Museum of Art, Jackson, USA; Bedford Gallery at the Regional Center for the Arts, Walnut Creek, USA; The Phoenix Art Museum, Phoenix, USA; North Carolina Museum of Art, Raleigh, USA; Lowe Art Museum at the University of Miami, Miami, USA; Milwaukee Art Museum, Milwaukee, USA; Arkansas Art Center, Arkansas, USA; Fresno Metropolitan Museum, Fresno, USA; Austin Museum of Art, Austin, USA.
From L.A., With Love, Galerie Praz-Delavallade, Paris, France.
Art on Paper, Weatherspoon Art Gallery, Greensboro, USA (exh. cat.).
Representation Drawings, Feature Inc., New York, USA.

1994
Can You Always Believe Your Eyes?, De Beyerd, Breda, The Netherlands.
Jim Shaw, Tony Oursler, Laura Carpenter Fine Art, Santa Fe, USA.
Single-Cell Creatures: Cartoons and their Influence on the Contemporary Arts, Katonah Museum of Art, Katonah, USA.
Arrested Childhood, Center of Contemporary Art, Miami, USA (exh. cat.).
Facts and Figures, Lannan Foundation, Los Angeles, USA.
Summer Academy I, PaceWildenstein Gallery, New York, USA.
The Return of the Cadavre Exquis, Santa Monica Gallery, Santa Monica,USA.

1993
Prospect '93, Frankfurter Kunstverein/Schirn Kunsthalle, Frankfurt, Germany.
Der Zerbrochene Spiegel (Thrift Store Painting Collection), Staatliche Akademie der Bildenden Künste, Vienna, Austria (exh. cat.), travelled to Deichtorhallen, Hamburg, Germany.
The Return of the Cadavre Exquis, The Drawing Center, New York, USA.
Into the Lapse, Royal Academy of Fine Art, Copenhagen, Denmark.
Four Centuries of Drawing: 1593–1993, Kohn Abrams Gallery, Los Angeles, USA.
SoHo at Duke IV, Duke University Museum of Art, Durham, USA.
Kustom Kultur, Laguna Art Museum, Laguna Beach, USA.
The Language of Art, Kunsthall Wien, Vienna, Austria.
Summer Reading, Texas Gallery, Houston, USA.
Sampler: Southern California Video Tape Collection 1970–1993, organised by Paul McCarthy, Studio Guenzani, Milan, Italy, travelled to David Zwirner Gallery, New York, USA.

1992
Helter Skelter: L.A. Art in the 1990s, MOCA, Los Angeles, USA (exh. cat.).
Songs of Innocence/Songs of Experience, Whitney Museum of American Art at Equitable Center, New York, USA.
How It Is, Tony Shafrazi Gallery, New York, USA.
Drawings, Stuart Regen Gallery, Los Angeles, US.
Just Pathetic, American Fine Arts Co., New York, USA.
Re-Framing Cartoons, Wexner Art Center at Ohio State University, Columbus, USA.
True Stories, Institute of Contemporary Art, London, UK (exh. cat.).
Tattoo Collection: autour du tatouage, une collection de projets, photos et textes, Air de Paris, Nice, France; Urbi et Orbi, Paris, France. This exhibition travelled to Daniel Bucholz, Cologne, Germany.
American Art of the 80's, Museo d'Arte Moderna e Contemporanea di Trento, Trento, Italy (exh. cat.).
The Day the Earth Stood Still, Cirrus Gallery, Los Angeles, USA.
LAX, Galerie Ursula Krinzinger, Vienna, Austria.
Rosamund Felsen Clinic and Recovery Center, Rosamund Felsen Gallery, Los Angeles, USA.
Irony and Ecstasy: Contemporary American Drawings, Center for the Arts at Wesleyan University, Middletown, USA.

1991
Biennial Exhibition, Whitney Museum of American Art, New York, USA (exh. cat.).
Presenting Rearwards, Rosamund Felsen Gallery, Los Angeles, USA.
Ovarian Warriors vs. Knights of Crissum, Sue Spaid Fine Art, Los Angeles, USA.
HAH, Roy Boyd Gallery, Santa Monica, USA.
The Store Show, Richard/Bennett Gallery, Los Angeles, USA (exh. cat.).
The Kelly Family, Bucholz/Schipper, Cologne, Germany.
California North and South, Aspen Museum of Art, Aspen, USA.
No Man's Time, Villa Arson, Nice, France (exh. cat.).

1990
Video and Dream, The Museum of Modern Art, New York, USA.
Berlin Film and Video Festival, Berlin, Germany.
Recent Drawings: Roni Horn, Charles Ray, Jim Shaw, Michael Tetherow, Whitney Museum of American Art, New York, USA.

1989
Total Metal, Simon Watson, New York, USA.
Boys Will Be Boys, Linda Cathcart Gallery, Santa Monica, USA.
Erotophobia, Simon Watson, New York, USA.
L.A. Six, Rena Bransten Gallery, San Francisco, USA.
Buttinsky, Feature Inc., New York, USA.
ACCEPTABLE ENTERTAINMENT & ABOUT T.V.: Appropriation and Parody in Contemporary Video Art, Municipal Art Gallery, Los Angeles, USA.
Thick and Thin, Fahey/Klein Gallery, Los Angeles, USA.
No Stomach, Instillation Gallery, San Diego, USA.
Romancing the Stone, Feature Inc., New York, USA.
Amerikarma, Hallwalls, Buffalo, USA.

1988
In the Afterglow of TV Land, Infermental VIII, Tokyo, Japan.
Telling Tales, Artists Space, New York, USA.

1987
L.A. Hot and Cool: The Eighties, MIT List Visual Arts Center, Cambridge, USA.
New California Video, A Survey of Open Channels: Open Channels III, Long Beach Museum of Art, Long Beach, USA.
Cal Arts; Skeptical Belief(s), The Renaissance Society at the University of Chicago, Chicago, USA.

Heterodoxy, Rosamund Felsen Gallery, Los Angeles, USA.
LA2DA, Museum of Contemporary Art, La Jolla, USA.

1986
Social Distortions, Los Angeles Contemporary Exhibitions, Los Angeles, USA.
Hang 12, Piezo Electric Gallery, Venice, USA.

1985
B & W, Los Angeles Institute of Contemporary Art, Los Angeles, USA.
TV Generations, Los Angeles Contemporary Exhibitions, Los Angeles, US.
The Magic Show, Atelier Gallery at University of Southern California, Santa Monica, USA.

1984
The Floor Show, Los Angeles Contemporary Exhibitions, Los Angeles, USA.

1976
Art as it Sees, Rackum Gallery, Ann Arbor, USA.

Awards and Grants
2004
John Simon Guggenheim Memorial Foundation Fellowship

1998
Visiting Artist in Residence, University of North Texas, USA

1997
Visiting Artist in Residence, Malmö, Sweden

1996
Visiting Artist in Residence, Malmö, Sweden

1995
Visiting Artist in Residence, University of Nevada, USA

1989
Louis Comfort Tiffany Foundation Grant

1988
Art Matters Inc. Fellowship Grant

1987
Long Beach Museum of Art, Open Channels Grant

1986
National Endowment for the Arts Visual Artists Fellowship Grant

Selected Bibliography

2012

Laubard, Charlotte, John Miller, Jim Shaw, and John Welchman, *Left Behind*, CAPC Musée d'art Contemporain, Bordeaux, France/Les Presses du Réel, Dijon, France.

Wilson, Michael, 'Jim Shaw at Metro Pictures', *Time Out New York* (19–25April): 43.

Harvey, Doug, 'Punks Out of the Past', *Modern Painters* (March): 52–59.

2011

Bovier, Lionel and Fabrice Stroun, *My Mirage*, JRP Ringier, Zurich

Bechtler, Cristina (ed.), *On the Beyond*, Springer-Verlag, Vienna.

Kelley, Mike and Dan Nadel, eds., *Return of the Repressed: Destroy All Monsters 1973–77*, Picture Box, New York/PRISM, Los Angeles: 16–111.

Hoet, Jan, Joost Declerq, and Peter Doroshenko, *Collection Vanmoerkerke*, Rispoli Books, Brussels: 222–23.

M. Biro, '*Reality Effects'*, Artforum (Special Issue: 'Art in LA') (October): 259.

Taft, Catherine, 'Beroep: dilettant – Interview met Jim Shaw', *Metropolis M* (June/July): 34–41.

Mizota, Sharon, 'Art Review: Jim Shaw at Patrick Painter', LATimes.com (22 May).

Wood, Eve, 'Jim Shaw: Cakes, Men in Pain, White Rectangles, Devil in the Details', WhiteHotMagazine.com (May).

Mclean, Kathleen and Pamela Johnson, eds., *The Spectacular of Vernacular*, Walker Art Center, Minneapolis: 84–87.

Siegel, Katy, *Sing '45*, Reaktion Books, London: 126–27, 166.

2010

Déjean, Gallien, 'Le Complot de l'Ornement', *May*, no. 5 (October): 134–43.

Jancou, Marc, ed., *Rive Gauche Rive Droite*, JRP Ringier, Zürich: 84–85.

Schad, Ed, 'Jim Shaw', *Flaunt*, no. 107: 98–101.

Lee, Catherine, 'It's a Stitch', *Art & Music*, no. 10 (Summer): 36–42.

Bernard, Étienne, 'Jim Shaw: Vernacular Mysticism', *02 Magazine*, no. 55 (Autumn): 24–27.

Broqua, C. and C. Vergès, 'Certains l'aiment Shaw', *Spirit, supplément du journal Sud Ouest* (30 April).

Tumlir, Jan, 'Jim Shaw: Left Behind', Previews, *Artforum* (May): 143.

Lavrador, Judicaël, 'Freak Shaw', *Les Inrocks* (May 23).

Lavrador, Judicaël, 'Jim Shaw, Apocalypse Now à Bordeaux', *Beaux Arts* (May).

Mine, Molly, 'Jim Shaw fait son show à Bordeaux', *La Gazette Drouot* (14 May): 189.

Lequeux, Emmanuelle, 'L'Univers fourmillant de Jim Shaw effeuille les traumas de l'Amérique', *Le Monde* (1 June).

Youssi, Yasmine, 'Jim Shaw raconte l'Amérique à Bordeaux', *La Tribune* (3 June): 30.

Bernard, Paul, 'Jim Shaw au Capc', *02 Magazine* (Summer).

Gallais, Jean-Marie, 'Jim Shaw', *Kaleidoscope*, issue 07 (Summer): 73.

Chaillou, Timothée, 'L'Amérique en questions', *Archistorm*, no. 45 (Nov/Dec): 132

Déjean, Gallien, 'Le complot de l'ornement', *mayrevue*, no. 5 (October).

Le Chevalier, Yann, 'Subversif Jim Shaw', *Parcours des Arts*, no. 23 (July–Sept.): 56–57.

Chaillou, Timothée, 'Jim Shaw', *Standard*, no. 28 (July–August).

Arnaudet, Didier, 'Jim Shaw', *Artptress*, no. 369 (July–August): 94.

Lorient, Claude, 'Grand Shaw théâtral à Bordeaux', *La Libre Belgique* (24–25 July): 50–51.

Estève, Julie, 'Jim Shaw: Une approche éclectique et chaotique est le meilleur moyen d'aborder le présent', *Art Actuel*, no. 69 (July).

D.S., 'Le côté obscur selon Jim Shaw', *Connaissance des Arts*, no. 683 (June): 38.

Blain, Françoise-Aline, 'Jim Shaw, le gentleman de la contre-culture', *Parcours des Arts*, no. 22 (April–June): 40–41.

Duponchelle, Valérie, 'Jim Shaw et ses BD de l'Apocalypse', *Le Figaro* (18 May): 36.

Godfrey, Dominique, 'L'Apocalypse selon Shaw', *Sud-Ouest* (7 May): 44.

Chateigné Tytelman, Yann, 'Letter on the Deaf and Mute', *Kaleidoscope*, no. 7 (Summer): 76–81.

2009

Rattemeyer, Christian, *The Judith Rothschild Foundation Contemporary Drawings Collection: Catalogue Raisonné*, The Museum of Modern Art, New York: 250–51.

Thomas, Elizabeth, *Matrix/Berkeley: A Changing Exhibition of Contemporary Art*, University of California, Berkeley Art Museum and Pacific Film Archive, Berkeley, California: 291.

Kollectiv, Pil + Galia,Jlm Shaw: London' *Art Papers* (July/August): 57.

Harvey,Doug, 'Prop Department', *Modern Painters* (February): 22–23.

Benhamou-Huet, Judith, 'Toulouse Lyon, l'art contemporain s'expose', *Les Echos* (1 October): 17 (ill.).

Sumpter, Helen, 'The Joy of Sects', *Time Out*, London (19–25 February): 45–48.

Bishop, Sophie, 'New Age for Art', *Mayfair Times* (February): 16.

2008

Buckley, Annie, 'Critics' Picks: Jim Shaw', Artforum.com (December).

Hoptman, Laura, *Live Forever: Elizabeth Peyton*, Phaidon Press, New York: 228.

Hamilton, Elizabeth, ed., *This is Not To Be Looked At: Highlights from the Permanent Collection*, The Museum of Contemporary Art, Los Angeles: 272–73.

Barliant, Claire, 'The Artless Dodger: Jim Shaw and his Endless Compendium', *Afterall*, California Institute of the Arts, Valencia, California, no. 19: 91–97.

Harvey, Doug, 'Jim Shaw's Real Mirage: A Partial Inventory', *Afterall*, California Institute of the Arts, Valencia, California, no. 19: 98–106.

Ruf, Beatrix, ed., *Blasted Allegories: Works from the Ringier Collection*, JRP Ringier, Zurich: 170–71, 277.

Harvey, Doug, 'Duking It Out at Patrick Painter with Jim and Peter and Glenn: Agree to dis', *LA Weekly* (9 December).

Myers, Holly, 'Art Utopia', LAWeekly.com (9 January).

Neil, Jonathan T.D., 'Special Focus: Reviews Marathon', *Art Review* (February): 82.

Sonic Youth etc.: Sensational Fix, LiFE, Saint-Nazaire/Museion, Bolzano/Verlag der Smith, Roberta, 'Jim Shaw', *The New York Times* (18 January): E 38.

Myers, Holly, 'Art Utopia', LAWeekly.com (9 January).

2007

Molon, Dominic, *Sympathy for the Devil: Art and Rock and Roll Since 1967*, Museum of Contemporary Art, Chicago: 228–31.

Bernstein, Joanne, *The UBS Art Collection: Drawings*, UBS AG, Zürich: 230–33.

Schwendener, Martha, 'Jim Shaw: The Donner Party', *The New York Times* (3 August): E31.

Garrels, Gary, *Eden's Edge: Fifteen LA Artists*, Hammer Museum, Los Angeles: 34–41.

Blondeau, Marc, Bovier, Lionel, Davet, Philippe, eds., *Jim Shaw: Distorted Faces & Portraits 1978–2007*, JRP Ringier, Zürich and BFAS, Blondeau Fine Art Services, Paris: 96.

Wolff, Rachel, 'The Annotated Artwork: "The Donner Party"', *New York* (28 May): 84.

Darling, Michael, Holte, Michael and Mark Coetzee, ed., *Red Eye: L.A. Artists from the Rubell Family Collection*, Rubell Family Collection, Miami: 202–203.

Ascari, Alessio, 'Jim Shaw', *Mousse*, issue 10 (September): 18–21.

Karich, Swantje, 'Visuelle wirbel und makabre end zeitstimmung', *FAZ* (2 December).

Tull, Dani, 'Jim Shaw Talks With Dani Tull About His Paintings', *NY Arts Magazine* (November/December).

Drohojowska-Philp, Hunter, 'Reviews: Eden's Edge', *Art News* (October): 219–20.

2006

Fifth Interpretation of the Collection, La Colección Jumex, Pachuca, Mexico: 90–91.

Danby, Charles, 'Jim Shaw', *Frieze* (June/July/August): 275.

Satz, Aura, 'Jim Shaw', *Tema Celeste* (July/August): 79.

Shaw, Jim, *Jim Shaw: O*, JRP Ringier, Zürich.

Richer, Francesca and Matthew Rosenzweig, eds., *No. 1*, D.A.P., New York: 342.

Harvey, Doug, *Jim Shaw: Selected Dream Drawings*, Patrick Painter Inc., Santa Monica.

Brugger, Ingred, *Superstars: von Warhol bis Madonna*, Kunsthalle Wien, Vienna

Danby, Charles, 'Jim Shaw', *Frieze* (June): 275.

Bonnin, Anne, 'Le Show de l'hérétique', *02* (Autumn).

Duncan, Michael, 'Opening Salvos in L.A.', *Art in America* (November): 76–83.

Roussel, Noë Ilie, 'Los Angeles: Elsewhere is Everywhere', *Artpress*, no. 322 (April): 34–44.

Lack, Jessica, 'Monsters ink', *ID* (May).

2005

Aupetitallot, Yves, ed., *JRP Ringier, Private View 1980–2000*, Collection Pierre Huber, Zürich: 203–206.

Hamilton, Elizabeth, ed., *The Blake Byrne Collection*, MOCA, Los Angeles: 67.

Kantor, Jordan, *Drawing from the Modern: After the Endgames*, The Museum of Modern Art, New York: 122.

Harvey, Doug, 'Night Vision', *LA Weekly* (20 January).

French, Christopher, 'Il Nostro Grottesco', *Flash Art*, no. 249 (December 2004–January 2005): 66.

2004

Tumlir, Jan, 'Destroy All Monsters – Jan Tumlir on Motor City Madness', *Artforum* (October): 85–86, 276–78.

O, Introduction by Yves Aupetitallot and Nadia Schneider, essay by Doug Harvey, interview with Jim Shaw by Lionel Bovier and Fabrice Stroun, Le Magasin, Grenoble/Kunsthaus Glarus, Switzerland/JRP Ringier Kunstverlag AG, Zürich.

Mitchell, Charles Dee, 'Report from Santa Fe: Everything in Excess', *Art in America* (November): 84–91.

Purcell, Gre,g 'Unpopular Authorship: The Drawings of Jim Shaw', *NY Arts* (January/ February): 62.

Schneider, Nadia, 'Im banne des O-ismus', *Ostschweizer kultur-magazin*, no. 120 (March): 32–33.

Sossai, Maria Rosa, 'Great Expectations', *Flash Art*, no. 244 (February/March): 152.

Eleey, Peter, 'Fifth International SITE Santa Fe Biennial', *Frieze*, no. 86 (October): 161.

Singerman, Howard, 'Howard Singerman on Pop Noir', *Artforum International*, no. 2 (October): 125.

2003

Harvey, Doug, 'Cracked Abstraction: The Geometrical Designs of Alfred Jensen, the "O-ist" Discoveries of Jim Shaw', *LA Weekly* (7–13 February).

Pagel, David, 'Eye-to-eye with Forgotten Codgers', *Los Angeles Times* (17 January): E 39.

Levine, Carey, 'Jim Shaw at Metro Pictures and the Swiss Institute', *Art in America* (March): 126–27.

Magnuson, Ann, 'L.A. Woman: New World "O"rder', *Paper* (February): 53.

Tavee, Art, 'Between Rock and a Hard Place', *Contemporary*, issue 55: 96–99.

Falconer, Morgan, 'Interview with Jim Shaw', *Contemporary*, issue 55: 78–83.

Church, Amanda, 'Jim Shaw, Metro Pictures', *Flash Art* (November/December): 54.

Bonnin, Anne, 'Jim Shaw', *Art Press*, no. 294 (October): 77–78.

Pécoil, Vincent, 'Série O', *O2* (Summer): 8–11.

Pollack, Barbara, 'The New Visionaries', *ARTnews* (December): 92–97.

2002

Stern, Steven, 'Sweet Charity', *Frieze* (June/July/August): 94–97.

McDonald, Ewan, ed., *(The World May Be) Fantastic, 2002 Biennale of Sydney*, Museum of Contemporary Art, Sydney: 189–92.

Stern, Steven, 'Shaggy Dogma Stories', *Time Out New York* (3–10 October): 58.

Kimmelman, Michael, 'Jim Shaw', *The New York Times* (4 October): E33.

Williams, Gregory, 'Jim Shaw – Swiss Institute', *Artforum* (December): 137–38.

Leith, Anne, 'Jim Shaw', *Modern Painters* (Winter): 148–50.

Eamon, Christopher, London, Barbara, Lowry and Biesenbach,

Klaus, ed., *Video Acts*, P.S.1 Contemporary Art Center, Long Island City, New York: 189–91, 197.

Guerrin, Michel, 'Le grand déballage de Jim Shaw', *Le Monde* (14 April).

Summers, Francis, 'Hungry for Death?', *Untitled*, no. 28 (Summer): 16–19.

Rivoire, Annick, 'Entrées Imaginaires dans le Réel', *Libération* (30 September).

Troncy, Eric, 'La Clé des Songes', *Numéro* (November).

Saltz, Jerry, 'A World Apart', *The Village Voice* (8–14 May).

Douglas, Sarah, 'Jim Shaw: The Goodman Image File and Study', *The Art Newspaper* (September): 2.

Burnett, Craig, 'Praise the Big "O"', *Modern Painters* (Autumn): 153.

Williams, Gregory, 'Jim Shaw – Swiss Institute', *Artforum* (December): 137–38.

2001

Brown, Neal, 'A Noble Art/Jim Shaw', *Frieze* (March): 104–105.

Klein, Mason, 'Jim Shaw – Metro Pictures', *Artforum* (Summer): 184.

Klein, Mason, 'Jim Shaw', *Cabinet*, no. 5 (Winter).

Dannatt, Adrian, 'It Is All Just A Dream', *The Art Newspaper*, no. 113 (April): 77.

Oursler, Tony, 'Jim Shaw', *ITS*, issue 3 (November/December): 54–63.

2000

Trembly, Nicolas, 'Jim Shaw: MAMCO', *Flash Art* (Summer): 120–21.

Kushner, Rachel, 'A Thousand Words: Jim Shaw Talks about his Dream Project', *Artforum* (November): 128–29.

Duncan, Michael, 'Shaw's Carnival of the Mind', *Art in America* (December): 86–91, 134.

Falconer, Morgan, 'Priceless', *Art Review*, no. 52 (October): 44–45.

Marc-Olivier, Wahler, 'Le "BAC" crée une synergie sans précédent', *Le Journal des Arts,* no. 101 (17 March).

Grandjean, Emmanuel, 'Chaud chaud, le Jim Shaw', *Tribune de Genève* (29 January).

Chauvy, Laurence, 'Le Mamco s'ouvre au monde de Jim Shaw, artiste aux mille et un styles', *Le Temps* (2 February).

Clarinval, France, 'Expos & Autres Culturiosités', Nightlife.lu, Luxembourg (May): 35–37.

Grandjean, Emmanuel, 'Le Mamco termine l'hiver avec le bouillonnant Jim Shaw', *Tribune de Genève* (February).

Nicola, Jacques, 'Attendant 2002, le Mamco cible l'imaginaire ameri-cain', *Le Courrier* (3 February).

Havanne, Bill, 'Exposition Jim Shaw au MAMCO: Un délire américain', *Le Messenger* (10 February).

Harris, Hanna, 'Jim Shaw; ja amerikkalainen unelma', *Suomen Kuvalehti* (25 March).

Basting, Barbara, 'Im Erbe schäu-mend kraulen', *Frankfurter Allgemeine Zeitung* (31 March).

Piron, François, 'The Shaw Must Go On', *Mouvement* (April–June).

Boyer, Guy, 'Jim Shaw sur deux niveaux', *L'Oeil* (April).

Troncy, Eric, 'Artistic du Mois Jim Shaw', *Beaux-Arts Magazine* (April).

Baumann, Daniel, 'Jim Shaw at Mamco', *Kunst Bulletin* (May).

Harvey, Doug, 'Crazy Summer', *LAWeekly* (7 July): 43.

Duncan, Michael, 'Shaw's Carnival of the Mind', *Art in America* (December).

Harvey, Doug, 'Ten Shows That Rocked My World: Jim Shaw at Patrick Painter', *LA Weekly* (29 December–4 January).

Trembley, Nicolas, 'La Morale de l'Art Modeste', *Art Press* (November).

Behrman, Pryle, 'Jim Shaw, Everything Must Go', *Contemporary Visual Arts* (June/July/August): 43.

Minh-ha, Trinh T., 'L'innécriture: Inescriptura', *El Poder de Narrar* (September): 192–256, 260, 282–85.

Viladas, Pilar, 'Barn Again', *The New York Times Magazine* (27 August): 50–51.

Farquharson, Alex, 'Inside Art', *Art Monthly* (December/January): 242.

McCormack, Brian, 'personaLIST', *LIST* (Spring/Summer): 124.

Claydon, Paul, 'Jim Shaw: Thrift Store Paintings, ICA, London', *Untitled*, no. 23 (Autumn/Winter): 37.

1999

Rugoff, Ralph, 'Rules of the Game', *Frieze* (January/February): 46–49.

Johnson, Ken, 'Art in Review: Jim Shaw', *The New York Times* (19 March 19): E39.

Verwoert, Jan, 'Jim Shaw: Casino Luxembourg', *Frieze* (November/December): 99.

Everything Must Go: Jim Shaw 1974–1999, essays by Doug Harvey, Noelle Roussel, Fabrice Stroun, Amy Gerstler; interview with Mike Kelly, Casino Luxembourg, Luxembourg.

Grabner, Michèle, 'Jim Shaw', *New Art Examiner*, no. 3 (November): 68.

Schneider, Caroline, 'Jim Shaw – Everything Must Go – 1974–1999', *Artforum* (May): 80.

Pollack, Barbara, 'Jim Shaw: Review', *Artnews* (June): 128.

Breerette, Geneviève, 'A l'Est, quoi de nouveau?', *Le Monde* (14/15 February).

Angus, Denis, and Jim Shaw, 'Respect Pop Culture (entretien)', *Omnibus*, no. 27 (January).

Leydier, Richard, 'Jim Shaw: Casino Luxembourg', *Art Press*, no. 249 (September): 76–78

1998

Gerstler, Amy, 'Jim Shaw: Rosamund Felsen', *Artforum* (April): 112.

Duncan, Michael, 'Variations in Noir', *Art in America* (April): 57–61.

Harvey, Doug, 'Jim Shaw at Rosamund Felsen', *Art in America* (May): 134.

The New Neurotic Realism, essay by Dick Price, The Saatchi Gallery, London.

Pop Surrealism, essays by Richard Klein, Dominique Nahas, Ingrid Schaffner, Aldrich Museum of Contemporary Art, Ridgefield, Connecticut.

Rian, Jeff, 'Sunshine & Noir' and 'LA Times', *Flash Art* (October): 61, 67.

Drolet, Owen, 'Pop Surrealism', *Flash Art* (Summer): 61.

Zimmer, William, 'Recipe for a Good Time: Surrealism and Pop Culture', *The New York Times*, Connecticut section (2 August).

Kimmelman, Michael, 'How the Tame Can Suddenly See Wild', *The New York Times*, Arts and Leisure section (2 August).

Madoff, Steven, 'Pop Surrealism', *Artforum* (October): 120.

McCormick, Carlo, 'Surrealism Goes Pop', *Juxtapoz* (Winter).

Kimmelman, Michael, 'In Connecticut Where Caravaggio First Landed', *The New York Times*, Arts and Leisure section (17 July).

Lombardi, Dominick, 'An Art Lover's Candy Store at the Aldrich Museum', *The Record-Review* (26 June).

Dietsch, Scott, 'The New Surrealism Gets Real', *The Villager*, New York (4 November): 1.

1997

Dunham, Carroll, 'Jim Shaw', *ARTnews* (January): 118.

Van de Walle, Mark, 'Jim Shaw: Metro Pictures', *Artforum* (March): 90–91.

Reisman, David, 'The Sleep of Reason', *Texte zur Kunst* (March): 117–19.

'Special Feature: Mike Kelley & the LA Art Scene', *BT* (February): 16–80.

Albretini, Rosanna, 'Jim Shaw: Rêveries d'un Artiste Conceptual', *Art Press* (April): 47–51.

Knight, Christopher, 'Lots of "Sunshine," Little Light', *Los Angeles Times*, Arts section (27 July): 4–5/85.

Sunshine & Noir, Louisiana Museum of Modern Art, Humlebaek, Denmark.

Display, essays by Lars Bang Larsen and Mikael Anderson, The Charlottenborg Exhibition Hall, Copenhagen, Denmark.

Nilsson, Hakan, 'Sunshine and Noir', *Flash Art* (November/December): 74.

Larsen, Lars Bang, 'Sunshine & Noir: Art in LA 1960–1997', *Frieze* (September/October): 93–94.

Angel, Angel, foreword by Cathrin Pichler, Kunsthalle Wien, Vienna/Galerie Rudolfinum, Prague.

Kozloff, Max, 'Sunshine & Noir: Art in LA 1960–1997', *Artforum* (December): 110–11.

Dunham, Carroll, 'Jim Shaw', *ARTnews* (January): 118.

RakeziĆ, SaŠa, Kathman, Bob, eds., *Flock of Dreamers: An Anthology of Dream Inspired Comics*, Kitchen Sink Press, Northampton, MA: 42

1996

Saltz, Jerry, 'Jim Shaw, "The Sleep of Reason"', *Time Out New York* (17–24 October).

Johnson, Ken, 'California Dreamer', *Art in America* (December): 89.

Peters, Werner, *Society on the Run: A European View of Life in America*, M.E. Sharpe, Inc, New York.

Preston, Janet, 'New York Letter Bomb' (review of 'Sleep of Reason' show at Metro Pictures), *Coagula Art Journal*, no. 24: 18.

Koether, Jutta, 'Unterhalb der Metaebenen', *Spex*, no. 12 (December): 52.

Pedersen, Victoria, 'Gallery Go "Round"', *Paper* (October): 30.

Killam, Brad, 'L.A. Stories, Dean Jensen Gallery, Milwaukee, Wisconsin', *New Art Examiner*, vol. 24 (October): 49.

Muchnic, Suzanne, 'Jim Shaw', *Art News*, no. 94 (April): 154.

1995

McKenna, Kristine, 'The Night Watchman', *Los Angeles Times Calendar* (8 January): 7, 84.

Urban, Hope, 'Jim Shaw', *Juxtapoz* (Summer): 26–30.

Ruben, David. S, *It's Only Rock and Roll*, Contemporary Arts Center, Cincinnati, Ohio.

Kandel, Susan, 'Art as Therapy', *Los Angeles Times* (12 January): F10.

Tumlir, Jan. 'Jim Shaw at Rosamund Felsen', *Artweek* (March): 37.

Muchnic, Suzanne, 'Jim Shaw', *Art News* (April): 154.

Carducci, Vincent, 'Destroy All Monsters', *New Art Examiner* (April): 46.

Greene, David A., 'Jim Shaw's Dream Drawings', *Art Issues*, no. 38 (Summer): 20–21.

1994

Clearwater, Bonnie, 'Arrested Childhood', *Art Press* (December): 33–40.

1993

Kandel, Susan, 'Art Reviews: Jim Shaw at Linda Cathcart', *Los Angeles Times* (6 May): F12.

Duncan, Michael, 'L.A.: The Dark Side,' *Art in America* (March): 41–43.

Heath, Chris, 'Artful Dodgers', *Details* (November): 119–23, 175, 176.

Kissick, John, *Art: Context and Criticism*, Wm. C. Brown Communications, Inc., Dubuque, USA.

Duncan, Michael, 'Jim Shaw at Linda Cathcart', *Art in America* (December): 110.

Thrift Store Paintings: Jim Shaw, Uta Nusser, Kunsthalle Wien, Vienna/Deichtorhallen, Hamburg, Germany

1992

Gardner, Colin, 'Helter Skelter at the Temporary Contemporary', *Artforum* (April): 103–104.

Klein, Norman M., Relyea, Lane and Gudis, Catherine, ed., Helter Skelter: L.A. Art in the 1990s, Museum of Contemporary Art, Los Angeles, USA.

Knight, Christopher, 'An Art of Darkness at MoCA', *Los Angeles Times* (28 January): F1, 4, 5.

Nesbitt, Lois, 'Art's Bad Boys', *Elle* (March): 91–93.

American Art of the 80s, essay by Jerry Saltz, Museo d'Arte Moderna e Contemporanea di Trento, Italy.

Rugoff, Ralph, 'Jim Shaw: Recycling the Subcultural Straightjacket', *Flash Art* (March/April): 91–93.

Whitington, G. Luther, 'L.A.'s New Look', *Art & Auction* (January): 83–85, 116.

True Stories, ICA, London.

Plagens, Peter, 'Welcome to Manson High', *Newsweek* (2 March): 65–66.

Liebman, Lisa, 'Jim Shaw', *Artforum*, vol. 30 (January): 101.

Kutner, Janet, 'An artist with a thirst for Pop', *Dallas Morning News* (12 June): 1C–2C.

Ruby, Dan, 'SoHo 1991', *South Atlantic Quarterly*, no. 3 (Summer): 662–64.

Kalil, Susie, 'Schlock Value', *Houston Press* (26 November): 31–34.

Yood, James, 'Et in Arcadia Ego?', *New Art Examiner*, vol. 19 (April): 24–26.

1991

Kandel, Susan, 'New York in Review: Jim Shaw', *Arts* (March): 106–107.

Shaw, Jim, 'Project for Artforum' (insert), *Artforum* (March): 81.

Heyler, Joanne, 'Jim Shaw: Nostalgia of Wow', *Flash Art* (March/April): 135.

Aletti, Vince, 'Thrift Store Paintings', *The Village Voice*, Literary Supplement (February).

Pagel, David, 'Jim Shaw at Linda Cathcart', *Art Issues* (April/May): 33.

Nesbitt, Lois S, 'Books', *Arts* (Summer): 106.

Walsh, Kelly, 'Jim Shaw', *Interview* (September): 68.

Smith, Roberta, '"Outsider Art" Goes Beyond the Fringe', *The New York Times*, section 2 (15 September).

Homes, A.M., 'Jim Shaw at Feature', *Artforum* (September): 132.

Nesbitt, Lois E., 'American Psycho', *Artscribe*, no. 88 (September): 44–47.

Armstrong, Richard, Hanhardt, John G., Marshall, Richard, Philips, Lisa, *1991 Biennial Exhibition*, Whitney Museum of American Art, New York.

Cameron, Dan, 'Not-Quite-Art', *Art & Auction* (November): 84–90.

Kandel, Susan, 'Teen Trauma', *Los Angeles Times* (28 November): F5.

Kimmelman, Michael, 'At the Whitney, a Biennial that's Eager to Please', *The New York Times* (19 April).

Knight, Christopher, 'Four Floors of Evolution', *Los Angeles Times Calendar* (28 April): 3.

Larson, Kay, 'A Shock to the System', *New York Magazine* (20 April): 86–87.

Troncy, Eric, 'No Man's Time', *Flash Art* (November/December): 121–22.

D'Amato, Brian, 'Thrift Store Paintings: Jim Shaw Recruits the Salvation Army', *Flash Art*, no. 161 (November/December): 126.

Decter, Joshua, 'Jim Shaw', *Arts Magazine*, vol. 66 (December): 80.

Ramirez, Yasmin, 'Jim Shaw's "Thrift Store Paintings" at Metro Pictures', *Art in America*, vol. 79 (December): 120.

1990

Knight, Christopher, 'Thrift Store Show: It's Priceless', *Los Angeles Times* (28 March): F1, F8.

Shaw, Jim, ed., *Thrift Store Paintings*, Heavy Industry Publications, California.

Saltz, Jerry, 'Lost in Translation: Jim Shaw's Frontispieces', *Arts Magazine* (Summer).

Knight, Christopher, 'Shaw's Wildly Funny Narrative Saga', *Los Angeles Times* (7 December).

Baker, Kenneth, 'Datebook Galleries', *San Francisco Chronicle* (8 December).

Nyo, Paul Tin, 'Jim Shaw', *Artweek* (13 December).

Rinder, Lawrence, 'Interview with Jim Shaw', *Matrix*, University Art Museum, Berkeley (December).

Schjeldahl, Peter, 'Low Cal', *The Village Voice* (25 December).

Helfand, Glen, 'Boy's Life', *SF Weekly* (14 November): 11.

Bonett, David, 'My Mirage reflects new image', *San Francisco Examiner* (23 November): C-2.

1989

Hickey, Dave, 'Jim Shaw, Stopping the Image Wheel', *Visions*, vol. 4: 6–9.

Gerstler, Amy, 'Jim Shaw', *Artforum* (Summer): 151.

Knight, Christopher, 'Recycling Art from a Heap of History', *Los Angeles Herald Examiner* (31 March): 4.

Weissman, Benjamin, 'Jim Shaw at Saxon-Lee', *Art Issues* (January): 23.

Clothier, Peter, 'The Next Wave', *Artnews* (December): 113–17.

Curtis, Cathy, 'Galleries', *Los Angeles Times* (29 December): F24.

Publications by the Artist
1986

Aioaeuie Ntnlnqrr, The End is Here Publications, California.

1981

Life and Death, The End is Here Publications, California.

1978

The End Here, The End is Here Publications, California.

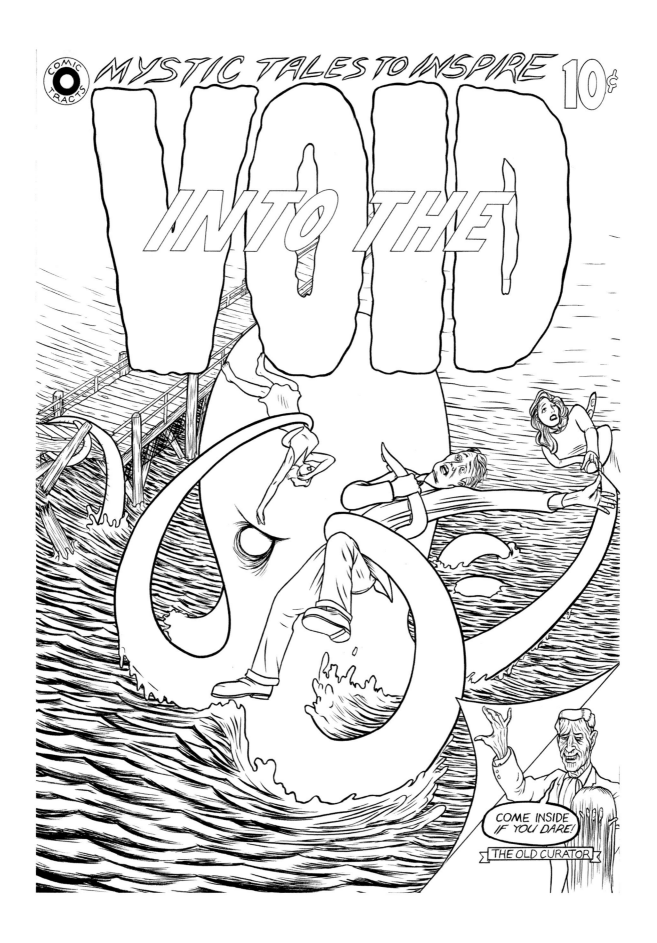

Into the Void, 2012, 20 ink on board panels, 53.3 × 38.1 cm

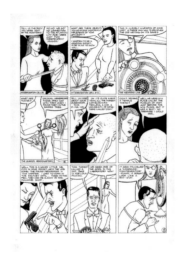
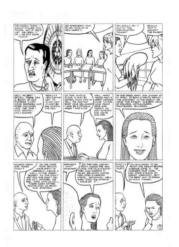
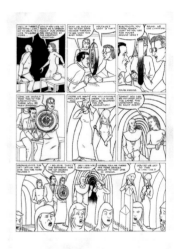
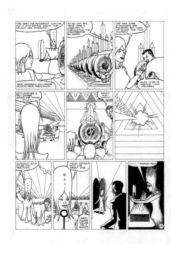

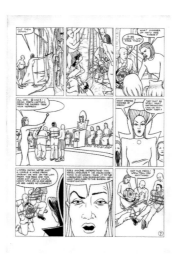

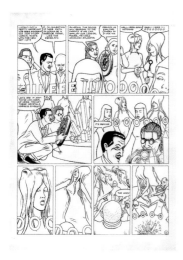
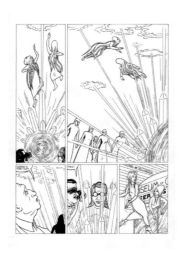
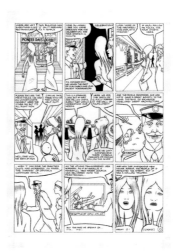

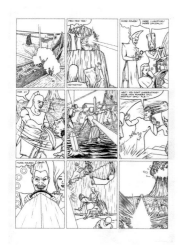
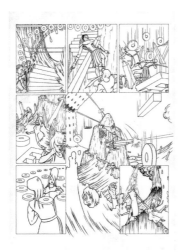

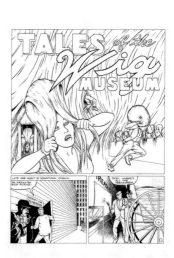

First published in 2012 by order of
the Trustees of BALTIC Centre for
Contemporary Art
by BALTIC Centre for Contemporary Art
Gateshead Quays
South Shore Road
Gateshead, NE8 3BA
www.balticmill.com

in assoiciation with:

Koenig Books Ltd
At the Serpentine Gallery,
Kensigton Gardens
London W2 3XA
www.koenigbooks.co.uk

on the occasion of the exhibition:

Jim Shaw: The Rinse Cycle
at BALTIC Centre for Contemporary Art
9 November 2012 – 17 February 2013

© BALTIC Centre for Contemporary Art,
the authors and Koenig Books, 2012

Editor: Laurence Sillars
Copy Editor: Helen Tookey
Production at BALTIC: Katharine Welsh

British Library Cataloging in
Publication Data
A catalogue record for this book is
available from the British Library

ISBN 978-3-86335-277-6

Catalogue design and production:
Peter B. Willberg

Printed in Italy

Cover:
Study for D'red Dwarf B'lack Hole,
2010, gouache and ink on paper
29.2 × 72.7 cm

Frontispiece:
*Nose sculpture wall sconce
(Freckled),* 2007, moulded plastic,
lightbulbs and wiring
88.9 × 52.1 × 40.6 cm

Distribution:

Germany
Buchhandlung Walther König
Ehrenstr. 4
D-50672 Köln
Tel. +49 (0) 221 20 59 6 53
Fax +49 (0) 221 20 59 6 60
verlag@buchhandlung-
walter-koenig.de

Switzerland
AVA Verlagsauslieferung AG
Centralweg 16
CH-8910 Affoltern a.A.
Tel. +41 (44) 762 42 60
Fax +41 (44) 762 42 10
verlagsservice@ava.ch

UK & Eire
Cornerhouse Publications
70 Oxford Street
GB-Manchester M1 5NH
Tel. +44 (0) 161 200 15 03
Fax +44 (0) 161 200 15 04
publications@cornerhouse.org

Outside Europe
D.A.P. / Distributed Art
Publishers, Inc.
155 6th Avenue, 2nd Floor
USA-New York, NY 10013
Tel. +1 (0) 212 627 1999
Fax +1 (0) 212 627 9484
eleshowitz@dapinc.com

Photo credits
All works © Jim Shaw
Pages 2, 91, 132, 181-3: courtesy Jim
Shaw and Metro Pictures, New York;
pages 4, 76-83: photo Thomas
Mueller, courtesy Jim Shaw; page 8:
courtesy Galerie Praz-Delavallade,
Paris; pages 19-22 (11), 23-31 (13),
33-9, 41-47, 49 (12), 50-55: photo
Frederik Nilsen, courtesy Jim Shaw;
pages 67-75, 96, 99: courtesy Jim
Shaw and Blum & Poe, Los Angeles;
pages 85, 88: courtesy Jim Shaw;
pages 86, 89: courtesy Galerie Guy
Bärtschi, Geneva; pages 92, 107:
courtesy Simon Lee Gallery
London/Hong Kong; pages 93, 123:
courtesy Marc Jancou Contemporary,
New York; pages 98-9: photo Joshua
White/JWPictures.com; page 101:
photo Lutz Bertram, courtesy Galerie
Praz-Delavallade, Paris; pages 102-5:
photo LeeAnn Nickel, Los Angeles,
courtesy Jim Shaw and Bernier/
Eliades Gallery, Athens; pages 108,
116-7, 124, 127: photo Todd-White Art
Photography, courtesy Simon Lee
Gallery London/Hong Kong; pages
118-9: photo Ilmari Kalkinen, Private
Collection, courtesy Art & Public,
Geneva; pages 120-1, 135: photo
Isabelle Arthuis, courtesy Collection
of Isabelle and Charles Berković,
Belgium; page 122: courtesy GFL
Collection, London; page 125: photo
LeeAnn Nickel, Los Angeles, courtesy
Galerie Praz-Delavallade, Paris; pages
129, 164-5: photo LeeAnn Nickel, Los
Angeles, courtesy Metro Pictures,
New York; page 130: courtesy
Collection de Bruin-Heijn and Metro
Pictures, New York; page 131: courtesy
Galerie Praz-Delavallade, Paris; page
133: courtesy André Sakhai and
Galerie Praz-Delavallade, Paris; pages
138-9 (17), 142-3, 162-3: photo LeeAnn
Nickel Los Angeles, courtesy Simon
Lee Gallery London/Hong Kong;
pages 140-1: photo LeeAnn Nickel,
Los Angeles, courtesy Jim Shaw and
Blum & Poe, Los Angeles; pages
153-7, 159: photo Frederik Nielsen,
courtesy Marc Jancou Contemporary,
New York; pages 160-1, 166-7: photo
Frédéric Deval – Mairie de Bordeaux,
courtesy Jim Shaw and Galerie Praz-
Delavallade, Paris; pages 172-3: photo
Rebecca Fanuele, courtesy Jim Shaw
and Galerie Praz-Delavallade, Paris.